Mike Chopra-Gant is Reader in Media, Communications and Culture at London Metropolitan University. He is the author of *Hollywood Genres and Postwar America: Masculinity, Family and Nation in Popular Movies and Film Noir* (I.B.Tauris, 2005) and *Cinema and History: The Telling of Stories* (2008).

The *Waltons*

NOSTALGIA AND MYTH IN SEVENTIES AMERICA

Mike Chopra-Gant

I.B. TAURIS
LONDON · NEW YORK

Published in 2013 by I.B.Tauris & Co Ltd
6 Salem Road, London W2 4BU
175 Fifth Avenue, New York NY 10010
www.ibtauris.com

Distributed in the United States and Canada Exclusively by Palgrave Macmillan
175 Fifth Avenue, New York NY 10010

International Library of the Moving Picture: 10

ISBN: 978 1 84885 029 3

A full CIP record for this book is available from the British Library
A full CIP record is available from the Library of Congress

Library of Congress Catalog Card Number: available

Printed and bound by CPI Group (UK) Ltd, Croydon, CR0 4YY

Contents

Acknowledgements

For reasons I cannot pretend to understand, it appears to be customary to thank last those people who make the greatest contribution to the writing of academic books, the people who endure on a daily basis the trials that writing brings to the author. Since I cannot understand the reasons for this convention and feel it unfairly treats those who are most important, positioning them as a sort of afterthought, I am pleased to express my gratitude, first and foremost, to my wonderful wife, Pam Chopra-Gant and our incredible daughters, Keshika and Umika. Only an author's family can begin to understand the lows and highs that come with writing. Thank you for bearing with me through all of these and sorry that it went on so long.

I would also like to thank my valued friends and colleagues, Gholam Khiabany, Milly Williamson, Christine Geraghty and James Bennett, as well as Anna Gough-Yates, Bill Osgerby, Paul Cobley and Iwan Morgan. I thank Simon Newman, of Glasgow University and Jonathan Lagerquist of the University of Helsinki, both of whom invited me to give papers based on this book and the curators of Special Collections at Stanford University, who supplied material from the Delmer Daves archive relating to the production of *Spencer's Mountain*. Thanks also to Philippa Brewster at I.B.Tauris, who has been more patient than any author has a right to expect an editor to be.

Finally, my thanks go to George Clinton, Sly Stone, Bootsy Collins, Neil Young and Steely Dan, who provided the suitably Seventies soundtrack that accompanied much of the writing of this book.

Introduction

Anodyne

In his commentary on the writing of literary theorist J. Hillis Miller – *J. Hillis Miller: Who Is He? Autoveilography (Aside)* – within Miller's own book, *Black Holes*, Manuel Asensi reflects on the ambiguities of the word 'anodyne'.[1] Deriving from two Greek words, 'an (without) odunos (pain)' the simplest meaning of anodyne is that of pain killer or reliever. But, as Assensi explains, an existence in which pain is never felt is an existence in stasis, one in which the senses atrophy. Thus the word 'anodyne' can also suggest a state of boredom. It is a term often used by reviewers and critics of cultural forms, who are able to exploit both of these meanings of the word simultaneously to describe works of art, literature, music, etc. that are unlikely to provoke controversy or cause offence, but which are, as a result, rather uninteresting.

When I have mentioned to people that I am writing a book about *The Waltons*, the most common response has been 'why?' Many of my associates have taken the view that the series is just too blandly inoffensive for there to be anything very interesting to say about it. It can be said, then, that so far as many media scholars are concerned (at least those of my acquaintance), *The Waltons* is certainly anodyne in the latter, pejorative sense. However, my position – and my answer to the question 'why?' in relation to writing a book about *The Waltons* – is that it is a worthwhile pursuit precisely because *The Waltons* is anodyne, *in both senses*, that it deserves serious consideration by scholars with any interest in the ideological operations of the media and of the workings of ideology within culture. The conjunction of both meanings –

boring/soothing – is particularly instructive, both in the specific case of this television show and, I would argue, more generally for understanding a wider range of cultural forms often dismissed by intellectuals as aesthetically valueless; cultural artefacts that are so bland that they are not deemed worthy of serious critical attention by cultural scholars.

Writing in the 1930s, journalist Maxine Davis considered the movies to be 'nothing more nor less than an anodyne for the bleak today', a place where people could find comfort and fulfilment by paying 'a dime or a quarter and buy[ing] a ready-made Elysium'.[2] While this account of the social function of movies in the 1930s is very far from a comprehensive one, it is certainly the case that cinemagoers often did regard visits to the theatre as a means of temporarily forgetting the troubles that everyday life presented. Similarly, by the time *The Waltons* first appeared on American television screens in 1972, Americans had perhaps wearied of watching news stories about the nation's economic woes; had tired of media coverage of civil unrest in its urban centres and of the structural violence of underlying social inequalities that lay at the root of these disruptions of civil order; and, perhaps worst of all, had been discomfited by the implicit inhumanity of the USA inscribed in appalling images of the terrified, agonised faces of helpless Vietnamese children bathed in American napalm while American troops stood by, seemingly immune to their suffering. In the face of all these reasons, to doubt the very idea of America, and particularly to question the validity of the American Dream, it is unsurprising that America in the early 1970s needed an anodyne. And an anodyne (in the therapeutic sense) is precisely what *The Waltons* provided. To attempt to understand *The Waltons*, then, is to endeavour to understand something important about the material socio-cultural setting from which it emerged and in which the series first mattered to millions of ordinary American television viewers. This examination of the social context in which *The Waltons* rose to popularity with American television viewers is pursued in more depth in Chapter 2. The argument I would make about this exercise is that by examining the series, we can

begin to look beneath the surface of the broad sweep of History (with a capital 'H'), the headline stories that tend to become the conventional way of gaining a historical understanding of the times – the big, significant events and important figures. Instead we can consider the affective responses of mediated culture (by which I mean both the cultural 'texts' themselves and the viewers' responses to those 'texts') to those events; something akin to what Raymond Williams called the 'structure of feeling' of the time.[3] By examining mundane, aesthetically unremarkable but nevertheless popular television shows like *The Waltons*, we can begin to understand how many ordinary Americans felt about their times and how television offered an anodyne to allay their unease at the events that comprise the History of those times.

If the implicitly judgmental question 'why write about *The Waltons?*' was one of the most notable responses of my peers to my announcement of this book, then the other noteworthy aspect of its genesis was my own surprise that nobody had done it before me. This discovery prompted a 'why?' of my own: why had nobody written seriously about a television show that was extremely popular in its time and has gone on to achieve a certain iconic status?

After giving this question quite some thought, my conclusion is that the reason why had no one written an academic book about the series before is in large part due to the way that media and literary scholars have conceptualised cultural value and hierarchies of taste. This, in turn, is largely a consequence of the way that academic cultural studies developed in its early years around a dialectical understanding of culture. Consideration of the way that these forces have combined to produce the intellectual and cultural terrain about which media and cultural studies today presume to speak also provides the answer to the first question, 'why write a book about *The Waltons?*'. To understand this fully we must indulge in a brief examination of media studies' and cultural studies' own histories, and particularly the extent to which literary study shaped their development.

In the nineteenth century knowing what counted as 'culture' appears to have been a relatively simple matter. There was a relatively stable canon of 'great' art and literature that embodied

the ideals of 'sweetness and light' proffered by Matthew Arnold in 1869 as the true markers of culture. For Arnold's contemporaries, and for many who followed him, 'culture' was not a matter of everyday, lived experience but a separate sphere of aesthetic activity. The idea that the only cultural works worth studying were those contained within a limited set (or canon) of exemplary works of art and literature – which could be supplemented by new works only by the decree of a self-appointed group of gatekeepers possessed of the education and 'excellent' taste to enable them to make such a decision – persisted well into the twentieth century. In the late 1950s, however, this idealist (and elitist) conception of culture came under fire from a new type of scholar, working-class lads who had entered the universities – hitherto exclusively a privilege of the wealthy – with the benefit of scholarships, and whose ideas were to lay the foundations for a radically new and more inclusive understanding of culture: most notably Raymond Williams and Richard Hoggart. Hoggart's *The Uses of Literacy*, published in 1957, and Williams' *Culture and Society*, published a year later, laid the cornerstones for the development of a new approach to the understanding of culture; what it is and what it does. This new approach was neatly distilled in the title of one of Williams' early essays, from 1958: *Culture is Ordinary.*[4]

Williams' and Hoggart's radical democratisation of the concept of culture paved the way for the development of cultural studies in the universities. But the way that cultural studies has developed since its birth has given it its own distinctive blind spots, which has led to the privileging of certain areas of culture over others, even within this more inclusive approach to the subject. During the 1960s and 1970s cultural studies (particularly in the UK), built on the foundations laid by Hoggart and Williams. Taking some of its key ideas from Marxist thought – notably Althusser's ideological state apparatuses and Antonio Gramsci's formulation of the operation of hegemony – British cultural studies concerned itself with both the ways in which culture – and the media in particular – worked to reproduce the political status quo, and the ways in which symbolic forms and ritual practices could be used as sites of resistance to that status quo.

This narrative of the development of thinking about culture is sometimes, over-simplistically, conceived as a dichotomy between a high (official) culture, of the type lauded by Arnold, and the other low (subcultural) forms examined by the new scholars of British cultural studies. In reality, however, there is a third term; a structuring absence in this dichotomy. For as much as 'high' and 'low' culture stand in opposition to one another, both also stand in opposition to an intermediate term – 'middlebrow' culture – from which both camps seek distinction. The importance of this imperative for both camps to distance themselves from the middlebrow can be clearly discerned in the writings of Theodor Adorno and Max Horkheimer, on the one hand – who, in the 1940s, championed 'difficult' avant-garde art as an antidote to the bland outpourings of the 'culture industries'[5] – and in more recent efforts of certain media scholars to promote 'cult' movies and television as instances of symbolic resistance, through the use of what Andrew Sarris earlier identified as the 'classic highbrow gambit' of raising 'lowbrow' forms to high aesthetic status in order to assert their distinction from the middlebrow.[6]

The overall impact of this complicated interplay of multiple dialectical discourses of cultural value has been to leave one distinct area of cultural production and consumption – the reviled middlebrow – relatively little examined by critical theorists and cultural scholars. Apart from a relatively small number of scholars who have been willing to brave the raised eyebrows of their peers when they disclose the subject of their research to be, say, soap opera or the 'book of the month club', the 'middlebrow' has mostly remained one of key 'exclusions which cultural studies has itself entrenched over the past thirty years'.[7]

There is, then, a void in the midst of cultural studies, where studies of middlebrow cultural forms should be if we seek comprehensiveness in our understanding of how culture works. This void operates almost as a prohibition of work on this area of culture,[8] ensuring that those who enter it find themselves in a scholastic 'ghost town', far away from the more densely populated and brightly lit areas of study, where other scholars excitedly cluster to debate the latest fashionable topic. In this wilful neglect of the

middlebrow, then, lies the answer to the question, why no one has
written an academic book about *The Waltons* before. And, since
no one has, it is also the answer to the question why this book
is needed. I wanted to write a book about *The Waltons,* at least
in part, because the middlebrow that it exemplifies has been so
neglected in cultural studies. The book is far from an adequate
redress of the imbalance, but it is hopefully a move in the right
direction.

If it is so important for cultural studies to start to give more
serious attention to the mundane, to unspectacular middlebrow
cultural forms, what insights might we gain from looking at an
example of these, such as *The Waltons*? What will this book actually
tell us? It is very easy to dismiss *The Waltons,* in particular – and
often the middlebrow in general – as regressive and politically
conservative, appealing to 'silent majority' conservatism, and
reproducing the prevailing dominant attitudes within a society.
However, the analysis presented in this book will show that such
a view is a misguidedly simplistic account of the working of the
middlebrow, and overlooks the complicated way that mainstream
middlebrow texts like *The Waltons* must continuously rebalance
themselves in the ebb and flow of the currents of contemporary
politics in order to preserve the verisimilitude of their, admittedly
essentially conservative, ideological message; to avoid the situation
where they can be summarily dismissed as simply regressive.
Paradoxically, as this book will demonstrate, the 'conservative
text' must outwardly assert its embrace of at least a limited form
of progressivism in order to avoid undermining its ability to
maintain its core beliefs by appearing to be hopelessly out of tune
with the mood of the times and thus alienating a large part of its
potential audience.

The prime example of this tendency in *The Waltons* can be seen
in the way the show constructs its image of family life. Certainly,
in the final analysis, there is a palpable emphasis on a traditional,
patriarchally governed family. This represents *The Waltons'*
ideological 'bottom line' in its construction of the family. But
laid over this are representational strata that superficially appear
to embrace progressive challenges to patriarchy. *The Waltons'*

constructs gender in such a way that it acknowledges progressive changes in the roles of men and women that were taking place in the early 1970s but nevertheless uses these ostensibly progressive representations of gender to reinstate a highly regressive version of the traditional separate spheres of influence for men and women, which form the basis for the continuance of a patriarchal disposition of power. In Chapter 4, I examine the implications of this dualistic superficial/progressive: structural/regressive representational mode for the show's construction of masculinity, looking at the way that *The Waltons* employs a split between generations to articulate the changes in the positions of men within an increasingly postindustrial economy in which the opportunity for financial reward, prestige and power had shifted away from the traditional, industrial and agricultural occupations, which had been associated with an unambiguously 'manly' type of masculinity, and toward the new 'knowledge economy', which required workers with a rather different set of characteristics. *The Waltons* presents this shift as involving a degree of feminisation of men, but offers up the anxiety produced by this apparent emasculation of men solely in order to assuage it by providing a reassurance that this change in the character of masculinity is a necessary prerequisite for the continuity of male dominance in a changing world.

The female counterpoint to this shift is discussed in Chapter 5. To the extent that *The Waltons* acknowledges women's desire to move outside of the domestic sphere and into the world of remunerated employment – and shows them doing so (albeit in limited ways) – it appears to be somewhat politically progressive. Once again, however, appearances are deceptive, and the show places strict limits on women's' incursions into a realm that *The Waltons* still evidently conceives as fundamentally a masculine preserve; granting that women may engage in what is effectively a form of paid domesticity outside the family home, but no more than that. In the interplay between these two related narrative dynamics we can see how *The Waltons* attempted to negotiate the contradictions between its essentially regressive vision of gender and more progressive pressures for social change in America at the start of the 1970s.

If Chapters 4 and 5 represent the most sustained 'textual' examination of *The Waltons* in this book, then the remaining chapters all concern themselves with various different contexts that advance our understanding of the show. As I have already indicated, Chapter 2 concerns itself with the socio-historical context of the show's genesis in the early 1970s; the political and economic trends, and the societal disturbances of the years immediately preceding its birth. This is the context in which thinking of *The Waltons* as a cultural anodyne is most productive. Chapter 3 will then attempt to position the show against the background of the history of television's representations of the American family, from the supposed heyday of the suburban nuclear family of the 1950s, through the surreal 'monster families' of the 1960s and on to today's, predominantly dysfunctional, television families. Finally, Chapter 6 considers the afterlife of *The Waltons*; the continuing affection for and commitment to the show and its values exhibited by its many dedicated fans. Before considering the life and afterlife of the show, however, this book will look at *The Waltons*' embryonic phase in the life-history and semi-autobiographical writings of its creator, Earl Hamner Jr, which are the concerns of the following chapter.

1

Origins and Production History

On 14 September 1972 a new television series appeared on American screens. It was not a radically innovative show of the kind that changes the way that television is made or how it is perceived by its audiences or by opinion leaders. It was a simple, rather unremarkable show presenting the mundane lives of a fictional American family through a very conventional television format of hour-long weekly episodes, each consisting of a self-contained storyline, but held together by character narratives that developed along longer arcs over several episodes or even across different seasons. It was the story of an ordinary (if large), rural, working-class American family struggling to make their way through hard times during the Great Depression of the 1930s. And while it may not have changed the way television was presented or how it was perceived, the show in question, *The Waltons*, was destined to become an enduring favourite of American viewers and of audiences in the numerous countries to which the show was exported. *The Waltons* remained on American television screens for nine continuous seasons in its initial run, and has since been repeated regularly on both network and cable television right up to the present day.[1] Indeed, the popularity of the show was such that it quickly acquired iconic status, with characters whose names and identities everyone knew and a catchphrase – 'goodnight John-Boy' – which rapidly entered the vernacular.

Earl Hamner Jr

The nine seasons of *The Waltons* consist of a series of original, self-contained episodes, with stories by various screenwriters (sometimes members of the cast, who also directed some episodes) written specifically for the show.[2] However, the characters themselves, the milieu in which the stories are set, and the nostalgic emotional register of the series all have their origins in Earl Hamner Jr's partly autobiographical novels about his youth.

Hamner was born on 10 July 1923 in Schuyler, Virginia, a small community in the Piedmont region in the foothills of the Blue Ridge Mountains, approximately 25 miles south-west of Charlottesville, the nearest large town for the young Hamner, as for the Walton family in the television series. In the late nineteenth and early twentieth centuries Schuyler had been a thriving community, built around the cutting plant of the Alberene Stone Company which quarried and produced soapstone tabletops (in essence Schuyler was a company town). The cutting plant was the only significant source of employment in the area and many of the houses in the town were company-owned. The closure of the soapstone plant during the depression sent the region into a drastic economic decline.

Hamner's early life and experiences growing up in this part of rural Appalachia, the eldest of eight children (like the Walton children, all having various shades of red hair) in a close-knit Baptist family, provided the raw material – the large family and individual characters; the situations and regional setting – for two of Hamner's novels, *Spencer's Mountain* (1961) and *The Homecoming* (1970). These novels, in turn, would be adapted into one of the most successful and long-running television shows of the 1970s.

Like John-Boy Walton, his fictional counterpart in the television show, Earl Hamner Jr displayed a pronounced enthusiasm for writing from an early age. As Hamner himself observes:

> As far back as I can remember, I wanted to be a writer. My
> mother once told me that I was writing my numbers when I

was two years old and reading by the time I was four. She
was my first teacher, and when I started grade school I knew
the first grade primer by heart.[3]

The young Hamner demonstrated a precocious literary talent.
Aged six, he wrote a poem titled 'My Dog' which was judged to
be of sufficient quality to be published in the children's page of the
Richmond Times-Dispatch.

In 1939 Hamner graduated from high school. He entered the
University of Richmond, with the benefit of a scholarship, the
following year.[4] University was very different from the life Hamner
had experienced up to that time. In particular, the financial
demands were considerable and it was not easy for a poor country-
boy to make ends meet, even with the benefit of a scholarship.
As a result, Hamner was forced to take on a considerable amount
of paid work in order to live. This onerous additional workload
took its toll on his studies, although he did manage to do well at
the subjects important to him: English and American literature.
As well giving him an education, university also provided Hamner
with an opportunity to start to rework the material contained
in a journal that he had been keeping throughout his youth. In
his biography of Hamner, James Person claims that some of the
material produced by the young writer while at university is easily
identifiable as an early draft of *Spencer's Mountain*. However,
negative feedback that this work attracted from one of Hamner's
professors suggests that there was still a long way to go before this
material would be ready for presentation to a wider readership.[5]

The Second World War interrupted Hamner's university career,
but he continued writing during the war and even managed to
submit a few stories to magazines in the USA, although none of
these was accepted for publication. After the war Hamner became
a beneficiary of the Serviceman's Readjustment Act (commonly
known as the G.I. Bill of Rights) which provided, among other
things, for returning veterans to receive a college education. On his
return to the USA Hamner took up his studies again, this time in
the College of Music at the University of Cincinnati. At Cincinnati,
among other subjects, Hamner began to study writing for the

radio and, during his time at the university, he sold his first script, to a nationally syndicated radio show called *Dr Christian*. The script brought him to the attention of the writing supervisor at a Cincinnati radio station, WLW, who gave Hamner his first writing job after he left college.

Radio, Television and Novels

In 1949 Hamner went to New York to collect a prize for winning a radio contest. At the award ceremony he met another young writer who was also there to collect a prize and who would, in time, become an important figure in Hamner's developing television screenwriting career: Rod Serling, later the creator of *The Twilight Zone* (1959–64). Later that year Hamner left Cincinnati and moved to New York. Serling took Hamner's place at WLW in Cincinnati. In New York, Hamner found employment at the National Broadcasting Company (NBC) where, while working on scripts for radio, he began to develop a fascination with the then new and exciting medium of television.

Although, as Hamner put it, 'the medium appealed to me from the first time I saw it',[6] the young writer's early attempts to move into television proved to be of little interest to television producers, who believed that there was a clear distinction between writing for radio, 'for the ear', and for television; 'for the ear and the eye'.[7] Undeterred, Hamner continued in his efforts to break into television. His persistence eventually paid off, and he was given an opportunity to write a script for a television show.[8] By Hamner's own – admittedly vague – account, the aura of sentimentality that would later characterise *The Waltons* was already evident in his writing:

I don't remember the story clearly. It was something about an oil well. While the owner drills he dreams of becoming rich and then discovers there is no oil in the well. But he realises that achieving wealth can also mean realising the richness of everyday life.[9]

While working for NBC in New York during the early 1950s, Hamner also wrote and published his first novel, *Fifty Roads to Town* (1953). In many ways the book was a reaction against a contemporary literary trend in which the South was depicted in a highly unflattering light. Hamner's response to this trend would prove to be one of the enduring features of his oeuvre. Echoes of the romanticised view of the South, and of small-town rural life in the USA generally, evident in the novel, would later resonate through *The Waltons*.

While Hamner found a degree of success (and, more importantly, work) in New York, his major breakthrough would not come until after yet another change of location. By the end of the 1950s the television industries had undergone significant changes and the centre of television production had moved from New York to Hollywood. Hamner began to experience difficulty obtaining writing work in New York and so he moved to California hoping to find work as a writer in the film and television industries there. When he arrived in Hollywood, however, Hamner met with the same problem he had encountered when he first attempted to make the move from radio to television. Film producers were reluctant to employ a writer with no experience of writing for the movies, and Hamner struggled to find work in the early days after his arrival on the west coast. As Hamner puts it:

> It did not matter that I had made a living for the last ten years as a staff writer for NBC. It did not matter that I had published two books. What mattered was that I had not written for film.[10]

After several months without success in finding work – on the suggestion of his friend, Ray Bradbury – Hamner submitted two scripts to the producer of *The Twilight Zone*, a new show created by his old acquaintance, Rod Serling. Unexpectedly, these scripts were accepted for the show and Hamner would go on to have a total of eight scripts for *The Twilight Zone* produced as episodes of the series. This piece of good fortune marked the end of Hamner's lean period in Hollywood and he continued to find work regularly

thereafter, writing scripts for television shows such as *Wagon Train* (1957–65), *The Invaders* (1967–68) and *It's a Man's World* (1962). Although these attainments would probably be sufficient to characterise his television screenwriting career as a success, Hamner's most significant achievements were yet to come.

Spencer's Mountain

The seeds of that future success had, however, already been sown by the beginning of the 1960s, with the completion of the second novel that Hamner alludes to in the above quotation: *Spencer's Mountain*. *Spencer's Mountain* is a novel that Hamner had been working on, consciously or not, for much of his life. Although it is a work of fiction, the novel is highly autobiographical and undoubtedly draws heavily on the private journals that the writer had been keeping since he was a young boy, and on the early manuscript, based on these journals, that had attracted such discouraging feedback from Hamner's professor at the University of Richmond several years earlier.

Hamner had started to work more seriously on the novel that would become *Spencer's Mountain* during his military service in the Second World War and he continued to work on it, in parallel with his other projects, right through the 1950s. The novel was finally completed in the early 1960s and was published by the Dial Press in 1961. The book was well-received by reviewers. Writing in the *New York Times* Book Review in 1962, John Cook Wylie commented that *Spencer's Mountain* 'shows every promise of realising at least a brief sojourn on the cenotablets of best-sellerdom' and described Hamner flatteringly as 'unmistakably the full-fledged William Makepeace Thackeray of Nelson County, Virginia'.[11]

Anyone who is at all familiar with *The Waltons* would probably agree that one of the most obvious characteristics of the series is its benign, familial, gently conservative tone. Certainly there is nothing obvious in the show that would suggest a need to regard it as being at all avant-garde. It is surprising, then, to discover that Hamner's writing was viewed quite differently around the time of

the publication of *Spencer's Mountain*. In his review of the book, Wylie observed of Hamner's work that 'nothing of this sort could possibly have been written by members of an older generation' and he identified the author as part of a new progressive, American literary oeuvre; a 'vibrant, new guiltless generation striving for the metropolis and the liberal arts'.[12] In contrast with the way his work is probably most commonly perceived today, then, in the early 1960s Hamner was seen not as a literary conservative, but as part of an exciting new generation of young American authors. Hamner's literary peers included Hamner's friend and fellow author, Harper Lee – whose letter praising *Spencer's Mountain* was reprinted on the back of the dust jacket – as well as Truman Capote and Joseph Heller, with both of whom Hamner claims some affinity: a literary generation whose work explored the details of everyday American life and who drew heavily on their personal experiences in their work.[13]

Later in the 1960s this view of Hamner would begin to change. Reviews of Hamner's work around this time start to appraise it in terms that are more consistent with current views of *The Waltons* as twee and conservative. Reviewing Hamner's subsequent novel in the *New York Times* in 1965, Orville Prescott remarked that the novel was 'a little too sweet and its gossamer thread of story is too frail and artificially contrived', and damned it with the faint praise that 'it would be as difficult to dislike "You Can't Get There From Here" as to dislike a basket of spaniel puppies'.

Notwithstanding this later criticism of his work, it is important to remember that Hamner was not regarded as a particularly conservative writer at the time of the publication of *Spencer's Mountain*.[14] Indeed, the novel itself is rather more liberal in many of its attitudes – in particular in its presentation of sexuality – and less obviously preoccupied with conservative family-values (although these are certainly present) than the later television series. In trying to understand the reasons behind the particular appeal of *The Waltons* to television audiences of its time it is worth spending some time considering some of the differences between the television series and the novel from which the setting, themes and characters of the television show are derived.

Spencer's Mountain is set in New Dominion, a fictional small town in Virginia's Blue Ridge Mountains, closely modelled on Schuyler and consisting largely of company-owned housing for the workers of the soapstone mill that provides the only employment in the town. The story begins on Thanksgiving eve in an unspecified year, presumably in the latter half of the 1930s.[15] The narrative revolves around the lives of the Spencer family; parents Clay and Olivia, their children, Clay-Boy, Matt, Becky, Shirley, Luke, Mark, John, Pattie-Cake, Donnie and, later, Franklin Delano and Eleanor. Also living within the family unit are Clay's parents, Zebulon and Elizabeth. From the outset it is clear that *Spencer's Mountain* is essentially a coming-of-age novel that revolves around Clay-Boy's journey from boyhood to manhood. Aged 15 at the novel's start, Clay-Boy is two years younger than John-Boy (Richard Thomas) at the start of the television series.[16] The novel follows Clay-Boy's journey through various rites of passage – his first deer hunt, the death of his grandfather, his first sexual encounter, and finally his departure for university – as he negotiates his path from boyhood to manhood. Although Clay-Boy's story is at the heart of the narrative, the novel employs an omniscient, unnamed narrator to tell the story, which contrasts with the key role played by (an older) John-Boy as narrator of the television series. This is perhaps the most striking formal contrast between the television show and the novel and it does alter the nature of the role played by Clay-Boy's character in the story. Although the character is central to the narrative, he is not its organising consciousness in the way that John-Boy is in the television series. As a result of this formal decentring of his character, Clay-Boy seems to be more vulnerable to the action of larger forces, to human passions and frailties than his television counterpart. Additionally, the other family members are positioned as considerably more peripheral to the main narrative thrust of the novel: a marked difference from the television series, which relies on its ensemble cast. This enables the novel to retain a clear focus on the relationship between Clay and Clay-Boy in a way that allows it to engage in a close examination of the young man's passage to adulthood and of the father's function as mentor and role model in that transition.

The construction of the father's character provides another significant point of difference between the novel and the television series. The qualities Clay Spencer possesses in the novel endow his character with a much earthier, less saccharine personality than that of his later counterpart on television. John Walton, in the television series, may not comply with many of the God-fearing, Baptist norms of his family, but his non-conformity is articulated in fairly innocuous ways: principally his reluctance to attend church regularly and his occasional (and usually moderate) consumption of alcohol. Clay Spencer, on the other hand, is explicitly constructed as an unambiguous 'wild' man. He is a heavy drinker, foul-mouthed, and prone to violence. Furthermore he is positively hostile toward religion in general, reserving his most vocal contempt for his wife's Baptist denomination. As the novel describes his character:

> Clay Spencer became a legend in the community. He could drink more whiskey, hold it down longer, and walk straighter afterward than any man in the community. He developed a flair for cursing and the swear-words he invented passed into the local language. He grew to a height of six feet two and always weighed two-hundred pounds unless he'd been in a good fight and if the fight were worth the effort he would usually lose from four to five pounds and gain them back at breakfast.
>
> He was always the first to arrive at a square dance and the last one to leave, and if the square-dance caller grew weary Clay himself would take over. While many of the mothers in the community expressed their disapproval of what they considered his wild ways, their daughters looked on him with favor.[17]

And this colourful, outspoken character is always particularly forthright in his expressions of contempt for the Baptist church. This antipathy is exemplified by his outburst when he discovers the possibility that his son might be required to enter the ministry in order to satisfy the eligibility conditions for a scholarship that would enable him to attend university:

It's the Baptists that galls me. I don't know what kind you
got down here, but where I live we got the Hard Shells. They
don't allow smoken, drinken, card-playen, dancen, cussen,
kissen, huggen or loven in any shape, form or size. They're
against lipstick, face powder, rouge, and frizzled hair. I'm
married to a Baptist and she might bring my children up
Christian, but I'll be damned if I'll have a Baptist preacher
in the family.[18]

Although it is possible to detect toned-down traces of some of these
qualities of Clay Spencer's character in the way the personality of
John Walton is elaborated in the television series, it is evident that
the latter character represents a considerably restrained version of
the larger-than-life figure of the father constructed in *Spencer's
Mountain*.

The novel differs from the later television series in other
respects too, notably in its treatment of sex. Sex is, at most, a
peripheral matter in *The Waltons*, something that is implied only
through oblique references, and then usually articulated through
one character in particular, the grandfather (Will Geer), a genial
and rather roguish old man. The Grandfather's advanced age and
the fact that the series repeatedly hints that his (distant) past may
have been more colourful than the diegetic present, operate as
distancing devices, ensuring that any reference to sexuality is kept
at some temporal remove from the diegetic present of the text. In
Spencer's Mountain, however, sex is explicitly a central part of the
coming-of-age narrative revolving around Clay-Boy – presented
very literally in several episodes throughout the book. It is also
figuratively present in the phallic imagery employed in a key scene
early in the book, in which Clay-Boy hunts and kills a deer.

The animal itself is shrouded in mysticism by the text, a spectral,
white (virginal) deer mythologised by the grandfather:

'Up on the mountain, when I was a boy,' the old man began
the story he told each year, 'there used to be a big old buck
deer that was white all over and had pink eyes. Lots of folks
that never laid eyes on him used to claim there wasn't no

such thing. Some of them even claimed he was a ghost. I don't say one way or the other, ghost or flesh. All I know is I have laid eyes on him'.[19]

The sense that the hunt is a metaphor for the sexual initiation of a young man is repeatedly reinforced throughout the scene. The realm which this mystical beast inhabits is described as place unknown and fascinating to the adolescent Clay-Boy; it is a place that 'housed all those things mysterious to the boy' and one that he 'had never explored, being forbidden by his mother'.[20] And while this might all might be read quite literally as merely a description of the deer hunt in which the boy is taking part, the phrasing of the scene invites a broader, more symbolic interpretation, an allusion to Clay-Boy's sexual inexperience: 'the mountain held *all that was unexplored* for Clay-Boy' (emphasis added).[21] The use of explicitly phallic imagery in the scene begins with the description of the deer; 'with its proud head high and erect, its many-pointed antlers regally aloft' and continues in the account of its killing by Clay-Boy: 'he plunged the blade into the fur and leather of the animal's throat'.[22] Similarly the moment of the beast's death is described in terms redolent with sexual overtones which reconfigure the slaying figuratively as a symbolic moment of ejaculation:

A shudder wrenched through the dying deer and when the boy felt the quiver of final strength wane from the antler he held, something seared through his body that filled him with awe and terror.[23]

Finally, the killing of the deer is clearly marked as a rite of passage, which intensifies the feeling that the entire scene functions figuratively as an act of sexual initiation marking Clay-Boy's passage from childhood to maturity; 'it wasn't no boy killed that deer ... It took a man to do it'.[24]

If the figurative language used to describe the killing of the deer transforms the scene into a metaphor for the sexual awakening of a young man, subsequent incidents in *Spencer's Mountain* are more literal in their treatment of sex. When Clay takes the family's cow to

be inseminated by a neighbour's bull, Olivia's objection to his being accompanied by Clay-Boy signal that there is more at stake than animal husbandry: 'Clay-Boy can just stay at home. I don't want him seeing things like that. You know what I'm talking about. Clay-Boy's too young'.[25] Her objections are overruled, however, by Clay who dismisses her concerns, arguing that knowledge of sex is an essential part of the boy's coming of age: 'if this boy don't know what a cow and bull does by this time it's time he was finden out ... It's time he was finden out what a man needs to know'.[26] Thus the parallels between animal and human sexual activity are only thinly veiled. When Clay-Boy witnesses the sexual union of the animals and remarks that 'I never saw anything like that before', the bull's owner observes, 'son ... the best part of liven is ahead of you'.[27]

Later Clay-Boy experiences this 'best part of liven' himself, when he spends a sunny afternoon in sexual union with a young woman in a field on the mountain. While, in this episode, the sexual act itself is only alluded to, rather than described in any detail, the scene is unambiguously sexual. When Clay-Boy returns home late in the day with sunburnt buttocks and back, his father's words unambiguously register the sexual nature of the episode: 'if a man's been away all day long with a girl and comes home with his backsides all sunburned that don't mean but one thing, in my way of seeing it'.[28]

The presence of these explicit references to Clay-Boy's sexual initiation in *Spencer's Mountain* is important because it represents one of the key differences between the source novel and *The Waltons*. The former is clearly a coming-of-age narrative, with Clay-Boy at its centre. Within this narrative, the sexual references in the book mark stages in Clay-Boy's passage from boyhood to manhood, from the metaphorical allusions to sex in the killing of the deer early in the novel, through the less figurative parallels drawn between the mating of bull and cow and the resultant sexual awakening of the young man, to the eventual consummation of his transition to maturity in the meadow on that sunny afternoon. Through all of these stages of sexual development, the novel adheres to a clear narrative theme, dealing with Clay-Boy's growth to manhood, his movement away from familial dependency and

his departure from the family home to make his own way in the world by the novel's end. While early seasons of *The Waltons* may have also exhibited this characteristic to some degree, the television series always showed a greater interest in the characters who, in the novel, are merely ancillary to the core coming-of-age narrative (and the television show's interest in these characters became more pronounced in later seasons when John-Boy's presence in the show became increasingly infrequent). These characters – the siblings, parents, grandparents and members of the wider community – enable the series to articulate a wide range of realistic issues relating to family and community life, providing it with the verisimilitude that gave it such a powerful resonance for the television audience. At the time of the publication of *Spencer's Mountain*, *The Waltons* was still over ten years away from its debut on American television screens. Much earlier than that, however, in 1963, Hamner's characters would be brought to the screen for the first time.

Screening Spencer's Mountain

Spencer's Mountain (1963 Daves USA) was the earliest effort to bring the novel that would later inspire *The Waltons* to the screen. Unlike the later television series, Hamner was not directly involved in the production of the movie. However, he was consulted by the director, Delmer Daves, who evidently wished to produce a movie that was as true as possible to the spirit of the book. In a letter to Hamner, soliciting the author's comments on the screenplay, Daves explicitly stated his desire to 'put the flavor of your fine book on the screen' and his hope that the author would recognise that 'I have done my very best to keep the richest of your ore in the principal vein of the screenplay'.[29] In general terms, Hamner was apparently satisfied with the screenplay, making only 'a couple of small suggestions and one request for a dialogue change'.[30] Notwithstanding the absence of any significant interference by Hamner, there are two very significant differences between the novel and the movie. First is the geographical relocation of the diegetic world of *Spencer's Mountain* from the familiar setting of

the Blue Ridge Mountains in Virginia to the Rockies: the movie was filmed in Jackson Hole, Wyoming, against the majestic backdrop of the Grand Tetons, a familiar location to many cinemagoers, used for numerous Hollywood westerns. The second change is the temporal displacement of the story from the Great Depression of the 1930s to more recent times which, although unspecified, are clearly identifiable from the cars that appear in the movie and the female characters' hairstyles as being the late 1950s or early 1960s. In other words, at the time of its release, it was a contemporary movie. Although it is the more fundamental structural and thematic changes discussed below that produce the major changes of tone between the novel and the film, each of these more superficial alterations also contributes to the sense that the film is significantly different from the book. The grandeur of the geographical setting, while undoubtedly attractive to the eye, overpowers the storyline of the novel, drawing the focus away from the characters and the depiction of family life that is one of the most appealing features of the novel. Paradoxically, given that the movie was set at around the same time as it was filmed, the geographical location of the film reintroduces a nostalgic tone, but one that is different to that in the novel. While the book's nostalgia is constructed through its emphasis on family relationships and the aura of innocence introduced by the children's characters, the nostalgic quality of the movie is derived from the horizon of expectation provided by the western movie genre, which is implicitly evoked by the geographical location. Although not exclusively known as a director of westerns, Delmer Daves did direct several notable examples of the genre in the 1950s – including *Drum Beat* (1954), *Jubal* (1956), *The Last Wagon* (1956), *3:10 to Yuma* (1957), *Cowboy* (1958) and *The Badlanders* (1958) – and so was well versed in the form. The geographical location of Jackson Hole itself was well known to fans of the western from many classic examples of the genre filmed there: for example, *Shane* (Stevens 1953 USA). Finally, the movie's male star, Henry Fonda, was a veteran of the western genre, having starred in iconic westerns such as *Drums Along the Mohawk* (Ford 1939 USA), *My Darling Clementine* (Ford 1946 USA) and, more contemporaneously, *How the West Was Won* (Ford 1962 USA).

Together, these generic elements transformed *Spencer's Mountain* into a movie that, while perhaps not actually a western itself, nevertheless exhibited a powerful nostalgia for the genre. Thus the quality of the nostalgia in the movie is essentially very different from that to be found in the novel and in the later television series. The film is not simply a celebration of family and childhood, nor of the moment of passage from youth to manhood, which are important features of both the book and its television adaptation. Indeed, although the sexual awakening of Clay-Boy certainly plays a part in the movie, it is relegated to secondary importance by the story of Clay Senior himself, which provides the film's main focus. Consequently elements that are key to the story in the book are omitted entirely from the movie: most notably the episode in which Clay-Boy kills the white deer; the incident that initially establishes the centrality of his coming-of-age narrative to the novel.

Thus stripped of its original temporal and geographical locations and one of its key themes, *Spencer's Mountain* is an oddly fragmented movie that lacks the strong sense of direction that the coming-of-age narrative provided to the novel. And although the ending of the book – in which Clay-Boy boards a bus to take up his place in college – is retained, this and the other incidents involving Clay-Boy always seem merely ancillary to the dominant feature of the movie: Henry Fonda's performance as Clay Spencer. In essence, then, the film is little more than a star vehicle for Henry Fonda, whose central role – which provides the movie's only sense of any sort of narrative direction – is played out against the background of a patchwork of vignettes drawn from the book, including among them elements of Clay-Boy's coming-of-age narrative, now displaced from the centrality it had in the novel, but not entirely absent.

This lack of a strong narrative core certainly did not harm the film's popularity: it earned some US$4.5 million in rentals, making it the 22nd highest earning film of the year.[31] Reviews of the movie were lacklustre, however. *Variety* described the film as a 'tepid tale', and noted that 'sophisticates may find "Spencer's Mountain" dramatically corny'.[32] Despite this, the review recognised that the film was likely to earn reasonable box office revenues and it praised the movie's patriotic tone, particularly its ability to

make the viewer 'feel there still is wondrous solidity in that great American institution, the American family'.[33] *New York Times* film reviewer, Bosley Crowther, was rather less tolerant of the film's shortcomings, criticising the movie for its blatant lack of realism and calling *Spencer's Mountain* a 'synthetic and insincere' example of 'Hollywood make-believe and sentimentality'.[34]

Although the film appears in the top thirty most successful films of 1963 (according to revenues earned on initial release), it is important to consider this success in the context of wider cultural trends – most importantly the general decline in cinema-going through the preceding decade and a half – in order to properly understand the cultural significance of the film version of *Spencer's Mountain*. It is well-known that movie-going in the USA entered a period of rapid and consistent decline in popularity after the end of the Second World War. By the early 1960s the movie-theatre audience was a small fraction of the size it had been in 1946, the peak year for cinema-going in America. Simply put, for a variety of reasons – not least the growth of television – movies were just not as popular in the early 1960s as they had been even a decade earlier. Consequently while is it certainly possible to detect ways in which the movies of this time register some of the wider social and political concerns of the period, there is a sense, in some of the movies of the time, of a loosening of the connections between films and the wider contemporary culture; a feeling that the films register, more than anything else, the position of a movie industry facing a declining market for its products: a position manifested through a tendency to rather nostalgically rework existing Hollywood formulae. This tendency is perceptible in some of the highest-earning films of 1963: *How the West Was Won* (Ford, Hathaway, Marshall, Thorpe, 1962), *Cleopatra* (Manckiewicz 1963) and *The Longest Day* (Annakin, Marton, Wicki 1962), all of which evoke memories of some of the most successful generic formulas of preceding decades – the western, the epic, the combat movie – when movie-going still occupied a central position in American cultural life.

It is my argument that the nostalgic tone evident in *The Waltons* contributed significantly to the popularity of the television series from the early 1970s on by reviving a set of positive emotional

associations from a mythic America of the past, at a time when contemporary America was beset by a range of economic, social and political problems. That would come in the early 1970s. At the time of the release of *Spencer's Mountain* in the early 1960s, however, America faced a quite different set of issues from those that would develop by the decade's end. The specific nature of these issues in the early 1960s contributed to the production of a cultural and political milieu that was generally more progressive, more adventurous, more forward-looking and positive about the future than it would be a mere decade later. This spirit of positive, forward-looking energy is captured in the words of President John F. Kennedy's 1963 State of the Union address:

> the winds of change appear to be blowing more strongly than ever, in the world of communism as well as our own. For 175 years we have sailed with those winds at our back, and with the tides of human freedom in our favor. We steer our ship with hope, as Thomas Jefferson said, "leaving fear astern."
> Today we still welcome those winds of change – and we have every reason to believe that our tide is running strong.

At the time of the release of *Spencer's Mountain* in 1963, then, the outlook for America was very different than it would be nine years later when *The Waltons* would become one of the most successful television series of its time. In 1963 America had hardly dipped its toes into the roiling waters of the war in Vietnam. Still in the early years of the space race, Americans could maintain their faith in the dream of a brave new world founded on scientific progress and the indisputable technological superiority of the USA over all other nations, and particularly the communist foe. The postwar economy still boomed, and the fracture lines in American society were much less visible than they would become only a few years later when the civil rights movement and the other countercultural protests that became increasingly commonplace in the late 1960s would start to tear apart the fabric of American society. The early 1960s was a time when taking chances and shaking up the established order seemed like exactly the right things to do, a disposition embodied in

the President at the time, who made a virtue of embracing change: 'young, fresh, exciting, even risky: that, above all else, was the spirit that Senator Kennedy', had presented during his Presidential election campaign.[35] And this energetic, forward-looking attitude was possible because fundamental social institutions central to the American sense of national identity had not yet been destabilised in the way they would be by the latter part of the decade. 'Family' still meant a working father and a domesticated housewife mother with their two cherubic blue-eyed kids; the word 'family' itself as yet untainted by the perversion afflicted upon it by the association it would gain with Charles Manson's homicidal devotees before the decade's end. In 1963, Americans seemed to have every reason to look forward, and little need to look to the past for reassurance about their identities and their common values. And while cinema audiences would, of course, still go to see the latest movie featuring one of Hollywood's most enduring stars, it does not appear that *Spencer's Mountain* really engaged the popular imagination of the time sufficiently to have any lasting impact. The movie was just too backward-looking at a time when everyone was still looking optimistically toward the future.

From Spencer's Mountain *to* Walton's Mountain

Hamner continued to write throughout the 1960s. He wrote regularly for television and published his third novel, *You Can't Get There From Here* in 1965. In 1970, the characters introduced in *Spencer's Mountain* were resurrected by Hamner in a novella titled *The Homecoming*.

The Homecoming is a rather strange work, particularly when considered in relation to *Spencer's Mountain*. Although written later, it appears to be a prequel to the earlier novel, and several episodes that are key to the coming-of-age narrative central to *Spencer's Mountain* apparently post-date the diegetic time of the later work. Consequently, in *The Homecoming*, the albino deer – the slaying of which marks an important stage in Clay-Boy's passage from boyhood to manhood – still roams the wilderness of

the mountain; the plot of land sold by Clay in *Spencer's Mountain* to finance his eldest son's college tuition remains in his ownership, thus preserving his dream of one day building a home for his family on the land; and Clay-Boy's sexual awakening, in a field on the mountain one sunny afternoon, remains a matter for the future. Hamner states that *The Homecoming* was a work he had intended to write for many years, based on events remembered from his childhood.[36] Although it is, in light of this statement, speculative to suggest other motives, it is nevertheless difficult to resist the feeling that *The Homecoming* was penned with at least one eye turned toward its possible adaptation for television. The brevity of the text certainly seems consistent with that interpretation – lending it a quality akin to an extended treatment for a television show, rather than a fully developed autonomous work of literature. Additionally, the temporal setting of *The Homecoming* before the events contained in *Spencer's Mountain* allows the later work to eliminate all trace of references to coming-of-age and the attendant sexual awakening of the central male character. This could be interpreted as a deliberate attempt to 'clean up' the material in order to make it more suitable for 'wholesome' family viewing. Whatever the truth about the motivation behind the writing of *The Homecoming*, the novella quickly came to the attention of a then relatively new television production company, Lorimar.

Lorimar had been formed in the late 1960s by a former advertising executive, Lee Rich, and two Las Vegas real estate developers, Merv Adelson and Irwin Molasky. By the early 1970s the company had produced a few television movies, but had had no significant hits. According to Hamner, Rich enjoyed *The Homecoming* and passed it on to his contacts at the CBS network, who commissioned the story to be produced as a one-off christmas television movie.[37] Hamner himself wrote the screenplay for the television film and, in the process of adaptation, the Spencer family became the Waltons in order to avoid potential legal problems with Warner Brothers, who still owned the rights to *Spencer's Mountain*.[38] *The Homecoming* aired on 19 December 1971 and attracted a large audience. Based on the success of *The Homecoming*, William Paley, Chief Executive Officer (CEO) of

CBS at the time, took the decision to develop a television series based on the characters created by Hamner, to debut in the fall of 1972. The first episode of that series aired at 8pm on Thursday, 14 September. *The Waltons* was born.

2

State of the Union: Turmoil and Nostalgia in Amerikkka

One of the hallmarks of the late 1960s is conflict: between war and peace, national interests and individual rights, social justice and racism, young and old, straight and freak, custodial liberalism and participatory democracy, us and them. Across the nation, a general rejection of the existing systems of authority and disobedience to previously respected 'superiors' in all their forms spread like wildfire in the Vietnam era, dividing the nation as it had not been since the 1860s.[1]

The secret of mastering change in today's world is to reach back to old and proven principles, and to adapt them with imagination and intelligence to the new realities of a new age.[2]

In 1963, the year in which *Spencer's Mountain* was released for theatrical exhibition, Americans may have had more reasons to look forward to a bright, prosperous, technologically-driven future than to draw comfort from their remembrance of a mythical past, but by 1972 the world looked very different. In the nine-year period between 1963 and 1972, America had witnessed some of

the bitterest conflicts and most violent confrontations – between
citizens who all thought of themselves as 'Americans' – since the
end of the American Civil War. The turmoil of the mid and late
1960s had given birth to (and was still in the process of producing)
some of the most radical shifts that had taken place in American
politics, society and the economy since the end of the Second World
War. These large-scale political and social shifts also brought about
more subtle changes in the culture; changes in the way Americans
thought about themselves and their nation, often heightening both
the self-evident contradictions in American society and exposing
hitherto unseen fracture lines that had effectively been masked by
the booming economy and ostensible political consensus that had
characterised the earlier part of the postwar period. In the year
The Waltons first appeared on American television there was still
more bad news yet to come in the following years: the oil crisis, the
cessation of aggressive military intervention in Vietnam without
having secured a US victory, Vice President Agnew's departure
from office amid allegations of bribery, fraud, extortion – all in
1973 – and President Nixon's disgrace and resignation, in 1974, in
the aftermath of the Watergate scandal. But even by 1972 it was
already evident that the notion of anything resembling national
consensus or even a coherent national identity had been shattered. In
addition, many of the beliefs that sustained Americans' confidence
in the essential goodness of the national character, and of the values
that had preserved their belief in the American Dream had almost
completely crumbled under the pressure of social forces outside the
control of politicians or opinion leaders. This dissolution of national
confidence did not happen overnight, of course, but in the relatively
brief period between 1963 and 1972 the American outlook had
altered dramatically. As Hunter S. Thompson succinctly put it –
commenting on the 1972 Presidential election campaign:

> the 1972 election is fated to be a dated, weakening election,
> an historical curio, belonging more to the past than to ... the
> future ... the weight of evidence filtering down from the high
> brain-rooms of the New York Times and the Washington
> Post seems to say we're all fucked.[3]

There was no single issue that caused the change in attitudes, nor did it happen all at once, but the shift was unmistakable. This chapter traces the contours of this shift in attitude and mood, highlighting some of the key causes of America's loss of self confidence by the early years of the 1970s and examining some of the manifestations of this change through a variety of contemporary popular cultural forms. Readers whose interest in this book is primarily in *The Waltons* and its televisual contexts, rather than the social context, may wish to proceed straight to the next chapter. What follows is an attempt to illuminate the social context from which the series emerged and which contributed to the form that *The Waltons'* vision of American life would take.

Decades do not assist historians by dividing themselves neatly into clearly differentiated epochs. However, since it is customary to speak of epochs by reference to a decade – the Fifties, the Sixties, etc. – it is necessary to acknowledge that each decade has a divided character, comprising a chronological period – which follows the divisions of the calendar – and a mythical one, which usually does not. In his study of masculinity in Fifties movies, Steven Cohan argues that the mythical 'Fifties' (as opposed to the temporal 1950s) actually began just after the end of the Second World War, in the demobilisation period that started in 1945.[4] Similarly, there are compelling arguments to be made for taking 1968 as the year that marked the divide between the (optimistic) Sixties and the (more downbeat) Seventies; as the year in which the mythical 'Sixties' ended and the 'Seventies' really began.[5] Following Cohan's example, in the remainder of this book the term 'Seventies' will be used to distinguish this mythical period from the chronological decade, the 1970s.

The shift that occurred in 1968 was by no means exclusively an American phenomenon. The general strike and student protests in Paris in that year signal that more widespread, global political currents were in play. Along with other developed, Western nations, the American political and social scenes were certainly profoundly changed by events that occurred in that year. It was the year in which, on 6 June, former US Attorney General, and prospective Democratic Presidential candidate, Robert F. Kennedy, fell victim

to an assassin's bullet; an event that brutally ended the nation's love affair with the political dynasty most closely associated with the progressive politics and optimistic outlook of the early 1960s. Almost exactly two months earlier, on 4 April, Dr Martin Luther King Jr – figurehead of the civil rights movement and its leading proponent of non-violent protest – had also been shot dead by an assassin. Together, these two events can be understood as marking a pivotal moment in American politics, the moment at which widespread belief in the possibility of a peaceful solution to the conflicts that had raged across America for much of the 1960s, and in the prospect for meaningful reform of American society, both evaporated. As one journalist put it, 1968 was the year 'when for so many, the dream of a nobler, optimistic America died and the reality of a sceptical conservative America began to fill the void'.[6] In November that year Richard Milhous Nixon, probably the most emblematic US politician of the Seventies, was elected 37th President of the USA. Nixon's election, seemed to mark the beginning of a new epoch. As one commentator has put it: '1968 Like a knife blade, the year severed past from future'.[7] The Seventies had begun.

By 5 November 1968, the date on which Nixon was elected to the nation's highest office for the first time, American politics had been dominated by social conflict and violent confrontation between different factions of the citizenry – and between citizens and those charged with enforcing the law – for several years. Indeed, by the end of the 1960s, the USA had been embroiled in a number of conflicts that were being played out along several different axes. The longest running of these conflicts – the ideological battle between the superpower nations, known as the Cold War – had commenced immediately after the end of the Second World War and had dominated American foreign policy throughout the 1950s. The intensity of the conflict had reached a peak during the Kennedy administration at the time of the Cuban missile crisis of 1962, at which time the Soviet Union and the United States appeared to be drawing perilously close to the brink of a potentially apocalyptic nuclear confrontation. Between then and Nixon's election, however, tensions between the two superpowers

had settled into a tense equilibrium. Two other distinct areas of conflict, however, remained volatile and problematic for the US establishment throughout the 1960s: first, violence between the police and national guard, on one side, and groups seeking to assert civil rights for African Americans on the other; and second, the American war in Vietnam.

'There's a Riot Goin' On'

On Wednesday 11 August 1965 two California Highway Patrol Officers were involved in a high speed pursuit of a car driven by Marquette Frye, a young African-American man. The officers eventually stopped the vehicle in Watts, an impoverished, predominantly black neighbourhood in Los Angeles. Although the police later denied allegations of using excessive force in the arrest, Frye's detention by the officers certainly provided a dramatic spectacle on the streets of Los Angeles, one that drew a large crowd of spectators. Tensions between the police and the onlookers grew rapidly. The officers drew their weapons to hold the crowd at bay while they made their arrest and departed from the scene. Rumours of police brutality spread rapidly among inhabitants of the neighbourhood; crowds gathered and, finally, violence erupted. The Watts riots, as the four days of civil unrest that followed are usually known, were not the first instance of racially inflected violence along the difficult path to the attainment of black equality. However, these particular events were given extensive 'live' coverage by television news across America. This 'live' coverage by the media had the effect of endowing the localised chaos and violence in Watts with a powerful sense of immediacy and proximity that was felt by millions of white Americans who had never ventured near a 'ghetto'. As a result of the role played by media coverage in shaping the way that the events in Watts were perceived by the nation, these four days of unrest seemed to mark a turning point; not so much the actual end of the consensus politics of the earlier postwar period as the point at which Americans were directly forced to face up to the reality of the existence of social

fragmentation and the real political conflicts that lay beneath the veneer of political consensus; to recognise the frequently harsh and volatile realities of life in American society at the time. Watts was only an early skirmish in a prolonged period of conflict, during which action by civil rights protesters and black power activists was repeatedly met with violently repressive counter-action – and frequently with pre-emptive violence – by police forces and, with increasing regularity, the National Guard.

In July 1966, Chicago exploded with a violence that was 'symptomatic of a deep sickness in society' according to a report in the Chicago Tribune.[8] In the same month – in Cleveland, Ohio – a bar owner posted a sign outside his bar in the predominantly black neighbourhood of Hough, reading 'No Water for Niggers' and posted employees to patrol outside the bar, armed with shotguns, in order to enforce the notice. Needless to say, in an economically deprived area with a population that was almost 87 percent African American, these actions were to prove extremely provocative. Six nights of rioting and violence followed. In 1967 it was the turn of Newark, Detroit and Plainfield New Jersey, among others. Some of the worst violence in the country, during this turbulent period, took place in Detroit in July that year:

> At week's end, there were 41 known dead, 347 injured, 3,800 arrested. Some 5,000 people were homeless (the vast majority Negro), while 1,300 buildings had been reduced to mounds of ashes and bricks and 2,700 businesses sacked. Damage estimates reached US$500 million.[9]

Also evident by the summer of 1967 was the fact that it was increasingly difficult to see the violence in American cities as a series of isolated incidents caused by a small number of troublemakers; the disturbances were now endemic, and symptomatic of fundamental social problems. In an extended article within an edition largely devoted to the 'problem', *Time* magazine noted:

> so far this summer, some 70 cities – 40 in the past week alone – have been hit. In the summer of 1967, 'it' can

happen anywhere, and sometimes seems to be happening everywhere.[10]

And, as another article in the same edition of *Time* noted, the character of the conflict seemed to have perceptibly changed, turning from what appeared initially a fairly straightforward series of racial conflicts into one that seemed much more like a systematic uprising of a whole social class:

> the televised glimpses of unsheathed bayonets, rumbling tanks and fire-gutted blocks in the heart of Detroit made it look as if the U.S. were on the edge of anarchy. 'The outbreak has become something more than a race riot,' said the Stockholm newspaper Aftonbladet. 'It threatens to become a revolution of the entire underclass of America'.[11]

More was still to come the following year, when riots flared up in numerous cities across America in the aftermath of the assassination of Dr Martin Luther King Jr – one of the leading figures in the civil rights movement and 'symbol of how divided the nation had become' – on 4 April.[12] Following these disturbances, however, the violence began to subside slightly and – although there continued to be significant instances of violence between police and protestors into the early years of the 1970s – these became less frequent near the turn of the decade.

Although the actual violence may have diminished by the last couple of years of the 1960s, the turmoil of the earlier years, and the fracture lines in American society that they exposed, left a lasting impression on American popular culture, which continued to register the racism and conflicts that characterised the American experience in the late 1960s. In 1969, the soul band Sly and the Family Stone released *Stand!*, their fourth album and the first to breakthrough to mainstream success. *Stand!* included two tracks that explicitly addressed the issue of racism: the rather direct and confrontational, *Don't Call Me Nigger, Whitey,* and the more commercial and accessible, *Everyday People.* The lyrics of *Everyday People* present an undisguised critique of racism – 'There

is a yellow one that won't accept the black one that won't accept the red one that won't accept the white one' – and pleads for tolerance and understanding – 'different strokes for different folks ... we gotta live together'. *Everyday People* was released as a single in late 1968, before the release of the album, and became the group's first release to reach number one in the *Billboard* singles chart, where it remained for four weeks during February and March. The album itself was also a best-seller, peaking at number 13 in the *Billboard* 200 chart and remaining in the charts for over 100 weeks.

A few of the songs on *Stand!* may eschew the more usual imperative of pop to *Dance to the Music* in favour of the more serious matter of addressing an issue as important as the systemic racism that lay at the root of the violence America had been experiencing for several years, but on the whole the album was an upbeat affair, and much more so than the band's subsequent release. In 1971 Sly and the Family Stone issued the follow-up to *Stand!*, an album that announced, both figuratively (through the music) and literally (through its title), the realities of social fragmentation, and conflict in Seventies America: *There's a Riot Goin' On*.[13] Although the rather lethargic, and often downright odd, material on this album tells us at least as much about Sly Stone's descent into drug addiction as it does about the political temperature of America at the start of the 1970s, Vince Aletti – in his review of *'Riot'* for *Rolling Stone* magazine – recognised the resonances between the music and the contemporary social scene. Aletti's review described the album as a 'record of a condition, a fever chart' and questioned whether this might be the 'new urban music', a new style that was 'not about dancing to the music, in the streets' but 'about disintegration, getting fucked up ... maybe dying'.[14]

Riots, protests and conflict with the police and other authority figures may have been the most notable characteristics of American urban life during the 1960s, but these were only symptomatic of deeper political tensions that had developed into this crisis over the course of the postwar period. Although these tensions involved a number of quite distinct groups within American society, they did at least have one general feature in common. In every case the tension could be seen as one between an exclusive political class

that possessed power and authority in the USA – the 'establishment' or, in contemporary street argot, 'the man' – and those who lacked access to power. These latter groups were the marginal, disadvantaged and disenfranchised: African Americans, women and the young. Another rock album, released in 1972, expressed almost perfectly this tense opposition between 'the man' and these various marginalised sections of society. Through its title, its cover art and several of the songs it contained, *America Eats Its Young,* by Funkadelic, captured almost perfectly the distrust – the sense of a loss of faith in the ideals of Americanness – felt by the marginal and disenfranchised. The cover art of *America Eats Its Young* mimicked the design of the reverse side of a one dollar bill, but with the centrally located words that appear on a dollar bill – 'In God We Trust' and 'One' (the latter literally the denomination of the note but, in this context, also a symbol of the idea of national unity) – replaced with an image of a red-eyed, bloody-fanged Statue of Liberty, draped in the Stars and Stripes, devouring a baby. Several other babies – the children of several different races – are held in this monstrous Liberty's arm, awaiting the same fate. As is evident from the cover art, the political message of this album was not, then, a subtle one. It was a direct rejection of the values of the American establishment and a graphic expression of dissatisfaction with all that the establishment had come to represent to America's disenfranchised and marginalised by the early years of the 1970s.

Similar explicit expressions of disillusionment with the idea of America can be found in other cultural productions of the time. Like that of *America Eats Its Young,* the front cover of the April 1971 issue of *Mad* magazine also pulled no punches, featuring a picture of the White House with a sign reading 'This Country is Out of Order' hung on the railings. Inside, the magazine featured a cartoon parody of *West Side Story,* which depicted the activities of a group of assorted hippies, black power activists, bomb-wielding anarchists, and 'earth-mother' women, all of whom were intent on attacking key icons of the American dream: as a character announces in one frame, 'today we're gonna smash the supreme symbol of American decadence! We're gonna show our might by taking over Disneyland!'[15] As the story in the cartoon

strip develops, the 'Rats' – as this group of subversives is known
– confront various representatives of the American establishment;
police, politicians, etc. At one point their leader, Cosmo – an Afro-
haired, composite hippie/yippie stereotype that manages to achieve
the remarkable feat of bearing more than a passing resemblance to
three of the best-known figures in the 1960s counter-culture; Abbie
Hoffman, John Sinclair and Jerry Rubin – comes face-to-face with
his father. The father encourages his son to return to their small
town where, 'we still value the things that made this nation great'.[16]
The son derisively rejects the father's pleas, however, unfavourably
comparing the slow-paced conservatism of small town life with
the 'anything goes' freedom that was such an important part of
the appeal that 'the underground' held for the young. The Rats
then encounter a succession of key cultural and political figures –
California's Governor, Ronald Reagan; J. Edgar Hoover; Reverend
Billy Graham and finally President Richard Nixon – each of whom
proves to be powerless to prevent the Rats from propelling America
into interminable descent into a morass of violence. Finally, toward
the end of the cartoon, a force appears that is capable of stopping
the Rats. But this group – a band of neo-Nazi Hells Angels – is
simply the political antithesis of the Rats, rather than a force capable
of restoring American normalcy. During the ensuing brawl, both
sides realise that their shared commitment to the destruction of
the establishment by violent means greatly outweighs their political
differences. In the final frame the groups unite, their leaders – armed
and menacing – advancing toward the magazine's reader singing (to
the tune of 'Tonight'):

> With might, with might,
> Our forces will unite!
> With might we'll have you slobs at our feet!
> With might, with might,
> We'll fill the land with fright!
> We won't stop till the job is complete![17]

Although it would be misleadingly simplistic to attempt to posit a
general social mood from a small number of cultural artefacts, the

overarching tone of this comic strip in *Mad* gives us some sense of the emotional condition of the American nation in the early years of the 1970s. Although well known for its satirical jibes at prominent political figures and, therefore, perhaps more closely associated with an anti-establishment stance, it is noteworthy that this *Mad* cartoon strip avoids taking sides between establishment figures and their countercultural opponents. Politicians and other prominent public figures are certainly depicted as weak: powerless to offer any resistance to the onslaught of anarchy threatened by various factions of the counterculture. However, the counterculture itself is not presented in a positive light either. These anti-establishment forces do not appear to offer the promise of a progressive new politics, of a more egalitarian society within which the essential character of the American Dream is preserved. All that they offer is descent into violence and chaos. It is also instructive that the protestors' ire in this cartoon is directed particularly toward two key symbols of modern America and its values: the small town – rejected by the Rats' leader as a place of stultifying tedium – and a synthetic and inauthentic culture, embodied by Mickey Mouse, whom he clubs over the head with a stick in one frame. By the final frame of the cartoon, the once opposed, now united, groups have discovered a common focus for their disenchantment: the idea of America itself. This was a message that *Mad* would deliver yet again on the cover of its July 1972 issue, which depicted its cartoon frontman, Alfred E. Neuman, chasing a rainbow, at the end of which stands not the pot of gold promised by legend, but only several overflowing trash cans; a damning indictment of the reality that lay behind the mythic ideal embodied in the American Dream.

The waning of national pride, and growing disillusionment with the American Dream were two of the most emblematic features of American popular culture as the Seventies emerged from the dust clouds raised by the turmoil of the Sixties. In her history of the cultural trends of the period, Stephanie Slocum-Schaffer describes the early Seventies in America as a time of confusion, regret, self-doubt and loss of the sense of purpose that had given American culture its sense of dynamism since the moment of the nation's entry into the Second World War. The Seventies, Slocum-Schaffer writes:

began like a pounding hangover. It was a fevered, rancorous, tumultuous time for the nation, and there was a feeling of impending doom overhanging Americans, as if the apocalypse was about to descend. This sense of negativity was the result, at least in part, of the self-doubt that racked the nation – doubt about the country's capacity to solve its problems or even to survive with its institutions and social structures reasonably intact.[18]

In official circles much of the blame for this malaise was laid at the door of the young. The baby boomers of the postwar era, who grew up in two decades of relative stability, and who benefited from the rapid economic growth that provided them with unprecedented levels of material comfort – the generation who grew up witnessing technological advances that had made the nation one of the world's two great superpowers – it was this generation who, as they reached young adulthood, turned around and started to question the political, social and economic foundations upon which the material realities of their lives had been built. The inevitable tensions produced by this youthful rejection of parental values reached a tragic peak in 1970 when, on 4 May, National Guardsmen opened fire on a group of student protestors at Kent State University in Ohio, shooting four dead. The immediate official response was both callous and unequivocal in its attribution of blame for the tragedy on the protestors themselves:

> This should remind us all once again that *when dissent turns to violence, it invites tragedy.* It is my hope that this tragic and unfortunate incident will strengthen the determination of all the Nation's campuses ... to stand firmly for the right that exists in this country to dissent and just as firmly against the resort to violence as a means of such expression [my emphasis][19]

In other words 'they had it coming'. This was a stance which resonated with many Americans; those whom Nixon would call the 'silent majority'.[20] And it was a view that was ultimately reinforced

by the President's Commission into Campus Unrest (the Scranton Commission), which concluded that youth culture – though born of the same principles of equality and justice that lay at the roots of the American Dream – had developed a deep sense of 'alienation and of opposition to the larger society'.[21]

In official discourse at the start of the 1970s, then, the baby boom generation – or at least a sufficiently large, vocal and visible number of its members – had become a problem. The political consciousness of this generation of Americans, and their willingness to stand up and protest was one, highly visible, manifestation of the 'problem' of youth. It was not, however, the only dimension to the American 'problem' of the young at the start of the Seventies. The rise of permissive attitudes towards sex and sexuality among the young provided another focal point for the anxieties of America's 'silent majority'.

Progress and Morals

When it comes to the matter of sexual behaviour (particularly the sexual behaviour of the young) there is a curiously persistent declensionist discourse in many of the Anglophone western cultures. The USA is no exception to this. The trajectory of this transhistorical, moralistic discourse is such that it insists that, at any given time in history, people's sexual morals are lower than those of the previous generation and that the general direction of sexual morality through the preceding decades has been downwards, and shows every sign of continuing in that direction. In this respect the Seventies was no different from any other time during the twentieth century. Notwithstanding the historical persistence of this discourse, and the concomitant fact that this persistence necessarily means that it is not peculiar to the 1970s, the existence of the discourse nevertheless points to another important facet of US culture that generated anxiety at the time. Furthermore, although the fact of the existence and trajectory of the discourse may be generally consistent in different periods, the precise character of the anxieties provoked does change according

to the times. In the 1940s, concern about sexual morals had been focused on the possibility of American soldiers cavorting with 'foreign' girls, while the women they left at home sought sexual solace with the available civilian men. In the 1970s, the focus of this discourse of moral decline had – like other areas of concern at that time – shifted to the young. And just as the anxieties raised by race riots and campus protests about civil rights and/or the war in Vietnam revealed a schism in American society, between social progressives and the conservative traditionalists who comprised Nixon's so-called 'silent majority', so too did this concern about sex and moral decline.

The issue of sexual morals and the young featured in a cover article in *Time* magazine on 21 August 1972, under the headline 'Sex and the Teenager'. The article inside the magazine presented a generally well-balanced account of changing sexual mores among the young in the early 1970s, reflecting a liberal, progressive viewpoint that did not view sex as shameful or 'dirty' but as an expression of humanity. Indeed the article considered the lack of sexual inhibition among many young people to be a potential path to greater emotional and physical wellbeing, leading to relationships that were 'more meaningful than the typical marriage in sharing, trusting and sexual responsibility'. Nevertheless, the article did acknowledge that these new, uninhibited sexual attitudes of youth would undoubtedly provoke concern among many of the parents of these teenagers.[22] Assessing the causes of the perceived rise in teenage sexual activity, *Time* identified three major trends: a general rise of 'permissiveness' in American society; a 'weakening of religious strictures on sex'; and the dilution of family influence over the behaviour of the young, which was seen as a corollary of the relatively recent development of a 'generation gap' between parents and their children.[23]

If a perceived increase in sexual activity among the young was regarded by some conservatives as a symptom of a moral decline within American society, and an inevitable concomitant of the rise in permissiveness and liberal attitudes, then it was by no means the only symptom of a rise in sexual liberalism in the Seventies, nor even the most visible. Inverting the moralistic stance taken by

some prominent Americans, some more progressive commentators regarded the new openness about sexuality as a healthy development, one that afforded new opportunities for human self-expression and contentment. Fuelled by such liberal beliefs, the early 1970s witnessed the publication of numerous books that dealt explicitly with various aspects of human sexuality; from the educational – such as Dr Alex Comfort's well known, *The Joy of Sex*, first published in 1972 – to the mildly prurient, such as Xaviera Hollander's best-selling autobiographical account of her life as a prostitute, *The Happy Hooker: My Own Story*, first published a year earlier.

In film, too, 1972 was a landmark year in the depiction of explicit sexual acts on screen. In June that year the opening of the movie *Deep Throat* (Damiano 1972 USA) at the New World Theatre on New York's 49th Street brought hardcore pornography out into the open. And if this was not exactly mainstream American culture, the movie's appearance certainly seemed to signal a significant shift in American attitudes toward explicit representations of sexual acts; one that allowed hardcore pornography to move out of the private club and the 'stag party' and onto Main Street, USA. Loren Glass provides an account of the film's extraordinary impact on American culture, noting that its opening:

> marked a turning point in American cultural history. Over six thousand people went to see the film in the first week. Mainstream reviewers praised it. Its New York success sparked a nationwide run, giving Middle America a strong dose of coastal cosmopolitan culture. The film, which originally cost only US$25,000 to make, eventually grossed over 25 million dollars, making it one of the most profitable films of all time.[24]

Absent from this account of the film's undoubted financial success, however, is a sense of the broader cultural impact that it had on American society in the 1970s. Discussing the film's impact in the *New York Times* in early 1973, Ralph Blumenthal coined a phrase that captured perfectly a new and increasingly commonplace attitude toward sexual representation: 'Porno Chic'.[25] According

to Blumenthal, since the release of *Deep Throat* there had been a pronounced erosion of the social inhibitions that previously would have prevented most people from admitting to watching hard-core pornography. *Deep Throat* was significant not because the explicit representation of sex was unheard of before it, but because it held an appeal for a wider spectrum of society than those who typically frequented seedy, disreputable porn cinemas. The film attracted many well-known celebrities as well as other 'respectable' figures. Truman Capote reportedly found the lead actress 'charming', and:

> Recent *Deep Throat* audiences are said to have included people like Johnny Carson, Mike Nichols, Sandy Dennis, Ben Gazzara and Jack Nicholson. Some French United Nations diplomats ... Some off-duty policemen went.[26]

Although Blumenthal's article was written at the time of a pending trial that would ultimately rule the movie officially 'obscene', it nevertheless captures a sense of the general aura of sexual permissiveness that had developed during the 1960s and which reached its apogee in the early 1970s: the degree to which expression of sexual interests that in earlier times would have been kept private had moved into the public sphere. Blumenthal's article concludes by outlining the plans of the film's producers for future similar films with larger budgets, suggesting the coming of a larger movement in US culture dedicated to extending the frontier of sexual permissiveness.[27]

While some contemporary commentators (and, no doubt, many ordinary Americans) may have revelled in the new, liberated sexual climate of the early 1970s, others viewed the trend as merely one more symptom of America's ongoing moral decline. The early 1970s may have been a peak time for permissive attitudes towards representations of sexuality but the period was also marked by the re-assertion of the more traditional, conservative attitudes, particularly among the religious right, that would rise to greater prominence in the later years of the 1970s and the early 1980s. At the forefront of this wave of religious conservatism was an

evangelical pastor from Lynchburg, Virginia, a founding member of one of the first 'megachurches', who would later become a leading 'televangelist': Jerry Falwell. It was still some years before he would give a name – the 'moral majority'[28] – to the section of society that he claimed to represent, but the sense of moral revulsion at the permissiveness of contemporary society was palpable in Falwell's writing early in the 1970s:

> We are living in an age of immorality... today, we're being brainwashed by television, by Hollywood, by the magazines of our day. We are being taught permissiveness and indecency. We are learning to accept the unacceptable. We are learning to love the unlovely. We are being brainwashed into thinking situation ethics is acceptable, that nothing is really absolute, wrong or right.[29]

Falwell's moral campaign was organised around three distinct but related strands: anti-homosexuality, anti-abortion, and anti-pornography. This campaign would gain greater momentum later in the decade, particularly following the publication of Falwell's manifesto, *How You Can Help Clean Up America* in 1978,[30] but the tendencies to which each of these themes can be seen as a backlash were already present and highly visible in the early years of the 1970s. *Deep Throat* brought hardcore pornography out into the open and even made it acceptable in some quarters; after the Stonewall Riots of 1969 the modern gay civil rights movement began to grow and gain confidence; and in January 1973 the Supreme Court delivered its verdict in a case that had first been argued before it two years earlier – Roe v. Wade – and in so doing had overturned all state and federal laws that had previously outlawed or limited a woman's right to an abortion. Taking these three elements into account, it is not difficult to understand why some of the more conservative elements in America felt, at the start of the 1970s, their vision of what America stood for was under attack.

Economic Problems

Bad as they were, the issues outlined above did not represent the full extent of the problems that faced America at the start of the 1970s. America's traditional sense of moral purpose may have been founded on principles of familial order and public 'decency' that were threatened by the increasing permissiveness of society after the 1960s, but there were other important aspects to the American sense of identity too. The promise of increasing economic prosperity for those prepared to work hard was also a vital part of that complex fusion of identity and aspiration known as the American Dream. However, this myth of an ever expanding economy also came under threat in the early 1970s. The cover of the 13 March 1972 issue of *Time* magazine presented the problem very bluntly, showing a picture of Uncle Sam turning out empty pockets. The caption simply asked 'Is the US going broke?' The associated article inside the magazine described America's economic woes in greater detail. Noting that 'Americans have long thought that they had the resources to accomplish practically any goal that they set for themselves', the article recounted a series of economic ills that had befallen the nation by the early 1970s. These included huge budget deficits at city, state and federal levels and concomitant rises in taxation levels that were necessary to service those deficits.[31] And in the first few years of the 1970s these economic problems were set to get worse, as the oil crisis of 1973 drove up fuel prices and heralded America's entry into the paradoxical condition of economic 'stagflation' – a (then) theoretically inconceivable phenomenon comprising high inflation, an economy in recession, and high unemployment. Reflecting the fact that the early 1970s was a time of considerable economic uncertainty in the USA, the cover of *Newsweek* magazine on 31 January 1972 – subtitled 'The Economic Issue' – depicted two hands with fingers crossed, juxtaposed against a quotation from President Nixon proclaiming – more from optimism than any real conviction – that '1972 will be a very good year'.

The economic difficulties of the early 1970s were accompanied by a range of social problems of the sort that usually follow from economic hard times. As *Time* magazine noted:

the nation's streets are dirtier, its mass transit more decrepit, its public hospitals more understaffed, its streets more crime-ridden today than in decades.[32]

Although the timing was coincidental and the significance is figurative in this context, perhaps no event provided a better metaphor for the condition of America in the early 1970s than the demolition – beginning in March 1972 – of the Pruitt-Igoe housing project in St Louis, Missouri. When it opened in the 1950s, Pruitt-Igoe had been emblematic of a utopian modernist vision of America. The grand narrative of modernism insisted upon the possibility of social progress through the application of rational principles to a range of problems, of which housing was only one example. The Pruitt-Igoe complex of 33 eleven-storey buildings, capable of housing 10,000 people, had first been occupied in 1954, amid hope that it and projects of its kind would help arrest and reverse the decline of urban areas and promote racial integration. In practice, however, the project had fallen very short of this ideal, and the result had been the creation of a large, predominantly black ghetto with extremely high rates of crime and vandalism. Marking the recognition of the failure of this kind of utopian modernist social engineering, in 1973 President Nixon announced the cessation of the construction of publicly-funded housing projects.[33] Of equal importance to this pre-emptive termination of the utopian modernist project, however, was what the destruction of Pruitt-Igoe implied about the demise of the American Dream. Property and National unity – one nation under God, indivisible, with liberty and justice for all – had always been cornerstones of the American credo. The failure of the Pruitt-Igoe project represented not only the literal destruction of property but also revealed the fracture lines that shattered this vision of unified nationhood. Pruitt-Igoe failed, in large part, because whites refused to live next to blacks; and the community that did end up occupying the project quickly turned against itself, transforming the whole estate into a quagmire of crime and vandalism. In Pruitt-Igoe the ideal of 'one Nation under God, indivisible' could not have been much further from the reality. The demolition of the buildings in 1972 symbolised a recognition

that only the most radical sort of practical solution could begin to address the problems of social division that the project itself had made all too visible.

Vietnam – the American War

The start of the 1970s also witnessed the dissolution of the myth of America's unquestionable military superiority over its foes. Massive expenditure on advanced technologies of war may have helped defeat Nazi Germany and subsequently held the Soviet 'threat' in abeyance – keeping the Cold War in stalemate for two decades – but against a relatively poorly-equipped guerrilla army in Vietnam, American military might had proven unable to secure victory. In the early 1960s there was relatively little dissent on the home front about America's involvement in Vietnam, at least compared to that yet to come. However, after 1966, changes in the laws on conscription raised the prospect of greater numbers of college students being drafted to fight in the war, and this may have played an important role in radicalizing key sections of American youth and crystallising attitudes more widely against the war.[34] By the end of the Sixties, the war in Vietnam had become one of the most divisive issues among the American public, one that so damaged the sense of a coherent and unified American national identity that the editor in chief of *Time* magazine was able to write in one issue that 'the country had lost a working consensus "as to what we think America means"'.[35] In addition to the demoralising effect the war had on the American spirit – the result of its exposure of the breakdown of consensus and the loss of a clear sense of America's meaning and purpose – by the start of the Seventies Americans had also to come to terms with the ego-deflating fact that it was a war that, despite all its military might and its technological superiority over the enemy, America could not win. Once again 1968 was the pivotal moment. It was the year of the Tet Offensive, the campaign that provided the 'wake-up call that finally alerted America to the unwinnable nature of the Vietnam conflict' and set America on 'the road to defeat and humiliation'.[36] While there is considerable debate

among scholars of the American war in Vietnam about the ultimate meaning and consequences of the Tet offensive, a common view is that the campaign was a tactical failure for the North Vietnamese: it exposed their weaknesses. Strategically, however, it was a success for the communists because it also revealed the extent to which the American public had lost the will to keep up the fight. For several years before, grotesque images of the war had been regularly beamed into America's homes on television news, and this had contributed to a turn of public opinion against continued US involvement in the conflict. In late February 1968, Walter Cronkite – the broadcaster most trusted by Americans to report the truth – publicly reversed his earlier position of support for the war, announcing to his audience that 'to say we are mired in stalemate seems the only realistic yet unsatisfactory conclusion'.[37] By 1968 the American public was, as Robert Schulzinger puts it, 'heartily sick of the war'.[38] Through the remainder of 1968 and 1969, discontent at America's continuing presence in Vietnam intensified. The Democratic Party's convention in Chicago in August was marred by violent clashes between police and anti-war protestors, demanding an end to US involvement in the conflict. In the summer 1969 edition of *Foreign Affairs*, the hitherto 'hawkish' former Secretary of Defence, Clark Clifford, added his voice to those calling for all US troops to be withdrawn from Vietnam by the end of 1970.[39]

Nixon's election to the Presidency in November 1968 had, however, complicated matters, making an early withdrawal more difficult. Reluctant to be seen as the first American President to lose a war, Nixon sought to achieve 'peace with honor', by securing the withdrawal of troops while maintaining America's standing in world politics. His strategy for achieving this involved intensive use of air power, with the aim of forcing the North Vietnamese to negotiate a peace on America's terms. The strategy failed, however, and cost America dearly by damaging international support for its other policies abroad. Furthermore, it increased the intensity of the antiwar sentiment at home. Central to Nixon's policies was the concept of Vietnamisation. Essentially, this entailed a progressive handover of control over South Vietnam to its own forces, with the borders between North and South being negotiated between

America and the North Vietnamese. In the pursuit of this policy, American troops were progressively withdrawn from Vietnam; from 545,000 when Nixon took office in 1968 to only 64,500 by May 1972.[40] The process culminated in the Paris Peace Agreement, signed in January 1973. The agreement was a pragmatic compromise on America's part. It may have finally allowed America to complete the withdrawal of its troops from the country but, in doing so, America effectively abandoned South Vietnam to its fate. The conflict, between the forces of South and North Vietnam continued between 1973 and the fall of Saigon in April 1975, when the South, no longer able to resist the advance of North Vietnamese forces, finally succumbed to the power of the communist North. America's long and sorry involvement in Vietnam may finally have come to an end, but the conflict wrought considerable trauma to American self confidence, the effects of which would reverberate through the culture for years to come.

Social Fragmentation and Culture

All in all, then, the latter part of the Sixties and the early part of the Seventies saw America facing an array of unnerving economic, social and political problems. The impact of these problems can be detected throughout American popular culture in the early 1970s. Two films released in 1971 and 1972 – one for theatrical release, the other made for television – provide a particularly good sense of the aura of paranoia and pessimism that had taken hold on the American sense of national identity early in the decade. The first of these, *Deliverance* (Boorman 1972 USA), presents a filmic re-enactment of one of the key tropes associated with the character of Americanness: the rugged individualism of the frontiersman. But the movie also demonstrates the radical disjunction between this foundational myth of individualistic self-reliance and mastery over the natural world, and the radically different realities of modern American life. In the film, four men – Ed (Jon Voight), Lewis (Burt Reynolds), Bobby (Ned Beatty) and Drew (Ronny Cox) – suburban professionals and businessmen from Atlanta, spend a weekend

canoeing down the fictional Cahulawassee River in the remote wilderness of Northern Georgia. On the face of it this would seem to be a re-creation of the mythical journeys of early American settlers, and an opportunity for the men to demonstrate the survival skills upon which the ideal of individualism is founded. Indeed, this is precisely the romanticised view of America's pioneer past that is voiced in the early parts of the film by Lewis. Lewis is forthright in his opinion that modern city-living is a degraded lifestyle that has emasculated the modern American man, stripping him of the essential manly qualities with which the nation was built. Lewis's scepticism extends to the idea of modernity itself, represented in the film by the dam and hydroelectric power plant that will be responsible for the flooding of the river valley which provides the setting for the film, a prospect which Lewis regards as the 'rape [of] this whole goddam landscape'.

Lewis may be set up, in the early parts of the film, as the embodiment of the pioneer spirit of rugged individualism, but he and his friends are soon forced to face the dark side of this romantic ideal, and the radical disjuncture between the romanticism of the myth and the brutish realities of what the film portrays as a socially backward, anachronistic and dangerous rural America. The inhabitants of the region where the four men begin their journey are shown to live in appalling poverty and to suffer from a host of physical and mental defects, which the film does not directly say – but does imply – result from inbreeding. While Lewis initially enjoys this encounter with what he evidently considers to be a more authentic experience of America, his friends do not share his enthusiasm. Later in the movie, even Lewis's attitude changes when – having killed one of the 'mountain men' who has raped Bobby – Lewis himself is seriously injured and the three remaining men (Drew having been killed earlier) become helpless victims of a wild and hostile milieu, with which none of them is really physically or mentally equipped to cope. At the film's end the three surviving men return to the city only too happy to obey the local Sheriff's injunction never to return to Aintry (the fictional town in which the river journey ends). The vision of rural America provided by *Deliverance* is, then, a highly stereotypical one; a vision of a place where it may

still be possible for a man to test his masculinity against the rugged ideals perpetuated in national myth, but in which the quotidian reality of the wilderness is of a brutal and lawless milieu in which violence and the rule of the gun holds sway. What is particularly striking about the film, however, is the way that it is not just the inhabitants of the setting – the 'backwoodsmen' and 'hillbillies' – who exhibit antipathy toward the presence of the outsiders from the 'big city'. In *Deliverance* there is a sense that the very landscape itself has turned against the city dwellers, presenting them with a setting that is both incomprehensible and dangerous to a generation of men raised in the comfort and relative safety of suburbia, and thus alienated from the rural scene. *Deliverance* presents a palpable sense of a sort of 'terror in the landscape' throughout; a sense that is well-captured by one of its most memorable images, near the film's end, in which a dead human hand rises slowly from the still waters of the now flooded valley.

A similar aura of terror in the landscape is discernible in the contemporary television movie, *Duel* (Spielberg 1971 USA). In this movie, David Mann (Dennis Weaver), a salesman – a suburban professional – drives through the inhospitable terrain of the California desert on his way to a business meeting. In the desert he encounters a fuel tanker driver who apparently takes offence at being overtaken by the salesman's car and repeatedly attempts, throughout the movie, to drive the salesman off the road (presumably to his death). Although on the face of it the film revolves around the homicidal actions of a psychotic individual, it is highly significant that the driver of the truck is never fully shown. This creates a strong sense that it is not so much human agency, but some inhuman force of nature, that threatens Mann. Throughout the film, the truck repeatedly confounds Mann's desperate attempts to evade the danger. When he stops, it stops, and waits for him to move before continuing the chase; like an animal toying with its prey. Several scenes serve to establish a metonymic relationship between the truck and the American landscape, iconically represented by the rust-red hue of the soil and rocks that dominate the California desert. A number of devices are used in the film to reinforce the implied metynomy between truck and terrain. Several scenes use long shots

showing the road extending into the far distance, with the truck initially imperceptible at the vanishing point, from which it emerges gradually like some autochthonous monster spontaneously issuing from the soil itself, its rusted and dirty red-brown body blending into the landscape in a way that starkly contrasts with the bright red paintwork of Mann's car. In another scene, numerous license plates from different States are clearly visible on the truck's front fender, producing a sense that the truck figuratively represents 'all America' and that the threat to Mann (whose apt surname may not be accidental) emanates not from an individual human agent, but from the nation itself and the earth upon which it stands.

Thus, in a way that is similar to that which he would later achieve with even greater success in *Jaws* (1975 USA), in *Duel*, Spielberg managed to invest the natural environment itself, the very soil on which the American Dream was built, with an aura of the terror in the landscape that is also apparent in *Deliverance*. Between the two films, one detects a profound sense of disturbance about the land upon which the nation is built, and of a people divided between professional suburbanites – who share a set of common values – and a series of non-specific 'others' who live outside the conformist confines of suburbia and who observe different values. However, whereas maverick outsiders had in the past been invested with an aura of romantic rebelliousness in American mythology, in these popular cultural productions of the early 1970s, the maverick outsider is a figure who represents an unambiguous threat to the survival of the conformist, suburban middle classes.

In January 1970 *Time* magazine published a rather pessimistic cover feature on these 'Middle Americans', as it named them. The article reflected their sense of disillusionment with key icons of the American Dream:

> The American dream that they were living was no longer the dream as advertised. They feared that they were beginning to lose their grip on the country. Others seemed to be taking over – the liberals, the radicals, the defiant young, a communications industry that they often believed was lying to them. The *Saturday Evening Post* folded, but the older

world of Norman Rockwell icons was long gone anyway. No one celebrated them; intellectuals dismissed their lore as banality. Pornography, dissent and drugs seemed to wash over them in waves, bearing some of their children away.[41]

Faced with these assaults on their beloved American Dream, these 'Middle Americans', as the article noted, 'sought to reclaim their culture'.[42]

'Oh mercy mercy me. Oh, things ain't what they used to be, no no'[43]

Given the grim prospects of the early years of the decade, it is hardly surprising that there was a perceptible turn to the past in mainstream American culture in the early Seventies. The nation indulged in nostalgic, and inevitably idealised, reminiscences of a not-too-distant past in which America's prospects had appeared much more optimistic. 'Everybody's Just Wild About Nostalgia' proclaimed the cover of *Life* magazine on 16 February 1971, heralding a special issue that took an affectionate look back at various different aspects of America's recent past and which noted that 'Old is in, and we are happily awash in the sleek and gaudy period that stretched from the '20s, through the '30s and into the '40s'.[44] The romanticised vision of the past contained in the articles in this special issue provided a theme that the magazine would revisit on several occasions in the first few years of the new decade, including an interview with John Wayne, which conflated reality and Hollywood myth-making, calling the actor 'an authentic American legend, a man who ties together strands of dreams and nostalgia for us simply by existing'.[45] The nostalgia theme was revisited again on the cover of the 16 June 1972 edition, using an image of a young woman dressed in 1950s period outfit, dancing with a 'hula hoop', to signal an article within concerning 1950s revivalism. The accompanying article gave an account of the revival of the styles and music of a decade that had only very recently passed, and postulated that the roots of this 'flight to the '50s' might lie in the *search for a happier*

time, before drugs, Vietnam and assassination' [my emphasis].[46] In a similar vein, *Newsweek* on 16 October 1972 featured Marilyn Monroe on the cover of an issue that reported on the 'yearning for the Fifties, *the good old days*' [my emphasis].[47]

The nostalgia bug also spread to pop music. In addition to Marvin Gaye's declaration in June 1971 that 'things ain't what they used to be',[48] further evidence of pop's sentimentalism appeared in January 1972, when an eight and a half minute single (occupying both sides of 7" 45 RPM disc) by an unknown New York folk singer reached number one in the *Billboard* charts and remained there for four weeks. The contemporary significance of this song was such that it has been identified as '*the* single of the fall and winter of 1972' (emphasis in original) by Jim Curtis.[49] At more than double the length of most hit singles of the time, Don McLean's *Miss American Pie* was certainly an extraordinary record, and it generated considerable speculation about the meaning of its deliberately ambiguous lyrics. *Life* magazine even ran an article attempting to unravel the allusions within the song.[50] While the precise meanings of the lyrics may be impossible to definitively fathom, it is at least readily apparent that *Miss American Pie* revelled in a warm, nostalgic vision of a mythical golden age of postwar America – the Fifties and Sixties – during which the baby boom generation, now in adulthood by the early 1970s, had grown up. While certainly nostalgic, the imaginative reconstruction of the recent American past provided by the song was bittersweet in certain respects: on the face of it the song is at least in part a lament for the late Buddy Holly. However, some interpretations of the song regard this aspect – 'the day the music died' – as a broader allusion to the figurative 'death' of American innocence in the period since the end of the Fifties.[51] Whatever ambiguities there may be in *Miss American Pie*'s vision of the past, it is at least clear that the past that the lyrics refer to was being viewed from a perspective, at the start of the 1970s, from which it was only possible to take a pessimistic stance on the state of contemporary America, relative to that past, and to look back with fondness at the earlier postwar decades. As Curtis puts it:

The tremendous popularity of 'Miss American Pie' expressed an awareness that the Sixties were over, and that the Seventies had begun.[52]

Curtis's observation signals an agreement with the argument I make earlier in this chapter concerning the necessity to think of the 'Sixties' and the 'Seventies' as mythical constructs rather than strict chronological periods. It also echoes my argument that there was a decisive shift between the optimistic viewpoint of the early part of the Sixties and the pessimistic one of the Seventies. In the final analysis, the precise interpretations to be placed on lines in McLean's song, such as 'I met a girl who sang the blues, and asked her for some happy news, but she just smiled and turned away'[53] and 'in the street the children screamed'[54] matter less than the general aura of a pervasive loss of hope implicit in those lines and in the couplet that ends the song, 'The father, son, and the holy ghost, they caught the last train for the coast'.

Politics

As well as being the year that Don McLean topped the charts with his tribute to America's recent past, 1972 was also a Presidential election year. Faced with such a testing array of social problems and the powerful nostalgic tendency toward the recent past evident throughout the culture, it is perhaps not surprising that American voters returned as President a figure who, in so many ways, seemed to personify that earlier era. The reasons why Richard Nixon was re-elected to the Presidency in 1972 were manifold, and were certainly not simply an effect of the general mood of nostalgia within American culture at the time. However, it is difficult to deny that Nixon's public persona harked back to the 1950s, that part of the recent past that was enjoying renewed modishness at the start of the 1970s.

That Nixon was running for office at all (let alone for *re-election* to the Presidency) necessarily evoked an echo of the 1950s. Nixon had entered the House of Representatives in 1946 and had achieved

national prominence for his role in the Alger Hiss case. Nixon was elected to the Senate in 1950 and served as Vice President to Dwight D. Eisenhower for eight years, from 1953 to 1961. In 1962, however, following unsuccessful campaigns for the Presidency (against John F. Kennedy) in 1960 and for the Governorship of California in 1962, Nixon announced his retirement from politics, rather dramatically informing the press that 'you won't have Nixon to kick around anymore, because, gentlemen, this is my last press conference'.[55]

Having thus apparently retired from politics in 1962, it must have seemed surprising to many Americans to see Richard Nixon running for the Presidency once again in early 1967. But times had changed dramatically in those few intervening years:

> As the 1968 presidential contest approached, events seemed to overshadow the individual candidates. The war in Vietnam was dragging on, and the war at home accelerated with massive antiwar marches, protests, and social upheaval. The universities were the scene of protests. Young people rejected convention, and the hippie movement flourished. Urban riots and racial unrest persisted. Political assassinations of President John Kennedy in 1963 and civil rights leader Martin Luther King, Jr, and presidential candidate Robert Kennedy in 1968 sent shock waves through the nation.[56]

The end of the Sixties was a time when the '"spectacle of violence" transformed the idealism of the Camelot era into a disenchantment and cynicism which threatened the bonds that held the nation together'.[57] Richard Nixon was the 'right man' for such a 'period of resentment' being, as one commentator observed, a 'virtuoso manipulator of discontents'.[58] The timeliness of Nixon's resurrection as a politician was due, in part at least, to his ability to evoke the population's (inevitably faulty) memory of an age just before everything started to go wrong. This was not simply a matter of his innate image; Nixon also self-consciously employed allusions to the past, to a mythical American 'golden age', in his political rhetoric.

References to the past pepper Nixon's speeches, in which they provide the rhetorical foundations for his vision of America's future. Nixon's first *State of the Union* address, in January 1970, was exemplary. Having set out his vision for the American future – in which poverty, crime and economic problems had been banished; in which the environment had been improved and in which the country was at the forefront of scientific and technological development and, most importantly, was 'at peace with all nations of the world' – Nixon took pains to establish the foundation of his vision of the future in memories of the greatness of America's past:

> In times past, our forefathers had the vision but not the means to achieve such goals. Let it not be recorded that we were the first American generation that had the means but not the vision to make this dream come true.[59]

Then, once again evoking nostalgia by referencing the words of Thomas Jefferson in 1802 – 'We act not "for ourselves alone, but for the whole human race"' – Nixon continued:

> We had a spiritual quality then which caught the imagination of millions of people in the world. Today, when we are the richest and strongest nation in the world, let it not be recorded that we lack the moral and spiritual idealism which made us the hope of the world at the time of our birth.[60]

The nostalgic tone evident in these words would become an enduring feature of Nixon's rhetoric. The following year, Nixon adopted a similar strategy of calling forth the past: this time to garner support for his proposal to reduce the size of Government:

> One hundred years ago, Abraham Lincoln stood on a battlefield and spoke of a 'government of the people, by the people, for the people.' Too often since then, we have become a nation of the Government, by the Government, for the Government.[61]

What Nixon stood for, then, as a cultural icon, was not merely the political Conservatism that determined his policies, but also a broader kind of ideological, nostalgic conservatism (with a small c) that appealed to many Americans' innate sense of tradition through the invocation of the 'time-honoured' values that they saw as lying at the heart of the essential American character. To some degree, Nixon's ability to resurrect his political career in the early Seventies derived from his capacity to embody these traditional values and to defend the continuing belief in them at a time when American culture generally tended to look back at the recent past with some fondness. This aspect of Nixon's political persona – a forward-looking man, perhaps, but not a radical reformer; a man whose vision of the future was solidly founded in a continuing belief in the America of the past – is manifest in his 1972 Presidential nomination acceptance speech:

> It has become fashionable in recent years to point up what is wrong with what is called the American system. The critics contend it is so unfair, so corrupt, so unjust, that we should tear it down and substitute something else in its place. I totally disagree. *I believe in the American system* [my emphasis].

Such explicit expressions of confidence in traditional American values were a key part of Nixon's 'fit' with the more general wave of nostalgia that swept across the nation in the early Seventies.

While much of the sentimentalism evident in early Seventies American culture frames the nostalgic tone of the time in general terms, some publications followed the President's lead and developed more explicit connections between the nostalgic view of the past and the traditional American values that seemed to have been lost in the view of contemporary American society presented by much of the media at the time. A photo essay in *Life* magazine in July 1972 exemplifies this tendency to counter the prevailing pessimistic media visions of contemporary America with sepia-toned, idealised images of a mythical American past.[62] Acknowledging that 'it requires an act of faith to call up the images of a land we all like to think we once knew' the article places the photographs of Leon

Kuzmanoff within an ideological frame that strongly implies that
– outside the urban and suburban milieus inhabited by increasing
numbers of Americans – there still existed that 'simpler America'
of the past; an America characterised by the straightforwardness of
life and the essential goodness of its people: from rural Alabama
and Pennsylvania through Indiana and on to Wisconsin, Missouri
and Idaho. This was an America untainted by the ills that beset
the most visible parts of the modern nation in the early 1970s, an
America in which traditional virtues still reigned: an America that
would also, for nine years, be presented weekly to the nation on
television from September 1972 in *The Waltons*.

Television Families

We need a nation closer to *The Waltons* than *The Simpsons*.[1]

LOS ANGELES (January 6, 2010) – The Parents' Television Council® is urging its members to file indecency complaints with the Federal Communications Commission (FCC) about Fox's 'American Dad,' which featured a man masturbating a horse during the Sunday, January 3 episode.[2]

On 23 September 2009, just days after the 37th anniversary of the first appearance of *The Waltons* on America's television screens, the ABC network broadcast the pilot episode of *Modern Family* (ABC 2009–), the latest in a long run of television series to place the family at the centre of its focus. This evident endurance of interest in television families suggests that there may be some truth in the claim made by Horace Newcomb, in his groundbreaking work on the subject – *TV: The Most Popular Art* – that family is at the heart of all television.[3] It is certainly accurate to observe that American television has, throughout its history, consistently shown considerable interest in representations of family life: the television family is very nearly as old as the medium itself and shows no sign of declining in importance. Some quantitative support for this view can be found in a content analysis of television families. Robinson and Skill identified and examined 630 fictional television series released between 1950 and 1995 on the four US networks, which featured the family as a 'primary story emphasis'.[4] Doubtless this

list does not include every appearance of a family in an American television show, and does include many shows that were much shorter-lived than *The Waltons*. Nevertheless, the study does show that, as a rule of thumb, the family has been one of the most consistently important sources of material for American television producers.

It hardly needs saying that the family has been at least equally ubiquitous in political discourse in the same period. Writing in relation to the British context, Deborah Chambers has persuasively argued that:

> Family-values rhetoric is carefully reconstructed by each new generation of politicians in western anglophone nations in the steadfast belief that the discourse of family crisis will be a vote catcher.[5]

These two phenomena – the importance of televisual representation of family life and the persistence of political discourses concerning the family – are not unconnected. Chambers rightly observes that, 'definitions of family values get regularly acted out and contested on a very public stage'[6] and, as former President Bush's oft-quoted statement in the epigraph to this chapter illustrates, the 'public stage' on which the struggle to define the meaning of the family is acted out is frequently television. Robinson and Skill note that:

> The fictional family on television, in its many forms, has become one of our most enduring benchmarks for making both metric and qualitative assessments of how the American family is doing in the real world. For many in the arena of public policy, the debate frequently points to television as a primary source for what is good or bad about the family institution.[7]

It is important to be clear that what is being suggested here is not a reductive and overly simplistic idea that the television family has either a causative or a mimetic relationship to the lived,

socio-historical realities of family life. Rather, it is argued that televisual representations of the family mediate those realities in a way that distills for us something of the socio-historical anxieties about the family at any given time and provides a mode of expression for ideological discourses about what the family means or should mean.

This chapter will provide a brief overview of how discourses about the family and family values have been acted out on television, almost from the medium's inception and up to the present day. In so doing, the chapter will place the particular take on family life presented by *The Waltons* into the wider context of the history of familial representation on television. This is, of course, not a simple task. The sheer number of programmes, through television's history, that have featured noteworthy representations of family life would make it impossible to comprehensively cover this subject within the constraints of this book. Furthermore, not all of those programmes will have afforded an equal degree of centrality to the family within their diegetic worlds, making like-for-like comparisons problematic and the construction of anything approaching an objective, comprehensive list of programmes concerned with the family impossible. I do not claim, therefore, that the list of television programmes discussed in this chapter represents either a comprehensive or a scientifically objective inventory of television's families. It is not even a representative sample of a kind that would satisfy social scientists. While I have not gone out of my way to do so, it is undoubtedly the case that my own unconscious biases and conscious interests in the subject will have informed the programme choices I have made. That said, I would argue that it is not a particularly unrepresentative list either, containing, as it does, some of the most popular and best remembered television families from each decade.

In the history of representations of the family on television, the 1950s is generally taken as being the heyday of the normative, 'all-American' nuclear family: the suburban, middle-class family consisting of breadwinner father, housewife mother and two or three kids. Thus the Fifties provide the mythic familial ideal against which later television families are judged, and – more often than

not – found wanting by the custodians of 'family values'. On the face of it, this association between 1950s television and images of familial equilibrium within an overarching patriarchal order would appear to be correct. The families found in the well-known sit-coms of the decade – *Leave it to Beaver* (1957–63), *Father Knows Best* (1954–63), *The Adventures of Ozzie and Harriet* (1952–66), *Make Room for Daddy* (1953–64), *The Donna Reed Show* (1958–66), for example – certainly do conform to the general ideal of 'family values' evoked as the 'gold standard' against which all others are measured in discourses about the family in later decades (both 'real' families and those in television fiction). Thus the stage would appear to be set once more for the now familiar declensionist discourse. The trajectory of this discourse begins at a high point, with the 1950s familial ideal expressed in the popular television shows of the decade. The discourse then traces an apparent ongoing and irreversible decline of 'family values' over successive decades, continuing up to the present, usually linking this decline to one or several of the changes within family structures that have taken place over the period: working mothers, loss of paternal authority, etc. At this point, a contemporary mode of representation of the family – usually the one that demonstrates the most alarming symptoms of (alleged) familial disintegration – is compared unfavourably to the 1950s ideal, thus providing the evidence necessary to establish the validity of the claims made by the discourse. Typically the claim will be made that the television shows adopted as examples are both representative of the contemporary televisual form and are reflections of contemporary social realities. Some versions of the discourse will even go so far as to claim that these television shows are, to some degree, a source of the social 'problem' of familial decline, through some unspecified, but confidently asserted process of media 'effects'. Having reached these conclusions, the discourse will insist that the examples cited provide compelling evidence of an urgent need to return to the 'traditional' values embodied in the 1950s version of the family.

There are numerous things wrong with this version of the 'family values' discourse. First, as Stephanie Coontz indicates in her study of nostalgic visions of the American family, the idea of

the 'traditional family' is merely that; an *idea*, which has little basis in reality:

> Like most visions of a 'golden age,' the 'traditional family' ... evaporates on closer examination. It is an ahistorical amalgam of structures, values, and behaviors that never coexisted in the same time and place.[8]

And while the Fifties may have been what Coontz describes as a 'profamily period if there ever was one',[9] the image of familial domestic harmony presented by television shows was no less a fiction at that time than it would be later on. It was, purely and simply, a myth that diverted attention from the often difficult realities of 1950s family life. These realities included widespread poverty, which resulted in the exclusion of some 40 to 50 million Americans from the suburban/consumerist dream presented by the television sitcoms;[10] racial discrimination, segregation and brutalisation by legal authorities; the subordination of women and children to men and the domestication (and concomitant devaluation) of women's labour, against which feminists like Betty Friedan would later revolt. Notwithstanding the disjunction between the image of 1950s family life presented by television and its messier lived realities, the image itself retains considerable symbolic purchase, acting as a structuring reference point against which all subsequent symbolic constructions of the family are measured and rendered comprehensible.

However, while there is undoubtedly a 'common-sense' association of the 1950s sitcom family with a normative model of family relations structured by a governing patriarchal framework, which might seem to imply that strong images of untrammelled paternal authority were the norm, in reality the true situation was, more often than not, more complicated. Rachel Devlin makes an astute observation when she notes that:

> Representations of 'bumbling' fathers in comic strips and on television in the 1950s – if not the distraction of television itself – has been viewed as the final blow to paternal

authority, the cultural genesis of the social reality of 'poor old Dad'.[11]

As Devlin suggest, the fathers of 1950s sitcoms are often far from being all-powerful patriarchal figureheads of the family. Furthermore, the way that fathers are represented in these sitcoms has a powerful resonance with a more widely dispersed set of discourses in the 1950s, relating to masculinity and patriarchal authority. It is quite commonplace now for cultural theorists and historians to group together these discourses under the rubric 'crisis of masculinity' and to detect signs of the 'crisis' in a number of contemporary cultural productions that alluded to either the demise of male power – such as *Look* magazine's trio of articles 'The Decline of the American Male' (later collected together and published as a book)[12] – or to men's increasing association with areas of activity conventionally associated with women: for example, *Life* magazine's 'The New American Domesticated Male'.[13]

Instructively, the generic mode through which these concerns about 1950s men were articulated was most often comedy or satire.[14] One reason for this apparent affinity between the image of masculinity 'in crisis' and comedy might be that the anxieties provoked by the figure of the (ostensibly) disempowered male were too emotive to be expressed through more serious genres. Another possibility, however, is that discourses in the 1950s that questioned the male hold on the reins of power in this way represent an instance of what Bakhtin termed the 'carnivalesque'.[15] Bakhtin's formulation of the carnivalesque is a complicated concept derived from a reading of social practices relating to medieval festivals in Europe. In essence (at least insofar as it is relevant to the discussion in this chapter) what Bakhtin understands as carnivalesque is a kind of ritual 'pressure valve' for society, through which the tensions which inevitably exist within a society may be safely released by permitting – within strictly prescribed parameters – conduct that would normally be socially unacceptable or problematic. In this way the carnivalesque helps to prevent a build up of greater pressure that might actually threaten the fundamental order of society. Typically, the behaviours sanctioned by carnival include

all manner of vulgarities, expressions of disrespect for established structures of authority and for the order of the establishment. Unsurprisingly, then, Bakhtin's concept has been very productively employed in the analysis of television shows such as, for example, *The Simpsons*, which routinely employ grotesque humour and the derision of authority in a very obvious way – even making these characteristics the most distinctive features of the show. However, it is important to remember that carnival is very much a *permitted* form of expression, and that the structures of authority against which carnivalesque humour is directed are the very same structures that allow it to happen. As Terry Eagleton reminds us, carnival, 'is a *licensed* affair in every sense, a permissible rupture of hegemony, a contained popular blow-off as disturbing and relatively ineffectual as a revolutionary work of art'.[16] Keeping this 'licensed' quality of carnival in mind, I want to argue in this chapter that, in this respect, there is very little deep ideological difference – despite enormous superficial differences, and variations in the extent to which patriarchal authority is mocked – between depictions of the family on television in the early years of the twenty-first century and those to be found in the 1950s sitcom. In the same way that *The Simpsons* does today, *Father Knows Best* and the other family sitcoms of the time permitted 1950s audiences to poke fun at the family in general – and at fathers in particular – thus allowing a release of pressure, but leaving the fundamental power structures that exist in families, and in the wider society, to remain unchallenged.

The Golden Age?

Father Knows Best follows the lives of the Anderson family of the Midwestern 'anytown' of Springfield:[17] father Jim (Robert Young), mother Margaret (Jane Wyatt) and three children, Betty (Elinor Donahue), Bud (Billy Gray) and Kathy (Lauren Chapin). A typical episode illustrates the disjunction between the 'natural' expectation of patriarchal masculine authority and the slightly different realities of family life, in which women (and often children) routinely circumvent the authority of the father. A conversation between

Margaret and her neighbour Myrtle early in 'Margaret Goes Dancing' (S1 E11) demonstrates how women are able to gain access to power through their cunning manipulation of men. Myrtle has been telling Margaret about the dancing classes she attends with her husband, and she encourages Margaret to come along to one with Jim. Margaret is uncertain of her ability to convince Jim to join in. However, Myrtle is confident that Margaret will be able to manipulate Jim into doing what she wants:

> **Myrtle:** Listen darling, you don't talk husbands into things. You put a general's uniform on them, and then you push them along and they think they're leading the parade.
> **Margaret:** But Jim has such definite ideas about being led into things , about maintaining his [eyebrows raised] 'masculine independence'.
> **Myrtle:** Oh poo! You should've heard Ed roar when I told him I'd signed up for the course, but now he loves it.

A little later in the episode Margaret shares with Betty women's secret for getting their own way with men:

> **Margaret:** Daughter, I'm going to let you in on a wife's great secret about husbands. But first, I want you to know that your father's a wonderful father and I couldn't have asked for a better husband, but he's still a male ... and a male likes to feel that he thinks up all the ideas. So the tactful wife, by various, er..., justifiably devious methods, plants the idea in his mind and then lets him go ahead and think it up, and everyone's happy.

Jim is not quite as easily fooled as Margaret expects, however. Sensing that 'something is up', Jim shares the male perspective on the power relationship between the sexes with his son, Bud:

> **Jim:** ... your mother's planning something. I don't know what it is but the symptoms are there. [Laughs]. Women are never so obvious as when they're trying to hide something ... you

watch. The next step is to soften me up by trying to make me comfortable or to get me in a good mood. Then comes the flank attack, little hints thrown out here and there to try to channel my thinking. [Laughs] Ah, they're a strange breed.

Jim's good humour does not last, however, when a phone call from his friend Ed (Myrtle's husband) reveals the plans made by the two women. The visual composition of this scene reveals much about the power dynamics at work in the marital relationship. Initially, Jim sits on the edge of the telephone table to take the call, his manner relaxed, his face smiling. When the women's plans for the evening are revealed by Ed, however, Jim stands up sharply, his tall frame giving him a dominant position on the screen, next to his wife. His demeanour changes too, his facial expression becoming stern and serious, signalling his 'natural' expectation to have sufficient authority over family arrangements to at least be consulted about these plans. Intensifying the contrast between the husband's sense of entitlement to power and the position of the wife, whose access to power can only be achieved by 'underhand' means, Margaret's manner becomes coy and childlike, her eyes flitting from side to side while she fingers her hair and clothing like a mischievous infant. Having discovered his wife's intention to manipulate him, Jim's response is to retreat entirely from female influence and take refuge in one of masculinity's traditional preserves: he refuses to go with Margaret to the dance class and instead goes alone to 'the club' for 'an evening with the boys'. However, the reality of the men's club does not live up to Jim's memories and expectations. He finds only a few of his old 'buddies' there; age-related ailments, marriage and death having taken their toll on most of the old friends he expected to find there. The conversation at the club disappoints too, discussion of pension benefits having replaced the night-long debates about 'Caesar's Commentaries' that now exist only in Jim's memory. Returning home early, Jim finds that Margaret's evening has also been a disappointment and that she has returned home too. He quickly acts on this opportunity to make up with Margaret and so restore familial relations to equilibrium, taking his old banjo outside to serenade his wife with a song – *Juanita* – with which he

used to woo her. Having smoothed over their earlier disagreement in this way, Jim persuades Margaret to go out dancing with him. She agrees, but on two conditions; first that they don't go anywhere near the dancing school and second that they stick to the waltz and the quickstep. Her insistence on this second condition provides a clear signal of her resignation to, indeed her embrace of, the status quo of family life since these were the dances that she and Jim have always danced together and which she had indicated, during the dance class, she wished to avoid at all costs. This signal of Margaret's acceptance of the familial status quo is reinforced by the closing scene of the episode. Margaret comes out of the house to go dancing with Jim. However she finds him already weighed down with their children, who were drawn out of the house by his music. Resigned to the fact that her life is now dominated by the demands of the family, Margaret joins the group and, with a laugh and an aura of good humoured resignation, speaks the final line of the episode – 'Margaret Anderson, this is your life' – a line that simultaneously positions her in the roles of mother and care-giver and provides a clear sense of the 'naturalness' of those roles. In the final scene, then, family equilibrium is restored. But while the final scene puts father back at the centre of family life (he is literally surrounded by the other family members), the fact that his appearance is vaguely clownish, as a result of the Mexican hat he is wearing, provides some sense of the culture's ambivalence toward fathers. Father may literally be at the centre of the family, but the figure he cuts is a rather comical one; an amiable buffoon, rather than a stern patriarch.

A similar argument can be made about *Make Room for Daddy* (1953–64), another of the most popular family sitcoms of the 1950s and early 1960s. In *Make Room for Daddy* the family consists of father, Danny Williams (Danny Thomas), an actor and nightclub entertainer, his wife, Margaret (Jean Hagen), their daughter, Terry (Sherry Jackson) and son, Rusty (Rusty Hamer).[18] An episode from early in Season Three provides an excellent example of the way *Make Room for Daddy* subverted the notion of patriarchal authority. 'Little League' (S3 E2) begins with the family at the breakfast table, where Danny, Margaret and Terry sit waiting for

Rusty to join them. Rusty bursts into the room wearing a baseball catcher's mitt and pretends to be catching balls. Danny almost immediately joins in. The sight of man and boy running around pretending to catch invisible baseballs creates a strong impression of Danny as a rather childlike character – the antithesis of serious, patriarchal masculinity. This impression is reinforced repeatedly throughout the episode. Rusty is trialling for a little league baseball team later in the day and, learning that the team has no coach, Danny visualises himself as the ideal candidate, despite having no relevant experience. At a meeting of the team's management, it is clear that no-one on the committee is impressed with either Rusty's or Danny's abilities. It is only the fact that Danny owns a vacant plot of land that could serve as a baseball field for the team that secures, for both father and son, the positions they desire. It quickly becomes apparent that neither Rusty nor Danny is cut out for these roles. Danny returns from the first practice session barely able to walk after the exertions of the game. In a later scene, first Rusty and then Danny return to the family's apartment, dressed in identical baseball gear. The inherently juvenile appearance of their clothing – entirely unexceptional for a young boy but incongruous on a mature man – and the visual similarity between man and child that their identical attire creates, produces a clear sense of infantilisation of Danny, transforming his character into a sort of man-child. Danny may be physically mature but he lacks any sign of the aura of authority and seriousness conventionally attributed to mature masculinity. This pervasive sense of Danny's character as an impotent, infantilised masculine type is reinforced when Danny reveals to his wife that he lacks the courage to tell his son that the boy is being dropped from the team. His request that Margaret should do it for him further reinforces the unmanly aspects of Danny's character. Thus emasculated, Danny can do nothing but stare forlornly at the floor under Margaret's gaze. In the scene that follows, Danny attempts a 'man-to-man' talk with his son after breaking the bad news. It is highly significant that this 'pep-talk' is delivered in the form of a song, a mode of delivery that simultaneously breaks with any sense of diegetic verisimilitude and negates the gravity and seriousness that would usually be expected

in such a situation. This scene exemplifies the way the *Make Room for Daddy* consistently negates any trace of the paternal authority that might expected in Danny's character, replacing this with a pervasive aura of childishness which displaces the father figure from his expected position of power within the family hierarchy. This is particularly foregrounded in the final scene of this episode. Having been removed from his coaching position on the baseball team, Danny petulantly resolves to sell his plot of land, solely in order to deny the team the benefit of its use. While he speaks to a real estate agent on the telephone, each member of the family individually – and finally all three of them together – stand next to Danny, loudly singing the song that he had earlier sung to Rusty. Their singing drowns out his conversation with the agent, finally forcing him to hang up the phone and abandon his plan to dispose of the land. The final scene provides a clear demonstration of the real disposition of authority within the family, Danny's will being subordinated to the demands of wife and children. In *Make Room for Daddy*, as in the case of Jim Anderson in *Father Knows Best*, the father may occupy a central position in the family structure but that centrality should not be conflated with power. The father is shown to be, if not entirely powerless, then at least to a considerable degree at the mercy of forces outside his control, his authority and agency having to be constantly re-negotiated with, and balanced against the demands of wife and children.

The popularity of shows like *Father Knows Best* and *Make Room for Daddy* lasted well into the 1960s. The last new episodes of *Father Knows Best* may have been aired in 1960, but the show remained sufficiently popular that it stayed on air through syndication until 1963, while *Make Room for Daddy* continued, as *The Danny Thomas Show*, until 1964. Around the time that these family sitcoms that gently subverted the notion of paternal authority were coming to their end, the television family turned in a new and decidedly strange direction; one that would consolidate the vision of disempowered television fatherhood established in the 1950s sitcom.

Freaky Families

In September 1964 both ABC and CBS networks introduced new family sitcoms. In both cases the families consisted entirely of monsters or, more accurately, of characters drawn from the Poverty Row horror movie's generic repertoire of supernatural creatures. The shows were *The Addams Family* (1964–66) and *The Munsters* (1964–66). If the suburban sitcoms of the 1950s based much of their humour on a reversal of expected power structures, making the father a figure of fun rather than the executor of patriarchal authority – indeed, making the failure of his efforts to assert authority central to the humour of these shows – then the 'monster comedies' of the 1960s broadened their comic scope and took aim at the family as a whole, making the very idea of normality – of the *average* American family – the target of their humour. Thus these shows took the family sitcom's carnivalesque reversal of norms to an entirely different level. While there are superficial differences between the two monster families, with the Addams's being a shade less cartoonish than the Munsters, both families dramatically mobilise key cultural currents – particularly discourses concerning conformism, consumerism and suburbanisation – which preoccupied Americans during the late 1950s, and which began to encounter their antithesis in the countercultural movements that started to take shape in the early years of the 1960s. At the heart of the issues raised by these trends was a key question: what exactly is 'normalcy'?

Social conformity became key feature of American culture in the 1950s. Three key phenomena were at the heart of discourses of conformism: suburbanisation, consumerism and the ideological resurrection of separate gendered spheres of influence, which had been much less rigid for several decades before as a result, first, of the great depression and, secondly of the Second World War. However, even while the 1950s was still in full swing, the potential of this conformity to produce a bland homogenisation within those sectors of society sufficiently affluent to participate in these trends became the subject of several notable works of literature, such as William Whyte's *The Organisation Man* (1956), Sloan Wilson's *The*

Man in the Gray Flannel Suit (1955), and even David Riesman's *The Lonely Crowd* (1950). While Whyte's book is more observational than overtly critical of the developments of the 1950s, the book has a pervasive aura of loss; a sense that, in the rush to 'belong' within organisational and corporate structures, the individualism and entrepreneurial spirit that had always been understood as central to the American character had vanished. This 'conformity' thesis is highly instructive when it comes to understanding television shows such as *The Munsters* and *The Addams Family*. Indeed it is difficult to imagine a clearer assertion of maverick individualism than the families depicted in these two shows. Taking the Addams' first, and leaving aside the inherent strangeness of the individual characters for the time being, the composition of the family unit itself represents a clear departure from the nuclear norm of mom, pop and 2.5 blue-eyed kids. In addition to the core family – consisting of father, Gomez (John Astin), mother, Morticia (Carolyn Jones) and kids, Pugsley (Ken Weatherwax) and Wednesday (Lisa Loring) – the Addams household is also home to an extended family comprising Grandmama Addams (Marie Blake), Uncle Fester (Jackie Coogan) and several ancillary characters, a giant butler, Lurch, and a disembodied hand, Thing (both played by Ted Cassidy) – the latter a sort of family pet. Similarly The Munsters' house is home to an extended family group, albeit a smaller one than the Addams': father Herman (Fred Gwynne), mother Lily (Yvonne de Carlo), son Eddie (Butch Patrick), a grandfather (Al Lewis) and a cousin, Marilyn (Pat Priest/Beverley Owen). Filling the role of family pet is a talking raven (voiced by Mel Blanc/Bob Hastings). It is immediately apparent that – in terms of the family structure alone – both of these 'monster families' are starkly different from the nuclear suburban family norm idealised in 1950s television shows. Furthermore, the members of these families are both superficially – in appearance – and in deeper aspects of their characters, worlds apart from the members of 1950s sitcom families. Indeed the disjunction between the Addams' and the Munsters' perceptions of themselves and the way that 'normal' characters (and the audience) see them is the comedic core of both shows. That Marilyn, a conventionally attractive young blonde woman, is regarded by the other Munsters

as ugly, freakish and unlikely ever to find a boyfriend, is a recurring gag in the show.

That these 'monster families' see themselves as normal and the rest of the world as strange is illustrated in a particularly direct way in one episode of 'Family Portrait' (S1 E13). Due to some unimaginably defective demographic analysis, a national magazine has identified the Munsters as the 'typical' American family and wishes to publish an article about them. Their selection as 'typical' is a matter of some pride for both Lily and Herman. Grandpa is less enthusiastic about being thought 'average', but Herman counters Grandpa's individualistic antipathy, insisting that it is 'an honour ... to be selected the average American family'. The episode proceeds in a fairly predictable fashion, foregrounding the humour that results from the mismatch between the Munsters' sense of their own normality, and the rest of society's sense of their freakishness. A similar strategy of inverting normative hierarchies is also typical of *The Addams Family*. In one episode ('The Addams Family Tree': S1 E5), for example, Gomez makes reference to a neighbour's house as 'a bit peculiar', with its white picket fence and pink geraniums: features that most others would regard as typical symbols of suburban American conformity.

Within the strange inner worlds of the Addams and Munster households it is, perhaps, more difficult to recognise the kind of transformation of the father into a bumbling, buffoonish figure of humour that I argue is a key feature of the 1950s family sitcoms. In both of these later shows it is the family in its entirety, with its inability to recognise its own incongruity within normative society, which is set up as the fool. That said, however, it is noteworthy that within both families it tends to be the mothers that lead family decision-making, the fathers being either too infantile (Herman Munster) or too consumed with libidinous desire (Gomez Addams) to exercise authority or make serious decisions. To this extent, then, these two shows are consistent with the pattern, established in the 1950s shows, of subtly shifting power away from the father figure. In an interesting article on these two shows, Laura Morowitz argues that, in the absence of fathers who spent the large part of each day at work, 'the ubiquitous presence of women rendered

the suburb as a new kind of "matriarchy"' with mothers having considerable authority: within the home, at least.[19] At the same time, Morowitz suggests, 'the suburbs introduced a new power structure, filiarchy, where children called the shots'.[20] While there is certainly some evidence to support these arguments in relation to the 1950s sitcoms, the turn taken by the 1960s incarnations of the television family suggests, instead, a fragmentation and dispersal of power between family members, each site of power often cancelling out the others. The overall effect of this is to leave the family unit as a whole rather anarchic and directionless; the family endures within the wider social order more through pure good luck than by virtue of any family member's possession of untrammelled authority.

This construction of the family as a kind of rudderless ship – reliant on good fortune alone to navigate its way through the complexities of a modern milieu in which it seems distinctly out of place – is also a key feature of another of the 1960s' notable television families, the Clampetts of *The Beverly Hillbillies* (1962–71). *The Beverly Hillbillies* enjoyed more sustained popularity than either *The Addams Family* or *The Munsters*: lasting for nine years, into the early years of the 1970s. While superficially bearing little resemblance to the Addams or the Munster clans, there are numerous deep structural similarities between all three shows. The Clampetts may lack the supernatural, monstrous characteristics of the Addams' and the Munsters, but these rough-hewn, simple mountain folk are every bit as much outsiders within the decorous surroundings of Beverly Hills as are the 'monster families' among the picket-fenced 'normality' of the suburbia that surrounds them. Like the 'monster families', the Clampetts also lack a normative nuclear family structure. Consisting of a core set of characters comprising father and daughter, Jed and Ellie May Clampett (Buddy Ebsen and Donna Douglas), Jed's mother-in-law, Daisy May 'Granny' Moses (Irene Ryan), a cousin 'once removed', Jethro Bodine (Max Baer Jr), and occasionally Jethro's mother, 'cousin Pearl' Bodine (Bea Benaderet), the family unit in *The Beverly Hillbillies* is one that is at once incomplete – since there is no mother to perfect the parental core of a nuclear family – and far

extended, due to the presence of mother-in-law and cousins. Two additional factors contribute to the Clampett's aura of Otherness, and thus their similarity to the Addams' and Munsters: first the sense of 'out-of-placeness' resulting from the displacement of the characters from their rural Ozark home, and their simple rustic way of life, to the refined setting of Beverly Hills, and second the fact that in all three families the father figure is physically present within the family home to an extent that marks a clear difference from the 'breadwinner' stereotype of the 1950s' (absent) fathers.[21]

The Beverly Hillbillies is also similar to the two 'monster family' shows in the way it organises the disposition of power within the family unit. Jed, nominal head of the Clampett clan is portrayed as a insouciant individual, little troubled by the material concerns of the world and having no apparent interest in exercising any authority within the family. Indeed, in a typical episode, 'The Family Tree' (S1 E25), when encouraged by Pearl and Jethro to make a conspicuous display of his privileged status by purchasing a limousine that would make him look 'like a duke or a' earl or somethin'', Jed displays characteristic humility toward the possession of the position and prestige that his millions of dollars would undoubtedly buy. The issue of status resurfaces later in the same episode when a genealogist engaged by a local do-gooder discovers that the Clampett family heritage can be traced back to the arrival of *The Mayflower* – thus endowing the Clampetts with the aura of a kind of American 'aristocracy'. This storyline continues into the following episode, 'Jed Cuts the Family Tree' (S1 E26), in which the genealogist's research puts the family on the threshold of access to real social status and power, including the possibility of a meeting with the President. Faced with this prospect of access to power and prestige, however, Jed lies to the genealogist about his grandfather's name, thus severing the lineage the genealogist has discovered and returning the family to their relative anonymity. Jed later explains to Granny that he has done this because he prefers a simple life. Jed's act represents a clear renunciation – by the titular head of the Clampetts – of the superior status, and concomitant authority, that is frequently taken to be coextensive with the position of the father in patriarchy.

This display of humility and lack of ambition for power on Jed's part in this episode is by no means unusual in this show. The real axis of power within the Clampett household runs between Granny, on the one hand, and Pearl on the other. Between them, these two characters represent competing versions of American womanhood, with the former symbolising a traditional type of femininity, whose access to a limited form of power was predicated on acceptance of women's domesticity, and the latter a more contemporary stereotype, configured in terms of modernity and consumerism.

If there is no overall balance of power within the Munster, Addams and Clampett households – patriarchal power having been negated by making the father a maladroit figure of comedy – another show included by Sylvia Moss in what she calls 1960s 'ingroup-outgroup' television shows appears to tip the balance of power more clearly in favour of women.[22]

In *Bewitched* (1964–72) not only is the husband/father portrayed as a bumbling fool, but the female side of the family – wife/mother, mother-in-law, daughter – are witches, and therefore enjoy literal access to power (or at least to powers). In 'I, Darrin, Take This Witch, Samantha' (S1 E1) great emphasis is initially placed on the apparent ordinariness of the protagonists. The episode begins with a short sequence before the titles, showing a series of chance encounters between Darrin (Dick York) and Samantha (Elizabeth Montgomery). The emphasis on their ordinariness is evident in the accompanying voiceover, which describes them as a 'typical American girl' and a 'typical red-blooded American guy'. This emphasis continues into the episode itself. When Samantha finally confesses to Darrin that she is not a 'typical American girl', the couple reaches agreement that, if their marriage is to succeed, Samantha will have to forgo her magical powers and 'learn to be a suburban housewife'. This agreement sets up the central conflict that the show would continually renegotiate throughout its entire eight-year run; a competition for authority within the family household, between patriarchy's feeble claim to continuing power (represented by Darrin) and an increasingly autonomous and assertive femininity: Samantha and particularly her mother,

Endora (Agnes Moorehead), who is not party to the agreement and continually uses her powers to undermine Darrin.

It is worth pausing for a moment at this point to consider the connections between the family as represented on the television screens of America in the 1960s and the lived realities of family life, and in particular relations between the sexes during the period. In an insightful analysis of the constructions of 1960s family life discussed above, Daniel Hamamoto uses Tzvetan Todorov's formulation of the fantastic in order to position these shows within their historical context.[23] According to Todorov, the fantastic represents a license to transgress the boundaries and limitations of the physical world: 'in social life or in narrative, the intervention of the supernatural element always constitutes a break in the system of pre-established rules'.[24] According to Hamamoto, this principle enabled the 'fantastic' family sitcoms of the 1960s to resolve or negotiate real 'social contradictions that could not directly be addressed because of their extreme sensitivity'.[25] In this respect, as Hamamoto explains it, the television family sitcoms of the 1960s function in much the same way that Claude Lévi-Strauss suggested that myths operate: symbolically resolving real, irreconcilable social contradictions by displacing them from lived experience to the realm of narrative, where it becomes possible to symbolically resolve problems that are, in reality, insoluble. In essence, the social contradiction which these shows address is a simple one: the increasingly insistent demands of women for greater autonomy from men and for equality (in status, wages, opportunities, power, etc.) with men, pitched against an unwillingness by patriarchy to relinquish its power in response to these demands. Thus conceived, these television shows – particularly *Bewitched* – become in effect a depiction of what is often termed the 'battle of the sexes'; an enactment of competing claims to power by women and men.

While Hamamoto's argument is certainly compelling in relation to *Bewitched*, where that battle is played out in each episode through the antagonistic one-up-man-ship of Darrin and Endora, it is less convincing in relation to the other 'ingroup–outgroup' shows of the time which are not as obviously structured by this competition for authority between a symbolic representative of patriarchy, on the

one hand, and a representative of feminism, on the other. Indeed it is possible to construct a more compelling argument about the entire group of 1960s shows, and their 1950s predecessors by looking at them the other way round; not from the point of view of women's claims on power (which are less strongly figured in the other shows, than in *Bewitched*), but from the point of view of framing the very idea of patriarchal authority as a joke. In this way all of these shows symbolically answer the demands of feminism (which were not particularly new in the 1960s so much as resurrected in that decade from their earlier origins)[26] by emphatically denying that men ever actually had that much real power in the first place.

'We Lost a Daughter, But We Gained a Meathead'

Despite the superficial aesthetic differences between shows such as *Father Knows Best* and *The Munsters*, and the difference in the extent to which they problematised the idea of patriarchy, in reality there were no fundamental ideological differences between the shows: they all gently and affectionately poked fun at the family in general, and at the father figure in particular. At the start of the 1970s, however, that characteristic of the family sitcom was about to undergo a radical change. The shows discussed so far were generally very successful in their time. *Father Knows Best* and *Make Room for Daddy* ran for six and eleven seasons respectively, while *Bewitched* remained on screen for eight and *The Beverly Hillbillies* for nine seasons, stretching from the Kennedy era to the early years of the 1970s. In each case the measure of success were the Nielsen ratings achieved by these shows. But, as those two emblematic shows of the 1960s were entering their closing phases, a new show centred on family life was about to come along; a show that gained a purchase on the culture that could not be expressed through ratings alone (although it was certainly successful in that respect too), a show with an anti-heroic father figure who would become a pop culture icon, whose catchphrases would enter the popular lexicon, and whose fans would demonstrate their devotion by, for example,

organising facetious campaigns for his election to the presidency in 1972 and 1976:[27] *All in the Family* (1971–79).

Although no-one could have known it at the time, the effects of the fragmentation of familial power structures – and in particular, the numerous small 'outrages' that all contributed to the symbolic dismantling of patriarchal authority observable in the television shows from the 1950s and 1960s discussed thus far – would coalesce in the early 1970s to produce a male character who was the embodiment of every petty insult that had been visited upon the idea of the father as a figure of untrammelled authority over the preceding two decades. This character, Archie Bunker (Carroll O'Connor), was a disgruntled blue-collar everyman; a stereotype that was destined to become a staple of the family sitcom ever since. Bunker's descendants can be found in most of the significant examples of the American family sitcom produced since the 1970s. As Arthur Asa Berger – writing in the mid-1970s – succinctly puts it, 'every situation comedy extant owes fealty to Archie and Edith Bunker and to Mike and Gloria',[28] and this remains as true today as it was then. Al Bundy (Ed O'Neill; *Married with Children*), Dan Connor (John Goodman; *Roseanne*), Peter Griffin (Seth MacFarlane; *Family Guy*), Stan Smith (Seth MacFarlane; *American Dad*), Jay Pritchett (Ed O'Neill; *Modern Family*) and the most emblematic and enduring of all these small screen fathers, Homer J. Simpson (Dan Castellaneta; *The Simpsons*) all owe a considerable debt to Archie Bunker. Even small screen fathers in the ostensibly non-fictional world of reality television sometimes bear an uncanny resemblance to Bunker; Ozzy in *The Osbournes*, for example. *All in the Family* must, therefore, be seen as marking a radical turning point in the representation of the family on television; the moment at which the hitherto gentle, good-humoured criticism of the family – and of fathers in particular – to be found in 1950s and 1960s iterations of the sitcom gained a keener edge and abandoned restraint; using its critical voice to present the family as a fundamentally dysfunctional unit. The swing has been a decisive one: from the 1950s family that is basically sound, albeit with a buffoonish father, to one in which the father is routinely represented as a seething, disempowered and angry individual – frequently positively bursting with rage –

within a family that seems to be held together by habit and a lack of viable alternatives rather than any real familial affection or shared values.

Although Edward Berkowitz argues that there is a particular continuity between Archie Bunker and Jed Clampett,[29] I would argue that Bunker's character actually has a more general continuity with what is, in effect, an archetype of the sitcom dad. This continuity transcends any merely superficial similarities that might link Bunker with Jed Clampett. Granted, as Berkowitz suggests, both characters do articulate a set of values that are out of step with their time and/or place: but there is a difference between Bunker and Clampett. Clampett may, as Berkowitz argues, belong to a fictional America constructed by the movies of the 1930s, where 'comic hillbillies and society matrons'[30] can rub shoulders, but Bunker's character is rooted in an altogether more realist representation of contemporary society, where he is forced to confront realities of contemporary life – racial integration, hippies and social protest among other issues – while possessed of a mindset that is shaped by an idealised, mythic version of the past in which such issues never arose. Thus, while it may be true that both characters are out of step with the times in which they live, this analysis does not go far enough. This productive way of thinking about the construction of sitcom dads applies not only to these two characters, but to all of the small-screen fathers discussed thus far. As Norman Lear, creator of *All in the Family*, remarked in an interview, 'We followed a whole bunch of shows like *Father Knows Best, Leave It to Beaver, Green Acres,* and other shows of the '60s'.[31] All of the father characters in these shows do indeed share a sense of displacement but it is not, strictly speaking, as Berkowitz suggests, a simple displacement in time. In reality, while inequalities between men and women certainly existed, there was not – within living memory – a 'golden' patriarchal age in which men's authority had been completely untroubled by the claims of others, and in which these male characters could have found harmony. Belief in such a 'golden age' is the product of a mythological imaginary which always perceives the past as a 'better' time than the present, and it is this mythical construct of a 'golden age' from which these characters are displaced. So it is not

so much that Jed Clampett and Archie Bunker share some special connection. The same connection is shared by all the small-screen fathers discussed thus far in this chapter: all those television fathers whose patriarchal authority is challenged by other family members or whose authority is undermined by their portrayal as a hapless buffoon or clown.

To suggest that there is an unbroken line of continuity between the 1950s iterations of the family sitcom and those of the early 1970s is not, however, to say that each of these representations of the family is essentially the same. Indeed Josh Ozersky alludes to the fact that later constructions of the family may even represent an inversion of certain aspects of earlier ones by his characterisation of later seasons of *All in the Family* as a kind of 'Father Knows Least'.[32] But, while accepting that certain inversions may have taken place over the decades that separate these sitcoms, it is important to keep in mind that, even in *Father Knows Best* itself, the father was regularly cast as the fool, and this characteristic of the genre – this refusal to take paternal authority very seriously – certainly remained intact by the early 1970s, and thrived in the character of Archie Bunker.

In one significant respect, however, Bunker is radically different from the small-screen fathers that preceded him. While Jim Anderson, Danny Williams and even the 'monstrous' Herman Munster and Gomez Addams were all rather likeable characters – at worst amiable buffoons – Archie Bunker was specifically created to be a thoroughly unlikeable misanthrope; an ignorant bigot *at* whom – rather than *with* whom – the audience laughed. Through this device, the show presents, for the first time in a family sitcom, a satirical critique of the kind of society and social structures that could produce such a thoroughly obnoxious being.

Far from simply alienating viewers, however, the audience's response to Bunker was rather more complicated. Despite Bunker's permanent scowl and litany of racist outbursts, many Americans seemed to intuitively understand the underlying forces that shaped Bunker's character.[33] Rather than seeing simply an objectionable bigot, the audience saw, under his skin, a downtrodden working man, stripped of all pride and hope, and found Bunker ultimately to be a

sympathetic figure. In this respect, then, it is possible to understand Archie Bunker as a backlash against the perceived injustices heaped upon patriarchy (or at least its televisual representation) over the preceding 20 years or so, in all of the earlier sitcoms to which *All in the Family* is connected. In one episode, Archie's wife, Edith (Jean Stapleton), explaining Archie's feelings toward his son in law, Mike Stivic (Rob Reiner), very clearly frames Bunker's hostility toward the world in general in terms of the forced abandonment of the ambitions that Bunker possessed as a younger man:

> He'll never be more than what he is now, even though he had dreams once, like you. He had to drop out of school to help support his family. He never will go to college. You have your whole future ahead of you, but most of Archie's life is behind him. So you see, he's jealous of you, Mike.

Embedded in this succinct summation of the reasons for Bunker's ire is a subtext that recounts a more general story of the demise of the white working-class man in American society. The story it tells is essentially the same as that to be found recounted repeatedly throughout Susan Faludi's *Stiffed: The Betrayal of the American Man*. It is the story of a masculinity that had been promised dominion over the world but which found the realities of life in the modern world to be very different. And it is this particular construct of masculinity – exemplified by Bunker's character; the downtrodden white working man – that established the tone for many of television's representations of the father since:

> the one whose every move results in his humiliation … who simply cannot meet the standard, which is now set by his previous victims, the sarcastic mass of women, children, employees.[34]

As this observation suggests, much of the pleasure the audience obtains from Bunker's character derives from watching him being hoist with his own petard. A perfect example of this occurs in the pilot episode, 'Meet The Bunkers' (S1 E1). The family is sitting

down to a meal to celebrate Archie and Edith's 22nd wedding anniversary when Lionel Jefferson (Mike Evans), a young African-American neighbour, calls in with a gift for Edith. Archie calls on Lionel to settle an argument he is having with Mike, over whether Archie is prejudiced against black people. During their conversation Lionel plays up to Archie's bigotry, performing, with a beaming smile, a polished repertoire of the stereotypical eye-rolling 'coon' mannerisms that, as far as Archie is concerned, signal black contentment. However, when Archie casually uses the Yiddish word, 'tuchus', Lionel seizes the opportunity to have a little fun at Archie's expense. Notwithstanding Archie's protestations that he has merely picked up some Yiddish words from 'a couple of heebs' at work, Lionel, with mocking politeness, enquires, 'you wouldn't happen to *be* one of them, would you?' As the scene progresses Lionel and Mike become increasingly insistent that Archie must be Jewish, drawing supporting evidence from the biblical origin of the names of his parents and his tendency to gesticulate with his hands when he talks. Archie becomes increasingly angry at their suggestion, until his temper finally explodes when even Edith begins to ask whether he is Jewish. The scene's punchline comes when Lionel shakes Archie by the hand, with the words 'even if you are, it doesn't change things between you and me. I mean, I'm not goin' to throw away nine years of friendship over a little thing like that', before Lionel turns and leaves the room, having clearly gained the upper hand over Archie. This scene performs a very effective reversal of hierarchies, taking the white racist's discourse of racial Otherness (and the accompanying implication of that Other's inferiority) and turning it back on him in order to expose his own disempowerment within a family structure characterised by fragmentation and dispersal of power between family members, which by that time was typical of the sitcom family. Archie, a white working-class man, possesses none of the privileged access to authority that is commonly assumed to be an attribute of the white male in patriarchy. He is portrayed as simply one more 'Other' caught in a complex set of social relations in which no individual holds the overall balance of power. The disjunction

between the reality of these power relations and Archie's self-deluding perception of himself as the mythic white patriarch of legend is both the source of *All in the Family*'s humour and of the audience's sympathy for Archie's predicament.

If focusing television's lens on the disempowered, emasculated father figure more directly than had been the case in the past was one of the key differences between *All in the Family* and its antecedents – and also a key element connecting the show to some of the most popular examples of the family sitcom that have come since – there was another aspect of the show that represented a similar disjunction with the past of the genre: the characterisation of familial relations as essentially conflictual. In the 1950s and 1960s, real conflict in the sitcom was rare: if they occurred at all, arguments between family members were trivial and were resolved by the episode's end. However, it was not so in the Bunker household where conflict constituted the primary mode of engagement between family members and the conclusion of each episode resolved absolutely nothing. This was a sign that television had begun to see the family in a different way than in the past, and *All in the Family* was certainly not the only example of this tendency in television shows of the time. Concurrent with the popularity of *All in the Family*'s fictional representation of the American family as a fundamentally dysfunctional entity, Americans could also tune in to watch both the real version of the disintegrating family – in the PBS reality show, *An American Family* (1973) – and its milder cartoon manifestation in Hannah-Barbera's *Wait Till Your Father Gets Home* (1972–74). Shows like these signal a fundamental shift in the way families were perceived in America, as the power of the image of harmonious family life provided by the 1950s sitcom began to wane.

In two crucial respects, then, *All in the Family* established a pattern that would shape representations of the family on television for decades to follow. The father may always have been a figure of fun to some degree, but from the 1970s onward he would, with few exceptions, become much more clearly the 'victim' of the sitcom's humour – which also became more pointedly satirical than it had been in the 1950s and 1960s – and the image of cosy suburban

familial harmony would be replaced by dysfunction and discord as the defining characteristics of television family relations.

All in the Family lasted nine seasons and almost saw out the 1970s. Politically, with the election of Ronald Reagan to the Presidency in November 1980, America in the early 1980s was witness to the ascendance of a radically neoliberal version of free-market conservatism. A new cultural mood accompanied this political shift. The prevailing emphasis on wealth, power, 'traditional' family values among other things was, unsurprisingly, captured by some of the most popular television shows of the time. *Dallas* (1978–91), the longest running, and perhaps the most emblematic American television show of the 1980s, caught the nascent mood of aggressive neoliberalism early. Its virtual doppelgänger, *Dynasty* (1981–89), was not far behind, its first season beginning just days before the new President delivered his inaugural address. Both shows centred on a version of family life, although the families depicted in them were about as far away from both the mundane middle-class family of *Father Knows Best* and the blue-collar Bunkers as it was possible to be.

While the earlier representations of the family on television concentrated on showing the viewer glimpses of easily-recognisable, ordinary, everyday family life, both *Dallas* and *Dynasty* presented viewers with a highly escapist glimpse into the lives of the extraordinarily wealthy. Interestingly, the families in both shows were headed by exactly the kind of silver-haired patriarch – the father figure who is not a clown, but a 'real man' who does expect to wield ultimate authority over the family – so strikingly absent from the television families found in the earlier sitcoms. Jock Ewing (*Dallas*) and Blake Carrington (*Dynasty*) – their names alone positively ooze a 'manly' aura of power – were certainly nobody's fools; there would be no clowning or buffoonery for them. Despite this renewed assertiveness of the patriarch as a figure of authority, what is striking about both shows is that the families they depict are, nevertheless, typified by precisely the same kind of fragmentation and dispersal of power among family members to be found in the earlier sitcoms discussed above. Members of the Ewing and Carrington clans live in constant conflict with one another, as they

struggle to assert their own claims to power, within families that are modelled more on the Borgias than on any mythical ideal of family life that ever had purchase in the USA. Thus, although superficially worlds apart from representations of the family to be found in the television sitcom, both *Dallas* and *Dynasty* at least share with the earlier shows the convention of depicting the fragmentation of power within the family and its dispersal among family members, rather than making it the exclusive preserve of the patriarch, even in television families with such ostensibly strong patriarchal figures.

The patriarchal fathers of *Dallas* and *Dynasty* failed to obtain a monopoly on power in their families and, in this respect, these shows were little different from some of the most notable contemporary examples of the sitcom. In *Family Ties* (1982–89), for example, the normative pattern of conservative parents and rebellious, politically progressive children – found in 1970s shows like *All in the Family* and *Wait Till Your Father Gets Home* – is entirely inverted. This also has the effect of inverting power relations between parents and children. Indeed the conservative attitudes and the embrace of neoliberal values by the children in this family are so finely attuned to the dominant political ethos of the time that it is the children who appear to possess a more 'natural' claim to authority than their parents, whose 'hippie' values appear to be closer to those of 'rebellious' youth.

In what is probably the best remembered sitcom of the 1980s, the situation is more complicated. *The Cosby Show* (1984–92) was groundbreaking for its presentation of a picture of black middle class life. Race complicates the familial power dynamics evident in *The Cosby Show*, constraining and shaping what it was possible for the show's creators to do. Race also makes it much more difficult to easily integrate the show into the argument made in this chapter; it is almost impossible to discuss the show without considering at some length its representation of a specifically African-American family, and that is something that it is not possible to undertake within the parameters of this chapter, for two reasons. The first is a practical matter: there is simply not the room to give sufficient consideration to this important matter and to contextualise the discussion within debates that have developed in the substantial body of literature

that touches on this show. Second, although race is certainly far from irrelevant it is, nevertheless, possible to understand the family dynamics depicted in *The Cosby Show* entirely within the context of the historical account of the television family sitcom set out in this chapter, without reflecting on the implications of race. Accordingly, for reasons that are entirely logistical, and acknowledging the limitations this move imposes on the analysis, that is the approach that I adopt in this chapter. Within those limitations, the argument I would make about *The Cosby Show* is that it represents a fairly faithful return to the form and style of the 1950s family sitcom, complete with the traditional, amiably clownish father figure, for whom any attempt to assert authority is destined to result in a demonstration of his complete lack of it. This situation is exacerbated in *The Cosby Show* by the fact that the wife has become a powerful, independent career woman and, unlike the 1950s sitcom wife, is no longer a homemaker who is economically dependent on her husband.

If 1980s shows like *Family Ties* and *The Cosby Show* represent departures from the template for representations of the family on television established by *All in the Family* then – taking into account the longer historical trend in television's depictions of family life – both shows merely represent a temporary diversion from the ongoing trajectory that has been the dominant mode of representation for television families since the early 1970s. That template – typified by fragmentation and dispersal of power among family members to the point of the complete negation of the father's authority – resumed its importance toward the end of the 1980s in two shows, *Roseanne* (1988–97) and *Married... With Children* (1987–97).

Both of these shows took as their focus blue-collar working families, in the mould of their televisual archetype, the Bunkers. Of the two, the Connor family in *Roseanne*, demonstrated the more complete inversion of traditional patriarchal values, positioning its star, Roseanne Barr (later Arnold) as the centrepiece of the show. It was, in effect, the Roseanne Barr show;[35] a televisual reworking of her earlier 'domestic goddess' stand up comedy routine, in which she performed an unglamorous portrayal of a 'typical' American

housewife. Within the family created in the show, Roseanne clearly possesses the upper hand over husband, Dan (John Goodman). While Dan may not be quite the clownish father figure of earlier shows, he is clearly very familiar with the locus of power within the Connor household, and readily accedes to the authority of his wife, often retreating from the domestic setting to the male preserve of the garage in order to reconnect with a sense of traditional masculinity and his own autonomy.

Roseanne was extremely popular with American audiences; for a time it was the most watched television show in America, and it was in the top five most popular American television shows for six of its nine seasons. One reason for the show's success was the realism of its depiction of family life; its willingness to confront issues often considered taboo, but recognised by audiences as ordinary problems that families really faced. Americans watched *Roseanne* and saw not the idealised visions of family life of earlier sitcoms, or the glamorised lives of the unimaginably rich, offered by *Dallas* and *Dynasty*, but a vision of family life that they could recognise as similar to their own. A 'warts and all' version of the domestic scene that, despite the problems it portrayed, nevertheless ultimately maintained the importance of the family and family values.

If *Roseanne* gave audiences an image of the family that reassured them that the urban heartlands of modern America comprised hard-working blue-collar folk with hearts of gold, *Married... With Children* confronted them with the polar opposite of this image: the Bundy family of Chicago, a n'er-do-well blue-collar family with hearts of pure wormwood. The construction of the characters in *Married... With Children* seemingly strives to eradicate any vestige of virtue in the television family, with mother, Peggy (Katey Sagal), portrayed as a materialistic and sexually obsessed trophy wife who is unequal to the task of keeping house (her only obvious occupation), while her astonishingly dimwitted and brazenly promiscuous daughter, Kelly (Christina Applegate), displays every promise of one day following in her mother's footsteps. The son, Bud (David Faustino), displays considerably more intelligence than the others but makes no productive use of his advantage, while father, Al (Ed O'Neill) is a stereotypical 'loser' with no greater

desire than to spend as much time as possible watching television and drinking beer; an unambitious shoe store clerk whose earnings are barely adequate to keep his wife and daughter supplied with hair dye and leopard-print 'boob tubes'.

Roseanne and *The Cosby Show* rode high in the Nielsen ratings through the late 1980s on the ABC and NBC networks respectively. Airing on the then new Fox network, established in 1986, *Married... With Children* could hardly hope to compete for ratings with these titans and, indeed, never achieved higher than 50th place in Nielsen's chart. However, *Married... With Children* was significant as much for its legacy as for anything it achieved directly on screen or through its impact in the television ratings. Truer than *Roseanne* to the satirical spirit of *All in the Family*, *Married... With Children* re-established the sceptical, and often almost nihilistic tone that would thereafter dominate television's representations of the family. The lineage of this representational tradition is acknowledged in certain visual motifs employed in later shows; the Simpson family's couch recalls that which dominates the living room in *Married... With Children*; *Family Guy*'s opening title sequence, featuring Peter and Lois Griffin sitting together at piano in their living room singing the title song, directly references the opening title sequence of *All in the Family*.

Married... With Children may have reintroduced the spirit of the Bunkers to the television audience, but the show would ultimately be eclipsed by another Fox programme which started life as a short segment on the *Tracey Ullman Show* in 1987 before graduating to its own half hour show in late 1989, ultimately becoming the longest running and most popular of all American television's family sitcoms: *The Simpsons* (1987–). In its early seasons, the outlook for the family in *The Simpsons* was every bit as bleak as it was in *Married... With Children*. True, homemaker Marge Simpson (voiced by Julie Kavner) possessed considerably more ability and enthusiasm for the domestic chores that (inevitably) fell to her than Peggy Bundy ever mustered, but Marge's character was rather more peripheral in the early days than she would become in later seasons. At the start, the focus was much more clearly on Bart (voiced by Nancy Cartwright); and Bart was portrayed as an

uncontrollable delinquent, the end product of hopelessly deficient parenting. At the root of Bart's problems – unsurprisingly, given the preponderance of paternal deficiencies in television's families – is his father, Homer (voiced by Dan Castellaneta), who becomes increasingly the central focus of *The Simpsons* in later seasons. Chris Turner notes the connection between the construction of Homer Simpson's character and a long line of sitcom fathers, especially Al Bundy – but also traceable back to the 1950s. Turner identifies Bundy as Homer's 'live-action doppelgänger'[36] but also acknowledges the importance of Archie Bunker's legacy in the creation of Homer's character. Bunker is directly referenced in one episode of *The Simpsons* in which – as in the opening title sequence of *Family Guy* – the title sequence of *All in the Family* is reproduced, with Homer and Marge taking the places of Archie and Maude at the piano, singing a re-worded version of 'Those Were The Days', the *All in the Family* theme song.[37]

By means of a sophisticated deployment of an enormous range of pop cultural reference points, *The Simpsons* transcends the abilities of its precursors to connect intertextually with key elements of the surrounding culture. Undoubtedly, television sitcoms as far back as the 1950s registered common anxieties about declining masculine authority and the reconfiguration of gender relations through the figure of the bumbling, clownish father. Homer Simpson, however, is far more than simply the latest incarnation of this trend. He is, Turner suggests, 'not just the latest and greatest version of conventional figure in American drama – the dumb dad – but a powerful symbol of consumer age America itself', the product of a historical epoch in which the American people have learned to take for granted their 'entitlement' to the satisfaction of their every impulse without concern for any consequences.[38] Homer J. Simpson is not, then, merely idiotic, slobbish, ignorant and utterly insensitive to the needs of others (though he is all of these things and worse), but in his idiocy, slobbishness, ignorance and insensitivity he is portrayed as an innocent; unselfconscious and devoid of agency and thus an almost blameless creature. He is entirely the creation of a debased culture that has evolved with its focus on consumerist imperatives, with little or no pause for self reflection, let alone self

doubt. These distinctive characteristics of Homer Simpson have been further refined in several subsequent sitcom fathers: Peter Griffin in *Family Guy*, Stan Smith in *American Dad* (both voiced by Seth MacFarlane) and most recently Phil Dunphy (Ty Burrell) in *Modern Family*.

With Homer J. Simpson offered up to the world as the American everyman, and his chronically dysfunctional family as the archetype of family life in contemporary America, it is little wonder that President George H. W. Bush took such an exception to the show, famously calling for a return to the more wholesome family and community values embodied by *The Waltons*. The spirit of Bush's call has been echoed more recently by conservative 'family values' activist groups in relation to the newer, and often grosser, manifestations of fathers and families in *American Dad* and *Family Guy* (see, for example, the epigraph to this chapter).

While it may be tempting to see the way the father and the family are depicted in these recent shows as something new, as this chapter demonstrates, it is not the case that they are different in their fundamental character as much as they are merely in extent. Homer Simpson may be the immediate progenitor of Peter Griffin and Stan Smith, but Homer's own antecedents can be traced back in time too; back to Al Bundy and Archie Bunker, certainly. But it goes back further than that, I would argue; the disintegration of paternal authority that is all too manifest in these characters having been a defining feature of the television sitcom's father figures from the genre's very earliest iterations. Homer, Peter and Stan may be clowns whose humour is of a coarser grain – and thus more obviously carnivalesque – than that found in *Father Knows Best* or *Make Room for Daddy*, but they are, nevertheless, still clowns and this essential quality of paternal clownishness connects the most recent instances of the television family – the Simpsons, Griffins and Smiths – with the earliest – the Andersons and Williams' – on a continuum that delineates the consistent pattern running through television's representations of the family through the postwar decades. At the end of the episode of *Father Knows Best* discussed earlier, all conflict within the family is resolved and an unstable equilibrium is restored, with father resuming his normative place

at the centre of family life. So too in a typical episode of *The Simpsons:* in which – regardless of the extremes to which Homer's transgressions go – by the episode's end he is reunited with his family, who accept and forgive his many character flaws, and resign themselves to the discrepancies between the realities of family life, as experienced by the characters in the show, and the mythical ideals that permeate the culture.

There are some clear contrasts between the way the family has been represented in the sitcom – the predominant mode of representation of the family – and in other shows such as *The Waltons* (and its derivative, *Little House on the Prairie* (1974–83)). Where the sitcom has consistently challenged the idea of masculine authority, through its carnivalesque inversion of normative structures of power, *The Waltons* has consistently upheld the law of the father, overwhelmingly portraying the father as a serious, responsible and respectable figure; the mythical breadwinner who, in return for providing for his family, expects and receives respect and status within the family setting. As I have argued in this chapter, this way of depicting the family, and the father in particular, is very much an exceptional case, and provides ample reason for a closer examination of other aspects of the construction of gender in *The Waltons* in the two chapters that follow.

(Not) Following in his Father's Footsteps: Masculinity on Walton's Mountain

If the civil rights movement presented a racial challenge to the hegemony of the white male in American society, a further test of male dominance came in the form of pressure from the newly invigorated women's movement. As I have noted before, these challenges are now often conceived by scholars as precipitating a 'crisis of masculinity'. It is, however, misleading to speak of a 'crisis' as if masculinity is an otherwise stable, essential condition. Since masculinity is not this, but a volatile social construct, it necessarily exists in a state of perpetual instability or 'crisis' and it is only the precise causes and nature of the particular historical challenges to the stability of masculinity that vary from one time to another. At the start of the 1970s, the various pressures from both the civil rights movement and the women's movement meant that white masculinity became very available for discussion. This discussion took the form not only of literal debates about the character of masculinity itself – what it meant to be a man – and the privileged social position enjoyed by men, but also exerted an influence on the forms that representations of masculinity took.

Unsurprisingly, since the show has such a wide array of different male characters, the impact of these debates about masculinity can be detected in the varying construction of male characters in *The Waltons*. As narrator of the prologue and epilogue of each episode, and one of the key male figures in the series, John-Boy's character is central to the series' conception of masculinity, and to the contribution that the construction of masculinities in the show makes to contemporary debates concerning the character of manhood. However, it is not John-Boy alone who articulates the conception of masculinity that the series promulgated: examination of how masculinity is elaborated across a wider range of the male characters is also highly instructive.

This chapter will examine in some detail how masculinity was conceived and articulated in *The Waltons*. The discussion of masculinity in this chapter is shaped by several key themes that define the form taken by representations of masculinity in the show. First, and perhaps the most important element in *The Waltons* construction of masculinity is the matter of a man's work or occupation.

Once, there was a relatively well marked – although certainly not absolute – division between masculine and feminine spheres of action and influence. Men went outside the home to work, and there participated in all aspects of the social life of the public sphere. Women's influence and realm of action, on the other hand, was predominantly located within the domestic, or private, sphere. Accompanying the idea of separated spheres of influence was a gendered conceptual split between rationality/action – seen as male traits – and emotionality/nurturing, which were understood to be feminine attributes. However, long before the civil rights and women's movements rose up to challenge white male hegemony, historical events had already disrupted this neat division of the world into gendered spheres of influence. Following the Wall Street Crash of 1929, unemployment levels in the USA soared. Since paid work – which exclusively took place in the public sphere – was predominantly a male activity, these events disproportionately affected men, in the first instance. In turn the impact on men had a concomitant impact on the position of women. As ever-

larger numbers of male breadwinners joined the unemployment lines, women increasingly moved into jobs that men would not do – low paid (but, at least, paid) work outside the home – as hard-hit families struggled to make ends meet. With America's entry into the Second World War, the movement of women into paid work intensified and the character of the areas of work into which women made inroads changed. This was the result of two related dynamics: first, the dramatic expansion of industrial production in response to the demands of the war effort, and second the need for large numbers of additional workers to directly replace the millions of American men who were conscripted into the armed forces. Not only did the Second World War see an overall increase in the movement of women into the workforce, it also witnessed a rise in the number of women moving into areas of heavy industrial and agricultural employment that had previously been almost exclusively male preserves. The image of 'Rosie the Riveter' became one of the period's ubiquitous emblems of women's foothold within these hitherto predominantly male areas of employment. When the war came to an end, considerable 'official' efforts were made to restore the earlier gender balance of the workplace. Among its other terms, the Servicemen's Readjustment Act of 1944 (also called the G.I. Bill of Rights) provided re-employment rights for returning veterans. The right of men leaving the forces to return to their old jobs was guaranteed, even if this meant removing workers who had been employed during the war to replace servicemen in their absence. This provision undoubtedly disproportionately affected female employees working in traditionally male areas of work. As Susan Faludi notes, 'Rosie the Riveter ... was demobilised and sent home to become an aspiring consumer who would depend on and spend the demobilised soldier's post-war wages'.[1] In the decade following the end of the Second World War, suburbanisation and consumerism provided the supporting infrastructure that facilitated a drive to restore normative, traditional gender relations based on the twinned ideas of the breadwinner male and homemaker female. As the publication of *The Feminine Mystique* in 1963 demonstrated, however, the return to domesticity and a life in which modern technology promised to ease the burden of domestic

labour left women unsatisfied. The mould that had been broken earlier in the century would not so easily be patched-up in the postwar period.

What had happened to the sexual division of labour in America was more profound and complicated than the simple movement of one sex into the traditional domain of the other. Certainly this movement took place but, in the process of this movement of women from one sphere of activity to the other – and often back again – any hitherto clear boundaries between those spheres had become blurred, so that it became less easy to see clear distinctions between male and female roles, rights and obligations in both the public and domestic arenas. Alongside this shift another, more profound, change was taking place in the American economy: a progressive shift from a mainly heavy-industrial economy, that could be readily associated with traditional masculine virtues, to an increasingly service based and more media-centred economy which, if anything, seemed more attuned to attributes more often traditionally conceived as feminine: communication, nurturing and service. This new service- and knowledge-based economy, which still predominates today, is one in which a clear and simple separation of roles and spheres of activity between men and women is almost impossible to achieve, with the result that all work of the types that dominate the service and knowledge economies tends to be conceived as 'feminine' when compared with the less ambiguously 'manly' industrial work that predominated in earlier times.

This shift from an industrial to a service economy plays a central role in most discussions of the 'crisis of masculinity'. Faludi sees this change in the economic basis of American society as the root cause of an increasingly commonplace masculine anomie that she perceives as coextensive with the idea of a 'crisis of masculinity'. Faludi outlines two aspects of the 'crisis' that follow from this radical change in the economic base. First, for the generation of men who returned to civilian life after the Second World War, the decline in the importance of industrial employment denied them the unambiguous sense of manliness that heavy physical labour had provided in the past. Second, for the sons of these men, there

was little prospect of maintaining a sense of continuity between the jobs they would be destined for in the service/knowledge economy and the occupations that had 'made men' of their fathers. Nor was there much prospect of the inheritance of a sense of self respect and authority from any feeling of manliness that the fathers could pass on to the sons, since these fathers were themselves struggling to come to terms with their own sense of occupational emasculation. In relation to masculinity in the immediate postwar period, I have written elsewhere about the notion that there was a kind of generational continuity of masculinity: a passing down of manual/industrial work skills and masculine attributes from father to son.[2] For a generation of Americans born later in the postwar period, the obvious sense of continuity that might be gained from the passing of work skills directly from father to son would be broken and, as Natasha Zaretsky observes, this would precipitate a symbolic crisis in the 1970s, formed around concerns for the future of the economy as it began to appear as if 'the industrial father of the postwar era had failed to transmit the work ethic to his son, revealing another aspect of the ... crisis of male authority'.[3]

This dimension of postwar gender relations is figured very clearly in *The Waltons*: John-Boy aspires to be a writer, not a lumber-man like his father. But, in *The Waltons*, this literal break in masculine continuity is reconfigured in such a way that it does not mean that the torch of masculine authority must necessarily go un-passed from father to son. On the contrary, the series artfully negotiates this symbolic fracture – and the larger economic shifts in society that this fracture registers – in such a way as to negate any sense of a loss of masculine authority. Furthermore, the presence of four sons in the Walton household enables the show to revisit this theme periodically and work through this symbolic renegotiation again and again in order to repeatedly offer reassurance. The precise character of this renegotiation may be slightly different on each occasion, but the overarching dynamic is always the same; whatever changes occur in the fabric of society, in *The Waltons* masculine authority remains central to the maintenance of familial and societal order.

Masculinity and the Writer's Vocation

This progressive change in the character of work in postwar America provides *The Waltons* with one of its key problematics: how to register the ontological realities of this shift in the economic base, while still providing some reassurance of the continuance of a social order built around an association of power with masculinity. As the sense of obvious manliness derived from the physicality of industrial labour waned with the ongoing growth of other sectors of the economy, how would it be possible to reassure viewers that the fundamental order of society would remain largely unchanged? For the most part, *The Waltons* articulates this theme, and attempts to negotiate its inherent contradictions, through its construction of the story of John-Boy's accession to maturity. Although even casual viewers of the series would be familiar with the general trajectory of John-Boy's career, as he pursues his literary aspirations, it is not a certainty at the beginning of the ongoing serial narrative that John Walton Jr will achieve his ambitions rather than following in his father's footsteps into the type of manual trade that would be unproblematically masculine.

In 'The Homecoming' and in some of the early episodes of the subsequent series there is a palpable tension between John-Boy's literary aspirations and alternative occupations that are framed as providing a more 'proper' masculine path. These alternatives would see the young man follow directly in his father's footsteps into a manual trade. This sense of masculinity as an aspect of vocational inheritance passed from father to son is established in the opening scenes of 'The Homecoming', which – like every episode of *The Waltons* that followed – consists of a visual montage presenting the *mise-en-scène* of the film, accompanied by John-Boy's voiceover, establishing the key themes that will structure the narrative to follow. In 'The Homecoming', the centrality of the theme of masculine continuity between generations is clearly established by John-Boy's words in this monologue: 'I was 15 and growing at an alarming rate … I was trying hard to fill my father's shoes that winter'.

Another early scene in 'The Homecoming' sets up the suggestion that John-Boy's writing represents a problem – an unwholesome secret that must at all costs be kept from his parents – and can only be undertaken covertly. At the start of this short scene, Olivia Walton enquires after John-Boy's whereabouts and is told by Grandma that, 'I heard him go up to his room. He closed the door and locked it again'. With evident irritation, Olivia enquires, 'what does that boy do up there?' and she exits the room to call the boy downstairs. Hearing her call, John-Boy, who is writing in his journal at the time, scrambles desperately to hide the journal underneath his mattress, apparently anxious to avoid having any member of the family discover his covert undertaking. In the conversation that follows, Olivia interrogates John-Boy about the reasons he finds it necessary to lock the door of his bedroom. There is a powerful sense of a sexual subtext to their talk – conveyed more by Olivia's stern, disapproving facial expression than by anything she says. This subtext infers the mother's belief that the boy has been masturbating behind the locked door of his bedroom. John-Boy's own appearance – apparently guilty and ashamed – and his half-hearted attempt to convince her that the door somehow 'just got locked', do nothing to allay his mother's suspicions. 'A door don't get locked all by itself' she replies, with a knowing look.

On the surface, this scene simply presents an amusing vignette of family life in the overcrowded Walton household, a comedy of mistaken beliefs and misinterpreted reactions. The mother 'naturally' assumes that the only possible reason why a 15-year-old boy would need to lock his bedroom door would be in order to obtain the privacy necessary to do what teenage boys will inevitably do. On an entirely different level, however, the scene is crucial for the way that it establishes an ideological equivalence between John-Boy's literary aspirations and a kind of social deviance – an indulgence in a behaviour that is prohibited, at least within this sternly religious household. The scene sets up the act of writing (and the aspiration to be a writer) as an activity that is outside the range of normative male behaviours, and something that must be kept secret from the parents: John-Boy is apparently content for Olivia's incorrect assumption regarding his conduct

behind the locked door to stand, if this belief preserves the secrecy of his writing.

In the scene that immediately follows this one, the idea of normatively gendered spheres of activity is reasserted. Olivia asks Grandpa to take John-Boy out to find a Christmas tree. When Mary-Ellen asks if she can accompany them, Olivia replies, 'cuttin' down trees is men's work, a girl's place is in the kitchen'. Thus a clear line is drawn between men's work and women's work, a line which John-Boy's ambition to pursue a literary career – rather than follow his father into a manual trade – transgresses, not because it is inherently feminine to become a writer, but because to do so represents a clear departure from the range of normative masculine activities. At the end of this scene, Olivia's concern over John-Boy's ambiguous behaviour behind the locked bedroom door resurfaces. Her facial expression registers evident dissatisfaction at John-Boy's explanation that he was doing his homework, and his remark that 'sometimes I just need a little privacy'. In another, later scene the association between John-Boy's character and masculinity of a non-normative type is reintroduced. Here, in a voiceover, John-Boy reads the notes he keeps in his journal, which reflect some of his anxieties about his development into a man:

> I've been thinking about myself and wondering what's wrong with me. I just can't seem to stop growing. Mama says it's natural but I'm scared if I keep getting taller I'll be a freak or something.

The interplay between conceptions of normative and non-normative masculinities is particularly marked in this scene. John-Boy worries that his becoming too tall marks him as 'a freak', although nothing could be more normal for a 15-year-old boy than to grow taller. However, the mode of expression of this anxiety, writing it all down in his journal, has been framed as a non-normative activity: an activity that is too passive, too feminine for a male teenager; a shameful activity that must kept secret from his mother, preserved from exposure by the locked bedroom door. Meanwhile the young man's locked door becomes a symbol of his mother's concern

about precisely what goes on behind it. In a later scene, in which Olivia finally learns the reality of what happens behind John-Boy's locked door, she is more supportive of his literary aspirations than the young man had anticipated. Notwithstanding his mother's acceptance, the disjuncture between John-Boy's literary aspirations and conceptions of masculine normativity persists. The tension this creates is expressed in a way that explicitly acknowledges the normative prescription that there should be continuity between father and son: 'I couldn't disappoint my daddy, you know he's got his heart set on me taking up a trade'.

Throughout much of the duration of 'The Homecoming' the father is absent, having been prevented from returning home by adverse weather conditions. John-Boy is given the task of finding his father and returning him home. This task, and the difficulties he encounters in undertaking it, further signals the problematic aspects of his masculinity. A key scene in this respect takes place midway through the film. John-Boy borrows a car to assist him in his quest to find his father. As he drives through the night, John-Boy's mind begins to drift, replaying imagined conversations with his father. The scene is shot as if a 'dream sequence'; it appears almost to be a flashback in which John-Boy's mind drifts to the past while he drives. In this sequence John-Boy converses with his father, who is present only as a disembodied spirit. Out of the darkness the father's voice calls John-Boy's name several times until the young man responds. Throughout the scene John-Boy's attention repeatedly drifts, only for him to be brought back to reality by his father's voice calling his name. Repeatedly, like a mantra, John-Boy intones a refrain that captures the film's key thematic concern: 'I want to be like you daddy. I'm trying'. This call and response exchange between father and son creates a powerful sense of the disjuncture between John-Boy's sense of duty to inherit the mantle of masculinity – his predetermined place in a hierarchical gendered order – from his father, and his true desire to become a writer. The father's role is, however, one to which the young man is not equal; with his mind constantly drifting, he is unable to even keep control of the car, and eventually his inattention leads to him running the vehicle off the road.

Abandoning the broken-down vehicle at the side of the road, John-Boy is forced to take refuge in a nearby church. As the action moves to the interior of the church, the sense of John-Boy as an outsider is doubly reinforced. First there is a visual separation of John-Boy from the congregation: they are all African-American, he is white. Thus John-Boy is marked by his skin as a literal Other within that setting. But, as he walks into the midst of the congregation, notwithstanding his racial difference, it is evident that he mixes easily with its members, who readily accept him as one of them. This effacement of the racial difference between John-Boy and the congregation raises the prospect of a differently constructed aura of Otherness attached to the boy, signalling a need to regard this boy who resists his prescribed, normatively masculine future as a marginal figure within the almost exclusively white milieu that 'The Homecoming' presents as a microcosm of America itself.

John-Boy's inadequacy as a man is further reinforced toward the end of the film. Having been unable to find his father, John-Boy is returned to the family home by the Baldwin sisters, two elderly lady bootleggers of whom the strict Baptist, Olivia, disapproves. On John-Boy's return to his family home, Olivia's fury is palpable. She makes no secret of her belief that the young man has been too busy on a frolic of his own, 'joyriding with two old lady bootleggers', to have applied himself properly to the serious task of finding his father.

At the end of the film, the father finally returns home. He arrives bearing presents for the children. Throughout the film's final scene John-Boy looks on, appearing awkward and uncomfortable as his siblings open their gifts. When John-Boy finally receives his own present from his father, he opens it, revealing a stack of writing tablets. Evidently, despite the young man's efforts at secrecy, the father has known of John-Boy's literary ambitions all along. In this way, 'The Homecoming' is able to reframe John-Boy's literary aspirations as a legitimate pursuit. Implicit in the father's gift of writing materials is an approval of the activity of writing. By having his writing explicitly authorised by the father in this way, it becomes an ideologically permissible future for the young man, rather than a threat to his masculinity. Although this final scene recognises

that John-Boy will not literally follow in his father's footsteps, by taking up a trade, his future as a writer is ideologically repositioned by this scene, becoming a gift bestowed upon him by his father. In this way, the scene restores the sense of continuity of masculinity from one generation to another that has been placed in jeopardy throughout the movie. John-Boy can both inherit the mantle of masculinity and become a writer. Indeed the gift of writing tablets, given by father to son, transforms these two hitherto opposed outcomes into the same thing.

On the face of it this conclusion to 'The Homecoming' would appear to resolve any ambiguity about John-Boy's masculinity. Indeed, by the time the first episodes of the television series were screened there had been some significant changes to the ideological positioning of John-Boy's literary ambition. Although early episodes of the series do not signal explicitly when they are set, a reference in 'The Carnival' (S1 E2) to the 'Century of Progress Exposition', the Chicago World's Fair of 1933–34, indicates that the television series must begin in 1933. Thus, there seems to be no chronology between 'The Homecoming' and the first episodes of the later series, which would appear to be set sometime before the time of 'The Homecoming'.[4] It is also notable that John-Boy is aged 17 at the start of the television series, two years older than he was in 'The Homecoming', providing some confirmation that continuity between 'The Homecoming' and the subsequent first season of *The Waltons* is limited to the characters and settings, with no sense of chronological or narrative 'flow' between the two.

John-Boy's character has grown in confidence in the series compared with the preceding Christmas special. This increase in confidence is signalled, in part, by a re-positioning of his literary aspirations. No longer a secret to be hidden from his parents, John-Boy's writing is now a central part of the ongoing serial narrative, and a significant element in the construction of John-Boy's character. In the series John-Boy is also positioned as the central organising consciousness of the story. As such, John-Boy's 'voice' has considerable authority over the text, introducing each episode and delivering its concluding moral. More than that, however, John-Boy's engagement in the process of writing, and

obtaining of the cultural and educational capital necessary to develop a career as a professional writer, is a key element of the diegetic background to just about every episode, and these aspects of his character are foregrounded as the main theme of many others.[5]

John-Boy's Legacies

Notwithstanding these important shifts relating to John-Boy's character, the implied association between writing and femininity found in 'The Homecoming' persists to some degree in the series. This association is made explicit in an early episode of *The Waltons*. Although the Waltons are a poor rural family, John-Boy receives two significant inheritances, one from each of his grandparents. Woven into the back story of the series, John-Boy has received from his Grandfather a plot of land known as 'John-Boy's meadow'. This legacy will become significant in relation to John-Boy's chosen occupation as a writer in later episodes, for reasons I will return to later in this chapter. Initially, however, it will be the Grandmother's legacy that is more significant for establishing an association between John-Boy's literary talents and femininity.

Having no money or property to leave to John-Boy, Grandma tells the young man, in 'The Typewriter' (S1 E5), that her legacy to him will be the gift of stories which have been passed down to her from earlier generations, and will now be passed from her to John-Boy:

Grandmother: My family were storytellers, and long before we had luxuries like electric light an' radio an' all this modernisms; why, we used to sit around the fireplace at night 'n' each one of us would take turns at tellin' stories: ghost stories, witch stories, long-ago stories of Indians and wars, and things that happened in the history of our family. And I've kept 'em. And now they're mellow in my mind and I'm ready to tell again.

John-Boy: Well, Miss Hunter told me that the talent of being a writer was a gift. Now I know where that gift comes from.
Grandmother: Well, all these stories I remember, I'll tell them to you, John-Boy. And that'll be my inheritance to ya.

Thus, while no longer framed as a problem or a shameful secret that must be kept hidden from his parents, this scene reveals that John-Boy's talent for writing and his literary aptitude have their origins in the female line of the family. And although, throughout the entire series, John and Olivia are unequivocal in their support of their eldest son's ambitions, a lingering sense remains that John-Boy's path through life represents a deviation from the conventional route of normative masculinity.

John-Boy's deviation from the 'manly' path is shown particularly clearly in the episode, which precedes 'The Typewriter', 'The Hunt' (S1 E4). In 'The Hunt' John-Boy, joins his father and a group of other local men on a turkey hunt on the mountain. The hunt is explicitly framed as a rite of passage by John-Boy's opening monologue: 'I remember a day in the 1930s when I went to Walton's mountain in search of manhood'. John-Boy frames his participation in the hunt in terms of his ability to fulfil the traditionally manly role of 'provider' for his family, 'I figure it's time I did my share of the providin''.

If the hunt represents an opportunity for John-Boy to prove his readiness to inherit the mantle of masculinity – his ability to step into his father's shoes – this is something he initially fails to demonstrate in practice. In the privacy of his room on the night before the hunt, John-Boy records in his journal his feelings about the expectation that he will kill another living creature; an act that he considers 'murder'. But, as his interior monologue signals, while he is 'right sick' about the prospect of killing, he harbours a greater fear about the implications for his manhood, should he prove unable to do so: 'I'm right scared about tomorrow ... and I'm also scared of what my life is goin' to be like if I fail'.

As the hunting party assembles, the following day, Grandpa complains loudly about his exclusion from the group: he is now considered too old to join the hunt. Determined to be spiritually,

if not physically, present at the hunt, Grandpa hands John-Boy his own rifle, an unambiguous metaphor for the passing of the mantle of masculinity from one generation to another. This sense of the hunt as a rite of passage in which John-Boy will have to measure his manliness against the standard set by earlier generations is reinforced later during a conversation between the men who do go on the hunt. The conversation concerns the character of John's great, great grandfather, the 'biggest man he [Grandpa] ever saw', a self-reliant individualist who came 'to this country with nothing but a mule, plough and a rifle'. 'Aw, they built men in them pioneer days alright', remarks Charlie, another member of the hunting party, his words establishing a high threshold for John-Boy's efforts to gain admission to manhood. When the moment finally arrives for John-Boy to prove his manhood – by shooting a turkey – he freezes, unable to take the shot. Mortified by his failure to measure up to the standards of masculinity established by his father and the Walton men of earlier generations, John-Boy judges himself a failure as a man; 'I found out about myself now and I'm not like you or grandpa. I'm just cowardly and I've shamed you'.

However, simply problematising John-Boy's masculinity would not serve the ideological interests of *The Waltons*, which depend on the show's ability to demonstrate that, while the character of manhood might be changing in some ways, at its core, masculinity remains a locus of authority. *The Waltons* can register the fact that there is talk of a 'crisis of masculinity', but must ultimately demonstrate that there is nothing really to worry about. Thus, in keeping with the typical pattern to be found in *The Waltons*, the problem of John-Boy's masculinity is set up only so that it can be resolved by the episode's end. This resolution is achieved when John is attacked by a bear later in the episode, and it is John-Boy who comes to his rescue and slays the beast. In this way, the episode resolves the 'problem' of John-Boy's non-normative masculinity by promoting a sense of difference from, but equivalence to, the masculinities of the young man's father, grandfather and the past generations of Walton men. John-Boy may not be able to kill during the turkey hunt, but by slaying a much more dangerous beast when the need arises he establishes an equilibrium (if an

unstable one that will have to be re-established from time to time) between the modern masculine type that his character represents and the more traditional versions of manliness represented by father and grandfather. John-Boy's closing monologue clearly registers this sense of difference-but-equivalence with the words, 'I became not a hunter, but a writer, and, I hope a source of pride to my father', words that invoke the father's approval in order to establish a non-hierarchical relationship of sameness between the terms hunter/writer that might otherwise stand in opposition to one another.

Although an equilibrium is re-established at the conclusion of this episode, it is not a stable one and John-Boy's masculinity is a matter that *The Waltons* will return to from time to time, on each occasion problematising his masculinity only in order to finally reaffirm its validity, and to thus re-establish the equilibrium between John-Boy's modern, writerly masculinity and the more traditional, more rugged versions of manhood represented by his father, grandfather and the never-seen, but legendary, earlier generations of Walton men.

Toward at the end of Season One, the tension between these alternative modes of masculinity surfaces again. Once again, it is articulated through issues relating to inheritance – on this occasion the ownership of land occupied by generations of Waltons. On this occasion, however, the story revolves around John and Zebulon, rather than John-Boy. In 'The Deed' (S1 E20), surveyors representing a large lumber company arrive on Walton's mountain, claiming that the company they represent is entitled to the timber rights on the land. This situation provides the occasion for father and grandfather to establish their authority in a way that is explicitly linked to land ownership and inter-generational inheritance, by proving the Waltons' title to the mountain that bears their name. The possibility of any dispute over the ownership of the mountain arises from the older generations' resolute adherence to traditional ways in the face of the onslaught of modernity. In this respect, the dispute contains resonances of the relationship between different masculine types that is articulated throughout the series by means of the generational dichotomy between the more traditional

grandfather and father, on the one hand, and the modern, forward-looking John-Boy on the other.

It transpires that legislation passed in the mid-nineteenth century enabled settlers with long-standing occupancy of land to register their interests with the local court and thereby obtain a deed establishing their legal title to the land. In keeping with the more traditional ways of the type of manhood represented by the older generations of Walton men, it is revealed that Zebulon's father had never bothered himself with the formalities obtaining the deed, preferring to rely instead on his long-standing possession of the land, and local custom relating to land ownership, to preserve his interest in the property. A remark that Zebulon makes to John-Boy registers the difference between that time and the diegetic present, 'time was we had no need for deeds or fancy scribblings'.

In addition to the opportunity that this episode provides for John and Zebulon to re-affirm their masculine authority by establishing their rights over the land, it also develops a secondary rite-of-passage narrative alongside the main story, once again providing an opportunity for John-Boy to measure his masculinity more directly against that of the older generations of Walton men. The main obstacle to establishing the Waltons' ownership of the land is the large sum of money required to pay the court fees. Wishing to contribute to this endeavour to the best of his ability, John-Boy finds numerous advertisements seeking men to work as apprentices in a nearby city and proposes to John and Olivia that he (John-Boy) should go to the city to take up one of these positions in order to earn extra money to contribute to the court fees. John flatly rejects this suggestion, in terms that explicitly distinguish the mature masculinity of the father from the nascent, tentative claims to adult masculinity presented by the still-childlike John-Boy: 'It is my duty to provide for this family and it is your duty to get yourself an education'. Eager to prove himself to be a man, however, John-Boy ignores his father's wishes and departs for the city, where he does take up an apprenticeship in a machine shop. By entering a manual trade, particularly in the mentored capacity that apprenticeship necessarily implies, John-Boy makes a direct attempt to follow in his father's footsteps in a traditionally masculine role. The sense

of connection between father and son is clearly presented in the transition between two scenes in this episode. In the first scene, John-Boy is shown on his first day as an apprentice, learning how to operate a metal-working tool in the machine shop. At the end of the scene, John-Boy re-starts his machine and begins to push a handle. There is an immediate cut from this image to another scene showing John working at the family sawmill, pushing a large log into a table saw. Not only is there a general sense of equivalence between the two types of manual labour undertaken by the men, but the two scenes are edited together in such a way that it appears that the pushing action begun by John-Boy in the first scene is continued and completed by John in the second, reinforcing the sense of continuity between father and son.

However, as has already been established in earlier episodes, direct inheritance of a mode of masculinity defined by its relationship to manual labour is not to be the narrative outcome for John-Boy. Although he is able to find and begin an apprenticeship, John-Boy's masculinity is still too tender for him to thrive independently, away from the influence of his family and outside the sphere of intellectual production, as a writer, that will continue to provide the locus for the development of his own mode of mature masculinity along the larger narrative arc of the series as a whole. This is clearly demonstrated when, shortly after being paid for his first week's work, John-Boy is attacked in the street by two men who rob him of his pay, leaving him destitute and unable even to pay the rent for his room in the city. Far from being able to contribute to his father's legal costs for proving ownership of the land, therefore, John-Boy's premature attempt to take on a 'man's role' becomes an additional financial burden on his parents, as he is forced to request money from his father in order to remain in the city. Furthermore, in order to keep his room in the boarding house in which he is living, John-Boy is forced to accept money from another resident: significantly, a woman, pointedly reinforcing his emasculation. John-Boy's continuing reliance on the support of his father, and that of a woman, undermine his attempts to fulfil the type of mature masculine role associated with his father. At the conclusion of this episode, John-Boy returns to his family, and the masculine

authority of the father and grandfather is validated by the grant of a deed by the Court, proving their ownership of Walton's Mountain, thus restoring a harmonious coexistence between the different types of masculinity – modern-intellectual/traditional-physical – of John-Boy and the two elder Walton men respectively.

While the 'problem' of John-Boy's masculinity is temporarily resolved at the conclusion of *The Deed*, subsequent episodes revive the tensions between the two different types of masculinity embodied by the various Walton men. Once again, land ownership and inheritance are key to the articulation of the friction between traditional and modern modes of masculinity. The background to the story in 'The Cloudburst' (S5 E8) is provided by John-Boy's purchase of an old printing press in an earlier episode, 'The Fledgling' (S4 E23). The purchase of the printing press has left John-Boy with a substantial debt, and he has fallen behind with his repayments. Threatened with repossession of the printing press by the bank, John-Boy agrees to sell the plot of land he owns, 'John-Boy's meadow' – his grandfather's legacy – to a land acquisition company, after accepting a verbal assurance from the land agent that the meadow will be kept in agricultural use, for grazing livestock.

The central conflict in this episode is particularly instructive for the way it mobilises the gendered associations of the two legacies that John-Boy has received from his grandparents. John-Boy sells the meadow – his grandfather's legacy, an inheritance having powerful associations with agriculture, manual labour and, accordingly, with a traditional type of masculinity – in order to finance the continued production of his newspaper, an offshoot of his writing career which, as I have argued above, has been framed in an earlier episode as a feminine legacy from the grandmother. Grandpa is, predictably, furious when John-Boy informs him of the sale, regarding it as a betrayal of the legacy of the unbroken line of generations of Walton men through whose hands the land has passed before being bequeathed to John-Boy. Implicit in the Grandfather's legacy is an expectation that John-Boy's will be a custodial role, the role of preserving the land for future generations. As Grandpa tells the young man, 'If I thought I coulda kept that land in safe keeping for the future you would have been the one person I thought I

could have trusted'. Later in the episode, Grandma tries to console Grandpa, explaining the motivation for John-Boy's actions in terms that clearly reference the differences between the traditional and modern modes of masculinity: 'will you try to understand that to John-Boy that newspaper, and his future, mean more to him than a hunk of land up on the top of that meadow'. Grandma's words construct a symbolic opposition between newspaper and 'hunk of land'; an opposition between a masculinity of the future – one that will come to occupy a preeminent position in the postindustrial knowledge economy that was, at the time *The Waltons* became one of America's favourite television shows, rapidly supplanting the declining industrial economy – and the traditional masculinities of the past, symbolically personified in the series by John and Zebulon, and represented directly in this episode by the meadow that would bind John-Boy to this anachronistic type of manhood. This dichotomy is a key element in the construction of John-Boy's character. John Walton Jr may be destined never to possess the obvious, superficially 'manly' attributes of his father and grandfather, but instead of these he will develop the intellectual character necessary for a man to rise to a position of influence and importance in the modern, postindustrial world.

At the end of 'The Cloudburst', there occurs what appears to be a decisive and irreversible fracture between John-Boy's character and those masculinities of the past. During a religious service held at the top of the mountain, John-Boy makes an impassioned speech about the folly of his action in disposing of the land, and the need to preserve the heritage of the mountain community. His words succeed in persuading other members of the community not to make the same mistake that he has made, by also selling their property to the land agent – notwithstanding the agent's rhetoric concerning the inevitability of progress and his confident insistence that 'the days of Daniel Boone are gone'. Although John-Boy's success in dissuading his neighbours from selling their land effectively puts an end to the company's plan to mine and industrialise the area – and thus renders John-Boy's former plot immediately useless to the company – the agent refuses to sell John-Boy his land back. Through this refusal the young man's connection with a legacy passed down

from past generations of Walton men is permanently severed. The sale of the land may have secured possession of the printing press that figuratively represents the occupation that will play a central role in John-Boy's future as a worker within the postindustrial informational economy. However, the cost of gaining this future is the permanent loss of the more traditional attributes that defined manhood in the past.

The radical intergenerational shift in the mode of masculinity between John Sr and John-Boy can be extrapolated to a sense that the masculine archetypes represented by each man are – if not exactly antagonistic, then at least mutually incompatible. This incompatibility is amply demonstrated by another episode in Season Five. In 'John's Crossroad' (S5 E15) the typical relative positioning of the two men's masculinities is reversed. Whereas throughout much of the progressive character development that unfolds across the longer narrative arcs of the series John-Boy is shown as having to attempt to fit into a masculine mould defined in terms of the manliness of his father and grandfather, in *John's Crossroad* it is John Sr who is shown struggling to fit an unfamiliar masculine mould as he tries to define a place for himself in the modern world; a milieu which his eldest son is able to negotiate with relative ease. This episode was filmed shortly after the actress Ellen Corby (Grandma) suffered a stroke. Her absence from the show was explained by the incorporation of a storyline, which paralleled reality, in which Grandma is hospitalised for a prolonged period while she recovers from an unidentified illness. This illness, and the attendant medical cost, provides the diegetic motivation for John Sr's entry into the modern setting of white-collar employment. Faced with the prospect of mounting outgoings, John decides to take a regular, paid job rather than struggle on self-employed at the sawmill. A scene early in the episode shows John standing in line at the employment office. In this atypical setting, his character appears decidedly anachronistic and ill-equipped for employment within a modern economy that values formal education and intellectual ability over the physical skills acquired through practical experience, which define John's masculine identity. Standing behind another man, who is carefully groomed

and smartly dressed in a sports jacket, shirt and tie (looking similar to all of the other men standing in line) John's appearance – blue denim jacket and jeans, slightly unkempt hair that is longer than the other man's – immediately differentiates him from all of the other job seekers. But it is not only his appearance that sets him apart. The conversation between John and the other man reinforces their difference by establishing the enormous disparity in educational attainment between John – who only completed high school – and the other men in line, all college graduates with degrees. Somewhat implausibly, given his lack of suitable formal qualifications or relevant experience, John is offered a job working in an office of the Highways Agency. His return home that evening is a source of some amusement to the family: he arrives in the kitchen wearing a new hat he has purchased in order to alter his appearance, in an attempt to blend in better with the other men – the 'city slickers' as Grandpa calls them – that John had been competing against for the job. The hat – which looks so incongruous juxtaposed against the more familiar denim outfit that John is wearing – emblematises the differences between John's 'true' identity and the performance of masculinity he will be required to undertake in order to function properly in the unfamiliar setting of the office in which he will be working.

Almost from the outset, it is clear that John's assimilation into the modern working environment of the office is going to be problematic. The office environment is too unfamiliar, too regimented, hierarchical and enclosed for John, a man who is accustomed to considerable autonomy in his working life, working mainly outdoors as his own boss. Chief among the many obstacles to John's successful integration into office life is the manager, Mr Morgan, a tyrannical bully who attempts to exercise absolute control over the office staff and the workplace environment. John, who is used to the outdoor life, finds himself uncomfortably hot within the stuffy office environment and opens the window behind his desk to get some fresh air. This action causes considerable excitement among the other office staff, who exchange nervous glances as they await Morgan's reaction. Without speaking a word, but with evident irritation, Morgan rises from his desk, walks over

to John's desk and slams the window shut. Later in the episode this window will again be used to dramatise the discomfort of John's character within the sterile office environment controlled by this authoritarian bully. While Morgan and other members of staff are out of the office for lunch, John again opens the window in order that he and a colleague, Mr Parsons, can enjoy some fresh air. On his return to the office, Morgan again slams the window shut, with the stern injunction, 'windows are to remain closed at all times'.

There are several different ways that John's problems in this new working environment could potentially be interpreted: class differences between the blue-collar Walton man and the white-collar setting, or a fundamental incommensurability between rural and urban milieus and the people who inhabit and work in them. But the presence of another office worker, Mr Parsons, frames the conflict specifically in terms of differences between generations of men (thus echoing the generational masculine dichotomy that is such a key structural feature of the series as a whole). In one scene, Parsons, who states that he has worked in the office for some 20 years, fondly reminisces about how things used to be in the past:

This office used to be a quiet pleasant place with the old manager. We were all good friends. They're all gone now. Kyle, Clem and Morgan, they're all new ... I used to enjoy this job before things changed, now I'm just hanging on to get my pension.

These new arrivals in the workplace – the neurotic Clem, who pops pills in order to cope with his working life ('it's the office. It's the only way I can keep my stomach right side up'); the sexual predator Kyle who endlessly pesters the female typist, and the bullying manager, Morgan – are presented as dehumanised archetypes of masculinity that inhabit the white-collar workplaces that will dominate the postindustrial economy in which John-Boy and perhaps some of the other Walton children will make their living. John finally demonstrates that he is unable to tolerate the constraints of this environment – he resigns after one week in anger at Morgan's treatment of Parsons, pointedly leaving behind the new

hat that had earlier represented his attempt to mould his identity
to conform with the requirements of this workplace. While John
– with his traditionally masculine attributes – is unable to remain
in this setting, it is clear from the way that John-Boy's character
narrative has developed through numerous episodes that he will
be better equipped than his father to negotiate the pitfalls of the
modern workplace. He will have the college education that his
father lacks and, by selling his land, forever severing his connection
with his agricultural/industrial heritage, he has made a conscious
choice to embrace the possibilities of modernity, to forgo physical
labour and willingly enter this realm of intellectual labour. Yet in
doing so there is never really any doubt that the integrity that John-
Boy has inherited from his forefathers will not be compromised.
He will carry the values he has inherited from the elder Walton
men into his future and so will not become just one more of the
dehumanised characters that John encounters during his brief foray
into this new and unfamiliar world.

Modern Man

Although the literary aptitude that will provide John-Boy with his
future career has been set up as a inheritance with distinct feminine
resonances, and although John-Boy's sale of the meadow he has
inherited from his grandfather permanently severs his connection
with the kind of traditional masculinity possessed by his father and
grandfather, the series nevertheless provides numerous reassurances
of the continuing integrity and authority of the new masculine type
represented by John-Boy's character. Although the land is gone,
and the direct connection with the masculinities of the past is
thereby broken, the values associated with the traditional vision
of manliness offered by father and grandfather – loyalty, honesty,
hard work, family, community and environment – will live on in
the young man.

Reassurance of the survival of these traditional values provides
the subject for a number of the episode-end monologues, narrated
by Earl Hamner Jr, speaking in the voice of an older John Walton Jr

reminiscing about his past. The survival of these 'essential' values in John-Boy's character also provides the subject of one episode, 'The Abdication' (S4 E11). In this episode, the everyday routine of Walton's Mountain is disturbed by the arrival of a movie production crew from New York. The crew are on location filming a movie based on a screenplay by the writer, A. J. Covington, who had spent some time with the Walton family in an earlier episode.[6] The film, set in the Blue Ridge Mountains, tells the story of a local man who travels far and wide seeking his place in the world only to find it when he finally returns home to the mountains. However, there is a problem with the movie: the dialogue written by Covington in his screenplay – supposedly using an authentic regional vernacular – fails to impress local onlookers as to its verisimilitude. Covington's words succeed only in presenting an overly stereotypical, cartoonish facsimile of the speech patterns and language of the local people. John-Boy comes to Covington's aid, re-writing dialogue for one scene in order to endow it with the required aura of authenticity. The rewritten scene is a success, convincing local onlookers and greatly impressing the film's director. As a consequence the director, Mr Walters, engages John-Boy to rewrite all of the scenes due to be filmed on location. So impressed is Walters with John-Boy's literary skill that he offers the young man the opportunity to move to New York to work for him as a screenwriter. The corollary of John-Boy's success is, however, Covington's failure: his services are no longer required and he is dismissed from the movie.

Faced with a difficult decision of whether to accept Walters' offer and leave Walton's mountain for an exciting, but uncertain, future in New York, John-Boy turns to his mother for advice. In light of the way that the series has established a strong association between John-Boy's literary ambitions and the feminine, it is significant that at this moment he should initially turn to his mother rather than his father for advice, thus reinforcing this gendered association. On this occasion, however, the link between writing and femininity is broken. Olivia listens in silence to John-Boy's excitable account of the offer made to him but is unable to advise and directs him to his father for counsel. In his turn, John bases his advice on a crucial distinction between different types of writing career. John

Sr apparently has little difficulty conceiving the life of an author or journalist as a suitable, serious occupation for his son: a man's work in the modern postindustrial economy. Work as a movie screenwriter, however, is a different matter; 'John-Boy, it's kinda hard for me to take this movie business seriously. I'd just hate to see you give up school to go chasing after a life like that'. On this occasion, however, the ultimate decision is John-Boy's own. At the moment when he must choose between the career on offer in the movie business, and remaining with the family to continue his education, it is the dehumanising potential of the former option that proves decisive. Just as his father would a few episodes later, in *John's Crossroad*, John-Boy decisively rejects employment that threatens to strip him of his humanity, rendering him little more than a cog in a commercial machine, as this conversation between the movie's director and John-Boy illustrates:

> **Director (Mr Walters):** This is a business and I think you're a valuable commodity.
> **John-Boy:** No disrespect intended, sir, but I don't like to think of myself as a commodity; to you or anyone else.

Just as *John's Crossroad* distinguishes John's character from those of his co-workers – setting his traditionally-constructed manly integrity and autonomy apart from the repressed, timid and conformist characters of the newer generation of male workers – the choice John-Boy makes in *The Abdication* assures the viewer that, although he may not be following his father's path precisely, he will enter the workplace in possession of the same integrity and independence of mind associated with his father; John-Boy's possession of which provides a reassurance of the survival of the traditional masculine virtues in the postindustrial age.

In later seasons John-Boy became an increasingly irregular presence in the cast of the show, as his move from college into employment displaced his story from the central narrative position it had occupied in the early days. Instead it becomes part of the back-story; an ongoing narrative, the momentum and direction of which is maintained through fragmentary references by other

characters in the course of other story-lines, rather than by being shown directly on-screen. A publisher's acceptance of John-Boy's manuscript, and his decision to leave home and move to New York in 'The Achievement' (S5 E24), the final episode of Season Five, signalled the end of the character's regular presence in *The Waltons*, a landmark registered by the closing scene of this episode in which John-Boy departs from well-established convention and says his 'goodnight' from outside the house. Near the end of Season Six, John-Boy reappears for two episodes, 'The Return' (S6 E20) and 'The Revelation' (S6 E21). The latter of these two episodes provides crucial narrative development in the story of John-Boy's transition to manhood.

The episode presents two different possibilities for the resolution of any remaining ambiguities concerning John-Boy's masculinity. The first seems to present John-Boy with a mundane and relatively unproblematic route to mature masculinity. John-Boy has been working for a newspaper in New York and has been dating Daisy Garner (Deirdre Lenihan), a young woman he first met at a local dance marathon in an earlier episode ('The Marathon', S3 E9) and whom he serendipitously meets again shortly after his arrival in New York. Early in 'The Revelation' John-Boy asks Daisy to marry him and, after some hesitation, she agrees. This storyline offers a straightforward route to the type of mature masculinity – as a husband and, presumably in due course a father – symbolised throughout the series by his own father and grandfather. Indeed, this element of the story provides the occasion for two scenes in the episode explicitly concerned with the transmission of masculinity from older to younger generations: one in which, following the announcement John-Boy's marriage, John takes his son aside for a 'man to man' talk, and another in which John-Boy passes on – as his own legacy to a younger Walton, Curt (Mary-Ellen's baby) – his old bedroom, and his memories of growing up and developing into a man of letters within its walls. Later, however, it becomes clear that John-Boy's attainment of mature masculinity through this marriage will prove problematic. It transpires that Daisy has a secret, she already has a young daughter from a previous relationship. She decides not to go ahead with the marriage in order

to remain in Virginia and become a 'real' mother to her daughter, at which point it becomes apparent that John-Boy's transition to mature masculinity will have to follow a different path. This alternative route is provided by the other narrative strand initiated at the start of this episode, when John-Boy receives an offer from his editor to become a correspondent for the magazine *Stars and Stripes*, the official newspaper of the US military, and to be posted to London in order to report on the war in Europe.

Although he will be a civilian correspondent rather than a soldier – and thus follow a slightly different path from his father, who served as a soldier in the First World War – the final stage of John-Boy's journey to manhood follows essentially the same trajectory as that of his father before him. John-Boy's transformation from boy to man will be completed by his military experiences in the Second World War just as his father's maturation had, through his own national service in the earlier war.[7] This path is traversed off screen for the most part, however, since John-Boy does not return to the forefront of the ongoing narrative until 'The Home Front' Pt 2 (S8 E2), when the family receives news that he has gone missing in action in Europe. Later in Season Eight, John-Boy becomes fully present in the series again, having been discovered, injured, and transported to a military hospital in Alexandria, near Washington.

Although certainly entirely coincidental and not intended by the programme makers to convey any symbolic message, it is a highly significant instance of serendipity that the return of the character, John-Boy, the central figure in the coming-of-age, boy-to-man trans-textual narrative that continues in and between episodes throughout almost the entire duration of the show, becomes inadvertently interwoven with the consequences of extra-textual forces, through the introduction of a new actor in the role, Robert Wightman: Richard Thomas, the familiar face of the character between 1972 and 1978, having permanently left the cast a little over a year before John-Boy's return. For the viewer, the return of the familiar character of John-Boy is, therefore, accompanied by an palpable sense that the John-Boy who has returned is not the same as the one who left, that the character has somehow

undergone a fundamental transformation during his absence; a period spent, crucially, in military service. By thus connecting this sense of transformation to a period in military service, despite the many other divergences between John-Boy's path and that of his father before him, there is a clear sense that the boy's path to manhood – at least in its final stages – has followed more directly his father's footsteps. John-Boy left Walton's Mountain still a boy, but he has come back a man, figuratively transformed by his experiences and physically remade by the change of actor in the role. If John-Boy's ability to inherit the torch of masculinity from his father had seemed uncertain in earlier episodes, none of this sense remains. Furthermore, his ability to become a fully masculine has been facilitated by the very choice of vocation that had earlier cast his masculinity into doubt. It is his wartime experiences that have turned him into a man and it was writing – the vocation so insistently associated with the feminine in earlier episodes – that took him off to war.

The first episode to feature the new actor in the role, 'The Waiting' (S8 E10), contains numerous references to transformation. A distinct unease about the change of actor – manifested as an excessive attention to the character's identity – can be detected early in the episode. Several characters make references to a picture of John-Boy in a newspaper, remarking that it is a 'new picture' and a 'good picture'. Later, after encountering her son's comatose body in the hospital, Olivia voices the anxiety more explicitly: 'something's different. From the first time John and I saw him something's changed'. In another part of the episode Jason expresses his feeling that 'things are never going to be same again', a feeling that is reinforced by the army doctor's unsettling words to John and Olivia when they first visit their son in hospital: 'he won't know you. He doesn't know himself'.

The Waiting ends on a more reassuring note. John and Olivia share Thanksgiving dinner at John-Boy's bedside in the hospital. As John and Olivia join hands while John prays for God's blessing on their family, John-Boy manages to make his hand move to touch those of his father and mother, the first sign of consciousness and signal that, though changed, there can be no doubt that this new

John-Boy will be rehabilitated into family life again: that he will take his expected role within the familial order that remains the show's central concern.

Despite this reassurance – and what longstanding follower of the show could really doubt that order would ultimately be restored? – the tension between continuities with the past and existential changes inherent in the passage from boy to man, occasioned by the war, is revisited in the 'The Furlough' (S8 E22), the episode in which John-Boy, now almost fully recovered from his injuries, finally returns home to Walton's Mountain. Although his sisters have gone to great efforts to restore his bedroom to the state it was in when he last inhabited it, the sense of continuity that this promotes is counterpointed by a palpable sense of loss. Unable to remember the full details of the plane crash in which he was injured, John-Boy remarks 'I feel like I've lost a part of myself. A very important part'. Writing at his desk later in the episode, John-Boy reflects on the emotional interplay between feelings of continuity and radical change; his sense of his own difference and his changed perspective on a world that has remained familiarly static: 'So much around me seems unchanged ... and yet everything is strangely altered'. This tension between the familiar and strange provides the occasion for a 'man-to-man' talk between John and John-Boy, in which both men reflect of the complex processes of remembering and forgetting that together produce an identity.[8] John-Boy reveals to his father his feeling of incompleteness after his wartime experiences, a feeling that a vital part of himself has been left behind. This emotion becomes an important point of similarity between the two men, as John reveals his own similar feelings following the loss of his brother in the First World War.

The narrative threads of both this episode and the longer, ongoing, story of John-Boy's accession to manhood fail to provide simple answers to the problematic of masculinity established in early episodes of *The Waltons*; a problematic that remains a constant presence throughout John-Boy's life story. However, in counterpoint to the unsettling implications of this aspect of this most central character, the series also provides a more reassuring

feeling, for the forces of patriarchy, that men will continue to possess a 'natural' authority, one that places masculinity in a position of almost godlike omniscience in relation to the diegetic world in which *The Waltons* takes place. This is achieved by the extra-diegetic narration that opens and closes almost every episode. Spoken by the creator of *The Waltons*, Earl Hamner Jr, the words of these monologues foreclose on the meaning of each episode; comfortingly shutting down ambiguities, tying off loose ends and smoothing over contradictions. But, more than this, the voiceovers are also presented as being the words of John-Boy. However, spoken from the retrospective position of one reminiscing about the past, these monologues must be seen as not simply the words of John-Boy, but of John-Boy *as a mature man*. As a structuring device, then, the monologues guarantee that, whatever obstacles or problems are ostensibly put in the way of John-Boy's inheritance of the torch of masculinity within the episodes, his ultimate accession to manhood and a position of 'natural' authority can never be in doubt: in the end, the 'last word' is always his. However ambiguous John-Boy's masculinity may seem at times, as he fumbles in his efforts to follow his father's path, the soothing voice of the narrator offers reassurance that there is ultimately no doubt that this authority is something he will attain.

One of these voiceovers demonstrates this particularly well, tying the authority of the final word with a clear sense of tradition and intergenerational legacy. At the time of filming the last episodes of Season Seven, it was not certain that Season Eight would be commissioned and it seemed possible that the final episode of Season Seven would, therefore, be the last. The final episode of that season, 'Founders Day' (S7 E23), finishes with an extended narration by Earl Hamner Jr. Hamner's words, poem entitled *Appalachian Portrait*, provide – in what might have been the 'final word' of the entire series – a sense of certainty about John-Boy's inheritance of an unambiguous masculine identity from his male forebears, something that the series has repeatedly called into question, only now to reassure the viewer that this continuity was really never in doubt:

I have walked the land in the footsteps of my fathers.

Back in time to where the first one trod, and stopped, saw sky, felt wind,

bent to touch Mother Earthand called this 'Home'. This mountain.

This pine and hemlock, oak and poplar. Laurel, wild, and rhododendron.

Home and mountain. Father, mother. Grow too the sons and daughters.

To walk the old paths. To look back in pride in honoured heritage.

To hear its laughter and its song.

To grow, to stand and be themselves, one day remembered.

I have walked the land in the footsteps of <u>all</u> my fathers.

I saw yesterday and now look to tomorrow.

5

Walton Women

... we do not agree that, by adopting one theory of life, Texas may override the rights of the pregnant woman ...
... the attending physician, in consultation with his patient, is free to determine, without regulation by the State, that, in his medical judgment, the patient's pregnancy should be terminated. If that decision is reached, the judgment may be effectuated by an abortion free of interference by the State.[1]

I mean, suppose you had a baby and you didn't want it? Is there any law that says you have to keep it?[2]

These two quotations, spoken almost exactly a year apart – the first, by a Supreme Court Justice; the second by a key female character in *The Waltons* – provide an illustration of the extent to which *The Waltons* participated in, and contributed to, contemporary discourses relating to some of the highly topical questions about social life and moral order in America in the early 1970s. Perhaps more overtly than any other instance in the show's history, the dialogue between characters in the episode that included these words – spoken by Mary Ellen – represented a direct intervention in an ongoing and highly controversial debate taking place outside the confines of the show. The debate was one of the key issues of the time and polarised the opinions of ordinary Americans. It is a debate that remains a controversial political issue to the present day. As happens frequently in *The Waltons*, this dialogue between characters briefly offers a progressive political position – that a

woman should have the right to chose whether or not to become a
mother – only to have it decisively dismissed by another character,
in this case the character who most consistently articulates the
show's overarching conservatism, the grandmother. In full, the
dialogue takes the following course:

> **Mary Ellen:** ... suppose you had a baby and you didn't want
> it? Is there any law that says you have to keep it?
> **Erin:** Course there is, Mary Ellen.
> **Grandma:** There is man's law and God's. Now it would behove
> you to remember that you're a young lady. Mary Ellen. You
> better start thinking about duty and responsibility.

On one level, this exchange can be seen as simply being a
commentary on a highly topical legal issue – the show's recognition
of the existence of this controversial judicial decision, which had
provoked widespread public debate. However, in a more abstract
sense, this scene also provides an instructive illustration of the
way that *The Waltons* consistently articulated a set of regressive
moral and social precepts regarding the social position and roles
of women.

The stance on the abortion debate manifest in this scene is self-
evidently informed by politically regressive, conservative religious
values. However, as with many aspects of the show, the stance *The
Waltons* took regarding the role and position of women in society
is more complicated than this. While it may, therefore, be fairly safe
to characterise the sexual politics of *The Waltons* in general terms
as regressive, traditional and conservative, any such generalisation
inevitably glosses over some of the complexities and contradictions
evident in the way the show went about presenting its conception of
the social place of women. This chapter will, therefore, look more
closely at the representation of women in the show, focusing on the
female character who most frequently embodied the complexities
and contradictions of femininity as it is conceived by *The Waltons*:
Mary Ellen.

In order to properly understand the representation of women
in *The Waltons* it is necessary to consider the social and political

contexts of the period in which the show was produced. Sexual politics in America during the early 1970s was characterised by radical changes in the way that the roles, rights and responsibilities of women were conceptualised. The changes in the position of male characters in *The Waltons* discussed in the previous chapter were to some extent the corollary of these shifts, as the gains made by women provoked anxiety about the impact they might have on the privileged position of men. It is important to be clear, however, that it was women more than men who provided the impetus behind the changes taking place for both sexes, changes that followed from pressures applied by the movement that is often termed 'second wave feminism'.

It is conventional for accounts of second wave feminism to identify the movement's origin in the publication of Betty Friedan's *The Feminine Mystique* in 1963. In reality, its history was much longer. Debates about the positions and roles of men and women in American society can be traced back at least as far as the early years of the twentieth century, but the Second World War represented a pivotal moment for feminism, and the real start of the second wave. The exigencies of the wartime economy necessitated an suspension (at least a temporary one) of the pre-existing ideology of female domesticity: indeed its near reversal. Women were called upon to enter paid employment outside the home in order to fill the labour shortage produced by the mass enlistment of working men in the armed forces and the simultaneous need to increase industrial productivity to meet the demands of the war effort. As Rebecca Hill rightly observes, the impact of this change in relation to work had far wider cultural repercussions; 'this material change was accompanied by an aesthetic transformation, as the domestic image of "woman" was challenged by idealised portraits of female militants'.[3] During the war, left wing feminists attacked the ideology of female domesticity, drawing parallels between the global conflict between democracy and fascism and women's struggles for equality with men and release from domestic labour, characterising domesticity as an example of fascist doctrine. In 1948, for example, feminist writer Claudia Jones declared that '"Women's place is in the home" is a false Hitlerite slogan',[4] echoing

the views of many female writers on the left that the ideology of domesticity was inherently fascistic. Hill again:

These writers used the notion of the 'fascist triple K' (Kinder, Küche, Kirche – children, kitchen, church) to bolster the critiques of domesticity that many women Communists had made since the labour movement's earliest days.[5]

While the war continued it was possible for much of the rhetoric of feminist writers to be reconciled, in general terms, with the broader national interest in defeating fascism. Immediately after the war's end, however, national priorities changed in a way that rendered this alignment of interests unsustainable. 'Rosie the Riveter' may have been a popular and politically useful image of the female worker while the exigencies of war persisted, but in postwar America ideological efforts began almost immediately to reverse women's movement into the workplace and to rapidly transform 'Rosie the Riveter' into 'Susie Home-maker'.[6]

At the forefront of the postwar antifeminist backlash was Ferdinand Lundberg and Marynia Farnham's notorious book, *Modern Woman: The Lost Sex*, published in 1947. Lundberg and Farnham were unequivocal in their dismissal of the arguments of feminists, pathologising women's demands for equality with men by claiming that feminist politics developed as 'an expression of emotional sickness, of neurosis'.[7] They were equally outspoken in their contempt for feminist writers, dismissing Mary Wollstonecroft – whom they characterised as the progenitor of feminism – as 'an extreme neurotic of a compulsive type'.[8] For Lundberg and Farnham, then, feminism was a psychological sickness, and its 'single objective: the achievement of maleness by the female' was the main symptom of that mental dysfunction.[9] The solution to this 'sickness', proposed by commentators such as Lundberg and Farnham, was the total relinquishment of women's claims for parity of opportunity with men and replacement of these demands with an acknowledgement of the social benefits accruing from the existence of complementary but different roles for the two sexes – men as breadwinners, women as nurturers:

A first general step toward the problem of rehabilitating women (and, through women, children of both sexes and adults of the next generation) would be public recognition in substantial ways of the powerful role and special importance of mothers as transmitting agents, good or bad, of feelings, personality and character.[10]

Key to this renewed accommodation of the sexes to their traditional roles, argued Lundberg and Farnham, was the 'recognition' that males obtained no particular benefit over women by virtue of their traditional modes of paid employment, and that any perception that they did was the result of disordered feminist thinking:

As to the reputedly dirty and degrading nature of work around the home and kitchen, women might well observe that many of the occupations of men are not precisely genteel, yet cause no male outcry ... The disproportionate odium that has come to be attached to household work and cooking in the home is the consequence not of anything inherently disagreeable in such work but of the repeated verbal fouling of their own nests by a long line of disordered female theorists and the disorganisation of the feelings of women in general.[11]

It is some measure of the pervasiveness of this sort of anti-feminist rhetoric in early postwar American society – and of the success of actions taken to remove women from the workplace and return them to the domestic setting – that much of what is argued in Friedan's book (published some 15 years after *Modern Woman: The Lost Sex*) in the first half of the 1960s, echoes the arguments feminists were making about women's lives in the 1940s, suggesting that little had changed for women in the intervening period. *The Feminine Mystique* is notable not so much for the novelty of what it had to say, then, as much as it is for its success in capturing the imagination of a much wider readership than earlier feminist writers had, and for its ability to penetrate the national consciousness more deeply. The political climate of America in the late 1940s and through the 1950s may not have been conducive to a widespread acceptance of

the argument that the ideology of domesticity functioned in such a way as to oppress women, but the 1960s was shaping up to be a very different time politically, and the more progressive political mood of the early years of that decade would provide fertile ground in which these ideas could take deeper root and grow.

Friedan's book presented an account the stultifying impact of postwar suburbanisation and the rise of consumerism from the point of view of a woman who had experienced those effects first hand, and who now demanded a more equal share of the benefits that postwar affluence had produced, benefits that had mostly been enjoyed by men. In 1970, Friedan's insider's account of women's domestic oppression was joined by another key work of the feminist second wave. The impact of this book was, arguably, even greater than that of Friedan's. Unlike Friedan, who had experienced the tedium of domesticity first hand and who was, therefore, able to provide an 'insider's account' of the role of the ideology of domesticity in women's oppression, the author of this new book was very definitely an outsider, a stranger to the ennui experienced by the American housewife in 1950s suburbia. Germaine Greer's *The Female Eunuch* became perhaps the most conspicuous manifestation of radical feminist thought at the start of the 1970s. But Greer's book was merely the tip of an iceberg that also included Kate Millett's *Sexual Politics* (1970), Shulamith Firestone's *Dialectic of Sex* (1970) and the anthology, *Sisterhood is Powerful* (1970). At the start of the 1970s, then, feminism was an idea whose time had finally come.

The reasons why ideas that had only managed to achieve limited circulation among left wing radical intellectuals in the 1940s should gain greater purchase on the popular imagination in the 1960s and 1970s are complicated, but undoubtedly the proliferation of mass media forms in the intervening years played an important role in spreading and popularising these ideas. Greer, in particular, became something of a media celebrity in America (as she had a little earlier in Europe) following the publication of *The Female Eunuch,* a role she apparently relished.[12]

This is not the place to attempt to recount in any greater depth the history of second wave feminism; it is possible only to provide

the briefest outline of some of the issues that concerned women activists, writers and intellectuals. However, for the purposes of this book, it is sufficient to recognise that the position of women in American society was changing radically in the early 1970s: that ordinary women were increasingly willing to take a political stand and insist on their right to equality with men, a stance that was dramatically reshaping the landscape of sexual politics at the time.

If media visibility was crucial to the widespread diffusion of the ideas of the second wave feminists, the celebrity of particular writers represented only the most explicit use of media for this purpose. It was certainly not the only way in which the media operated to disseminate ideas about women's status in American society. While feminist intellectuals participated in a very literal sense in a public debate about women's roles and status in society, numerous films, books, television shows and other media forms also made contributions to this debate less directly: through the way that their representations of women, men and the relations between the sexes revealed, and occasionally problematised a set of social norms concerning the roles, status and behaviour of both women and men. In this respect *The Waltons* was not exceptional. The same could be said of most cultural productions of the time. However, the range of female characters present in the series, and its emphasis on the domestic setting, did afford *The Waltons* an unusual degree of scope for presenting some of the issues arising in debates about sexual politics at the time. Furthermore, the duration of the show's initial run permitted a degree of character and narrative development that was not possible in less successful, shorter running shows. The argument developed in this chapter will be that, while ostensibly accommodating some of the demands of progressive feminism, and to some extent recognising the desirability of changes in women's status, overall *The Waltons* consistently reasserts the 'naturalness' of a politically regressive vision of women's domesticity, and consequently of extremely limited changes in the position of women in American society.

For the most part the shifts in sexual politics taking place in American society through the 1960s and the 1970s are registered

more subtly than in the example introduced by the epigraph to this chapter – a storyline in one episode which appears to comment directly on the important and emotive issues raised by the Supreme Court's decision in Roe v. Wade. More usually, it is not by direct reference to a topical issue that the show comments on the issue, but more pervasively through the mode of construction of various female characters and the manner of their incorporation into story-lines – both those of individual episodes and the longer story arcs that connect episodes and build a deeper understanding of the character. As with the representation of men in *The Waltons*, the presence of multiple generations within the family enables the series to present and negotiate the different and often contradictory political stances available, acknowledging that there had been tangible changes in women's status, political attitudes and aspirations while at the same time maintaining an overarching sense of the continuing value of more traditional female roles.

Generally speaking, it is not difficult to see that *The Waltons* maintains, throughout the entire duration of the series, a fairly rigid gendered division of labour that positions women firmly in the domestic realm of unpaid work and men in the public sphere of paid employment or business enterprise.[13] This gendered division is clearly established in a scene 'The Homecoming'.[14] At the end of the scene Olivia asks John-Boy and Grandpa to go out to find a tree for Christmas. Olivia's request prompts Mary Ellen to ask if she can accompany them. Olivia rebukes her with the words, 'cuttin' down trees is man's work, a girl's place is in the kitchen'; words that unambiguously restate the ideology of domesticity. That the show's position on the linkage between domesticity and women is sometimes contradictory is, however, evident in the pilot episode of the series, 'The Foundling' (S1 E1). Having been instructed by his mother to milk the cow, John-Boy complains that 'in books it's always girls that milk the cows'. 'Just goes to show you shouldn't believe all you read in books' Grandma swiftly responds, apparently negating the normative conception of gender roles invoked by John-Boy. In general, however, the normative division of roles, organised around the twinned conceptions of female domesticity and male economic productivity, is one that *The Waltons* consistently upholds.

Typically, Grandma takes the ideological lead as the show's staunchest advocate of a traditional domestic role for women. At the other end of the political spectrum is Mary Ellen, the character who most regularly articulates the progressive challenge to this traditional, normative conception of the woman's role. In early episodes of the first season of *The Waltons*, Mary Ellen's divergence from a narrowly defined vision of femininity is established through the construction of her character as a 'tomboy'. In this guise, Mary Ellen operates as a cipher through which the text articulates and negotiates the contradictions between the contemporary social realities of women's legitimate demands for sexual equality and *The Waltons'* essentially conservative ideological construction of womanhood.

Baseball Gloves and Pretty Dresses

An early episode in Season One makes clear the ideological contradictions inherent in the construction of Mary Ellen's non-conformist femininity. Although 'The Hunt' (S1 E4) is primarily concerned with John-Boy's transition to normative manhood, the narrative of the episode has a secondary strand which foregrounds the female counterpart to this story. 'The Hunt' provides an early glimpse of the contradictions embodied by Mary Ellen's character, and the tension that these produce, between the normative feminine path and the non-conformity of a young woman who will repeatedly reject the socially prescribed domestic role.

The overarching theme of 'The Hunt' is the transition from childhood to adulthood and the dominant narrative strand of the episode is focused on John-Boy's rite of passage to manhood. While the young man's movement toward adulthood is framed in positive terms, as a necessary and desirable development, the episode's secondary narrative strand frames Mary Ellen's development into a mature young woman rather differently. Early in the episode, Mary Ellen's association with an unconventional, 'tomboyish' femininity is clearly established. In one scene, early

in the episode, Mary Ellen enters Ike Godsey's store to make an instalment payment toward a new baseball catcher's mitt that she has almost finished paying for: a commodity entirely consonant with the construction of her character as a 'tomboy'. While Mary Ellen is at Ike's store, two further characters enter: G. W. Haines (David Doremus) and Martha Rose Coverdale (Cindy Eilbacher), both classmates of Mary Ellen. Mary Ellen has a schoolgirl crush on G.W., and her decision to purchase a new catcher's mitt has, to a large extent, been motivated by her belief that it will enable her to develop a closer relationship G.W., through their shared love of baseball. However, at the very moment that Mary Ellen – trying on the glove for size – declares herself 'able to handle anything G.W. throws at me', G.W. enters Ike's store with Martha Rose and 'throws' Mary Ellen something she was certainly not prepared for. Apparently uninterested in either Mary Ellen or her catcher's mitt, G.W.'s attention is raptly focused on the normatively feminine (and rather spoiled) Martha Rose, who orders him to buy candy for her and directs his attention away from Mary Ellen and her new glove, and toward a dress on sale in the store which, she says, would make her look 'like a dream'. The scene is structured by a set of oppositions that construct the type of femininity embodied by Mary Ellen as the non-conformist counterpoint to the hyper-normative femininity of Martha Rose. Mode of dress is a crucial element employed to construct the opposition between the two young women (and the feminine 'types' they represent): Mary Ellen, wearing her customary, rather asexual blue denim jeans and shirt, while Martha Rose is dressed in a more obviously normative feminine style; in a checked dress, with her hair tied back with a bow. This superficial visual contrast between the two types of femininity represented by these characters is reinforced by the connotations carried by the commodities in Ike's store that capture their interest. Mary Ellen is there for the catcher's mitt, an item having self-evident associations with a physically demanding sport more conventionally associated with men than women, and which affords little potential for maintaining a normatively feminine demeanour. Martha Rose, on the other hand, is there for the dress; an equally self-evidently normative

feminine commodity. At the same time, in a more subtle way, the scene reinforces the gendered stereotypes of these two very different modes of femininity through the fundamentally different relationships that the two young women have with the economic system. In this respect it is highly significant that Mary Ellen has come to the store to make a payment toward the catcher's mitt. Mary Ellen uses her own money to make the payment, money she has earned through her own labour and enterprise. Martha Rose, on the other hand, exemplifies a mode of femininity that is entirely reliant economically on men: when she enters Ike's store she instructs G.W. to purchase candy for her (relying on his economic power) and, when she decides she wants the dress, states that 'I'm gonna tell my daddy to buy me this little dress; that's exactly what I'm going to do' (relying on the father's economic power). Martha Rose's character represents an archetype of a mode of femininity that is not only economically dependent on men during her childhood – as signalled by her reliance on her father to buy the dress for her – but one that also seems likely to remain economically dependent on men in the adulthood yet to come – as indicated by her need to have G.W. (potentially a future husband) purchase her candy for her.

Mary Ellen's relative financial independence is presented as a positive attribute, and can be read as a progressive aspect of *The Waltons*' representation of femininity, albeit one that does little more than reference the increasing economic independence of women in America at the time. However, this progressive dimension is diluted significantly by Mary Ellen's evident need for validation from a man. Mary Ellen wants the baseball mitt, at least in part, in order to gain G.W.'s attention. This need for male validation sets a limit on the political progressiveness of her character. In a later scene, Mary Ellen struggles to understand G.W.'s willingness to accede to Martha Rose's demands and seeks counsel from John-Boy. 'Well sister there comes a time when boys like girls to be different...', advises John-Boy, framing his counsel in terms of a heterosexual economy of desire that is presumed to be normative: as John-Boy's advice continues, a young man 'might still like the catcher's mitt, but he'd rather see the girl in

the fancy dress'. John-Boy's advice also introduces a sense of the development of an active/passive sexual dichotomy accompanying the shift from childhood to maturity. In the former there is less of a sense of hierarchy between males and females: in childhood both may play baseball equally. As they mature, however, the female must become the passive object of the male gaze: she abandons sport and wears the dress so that he might admire her, valuing her for her appearance alone.

This, then, is the key structuring dichotomy at the heart of *The Waltons'* construction of femininity; the contradiction which Mary Ellen must negotiate in her movement toward mature femininity. The contradiction is not resolved within the self-contained narrative of this particular episode and, indeed, the way the episode is concluded merely postpones resolution of the conflict. Trapped between her own, nonconformist, 'tomboyish' immature femininity, and the pressure to conform to a more normative feminine type – pressure that increases progressively as she approaches maturity – Mary Ellen temporarily yields to the normative script. Having finally saved enough money to make the ultimate payment on the catcher's mitt, Mary Ellen instead purchases the dress, remarking to Ike that 'catch doesn't seem to be the game G.W. wants to play any more'.

But making this radical transition to an entirely normative feminine script turns out to be less straightforward than simply swapping one mode of dress for another. 'Did you ever in your life see anything so pathetic?' Mary Ellen asks Olivia when she tries on the dress and realises that while it may literally fit her body it does not figuratively fit with the temperament of her character. Using Mary Ellen's character in this way, showing her struggle with the contradiction created by the co-existing aspirations to autonomy and equality with men (her 'tomboy' self), and the impulse to submit to hetero-normative femininity (her desire for a close relationship with a man), *The Waltons* maintains an uneasy equilibrium between the ideological imperative to maintain a traditional, conservative vision of the place of women, and a politically pragmatic recognition of the legitimacy of claims being made by women at the time to greater

equality with men. At the end of 'The Hunt', this issue is almost completely sidestepped. Unhappy with the results of her attempts to conform to a feminine pattern that does not fit her character, Mary Ellen returns the dress to the store and, instead, takes the catcher's mitt. In the final scene, Mary Ellen is shown playing catch with G.W. while two of the younger children play 'Indians' nearby. Through this device – in effect, symbolically returning Mary Ellen to childhood – the episode avoids having to decide between the two competing archetypes of adult femininity that it has introduced. The conclusion of 'The Hunt' re-asserts the association between Mary Ellen's 'tomboyish' character and childhood and, in so doing, avoids having to take a position in relation to mature women's claims to the rights of economic independence and equality with men.

Having thus postponed rather than resolved the question of Mary Ellen's non-conformity, however, this becomes an issue to which *The Waltons* will return repeatedly throughout its run. In many of the early episodes Mary Ellen's 'tomboyish' character remains the vehicle through which the non-conformity of her femininity is expressed. This tomboyishness frequently causes her to exceed the conventional boundaries established for feminine conduct. In 'The Reunion' (S1 E13), for example, Mary Ellen becomes involved in a fight with a schoolboy, suffering a black eye as a result (her third in a year, we are later informed). At the dinner table later on, Grandma (as ever, the character most closely associated with womanhood of the more traditional kind) chastises her in terms that reinforce the ideological prescription that this is not only unacceptable behaviour, but is unacceptable precisely because it transgresses clearly defined gendered boundaries: as Grandma puts it, 'time you started behavin' like a lady, Mary Ellen'.

However, as the series progresses, it becomes increasingly apparent that Mary Ellen is unlikely to surrender readily to the pressures to conform to a straightforwardly normative feminine script. As the first of the female children to approach adulthood, Mary Ellen becomes ever more vocal in her expressions of discontent at women's status and roles within the regressive,

traditionally-gendered division of labour. Mary Ellen first voices her dissatisfaction at the woman's lot in life in 'The Deed' (S1 E20):

> **Mary Ellen:** You know Grandma, life is rotten for females. Nothing but dishes and sweeping and ironing. That's it for females.
> **Grandma:** Your time will come child.
> **Mary Ellen:** But Grandma, I'm 13 years old and nothing has happened to me. Life just passes me by and all I do is sit around.
> **Grandma:** Well I got the solution to that. You go out and start churning some butter. Maybe we can sell a few pounds. Well go on!

This brief dialogue encapsulates a dynamic that will be repeated numerous times throughout the nine seasons of the show. Mary Ellen, clearly recognisable as the show's emblem of modern femininity, espouses a desire for something better than the life of domestic drudgery offered by a woman's traditional place in the economic and social order, only to have her feelings summarily dismissed by the supposedly pragmatic 'commonsense' of the grandmother, Mary Ellen's dialectical counterpart. The following exchange between the two women, from 'The Cradle' (S2 E19), follows the same pattern:

> **Grandma:** Mary Ellen, where you off to?
> **Mary Ellen:** I'm just pondering my destiny being born a woman.
> **Grandma:** Ah, good heavens! That's no destiny. That's just a simple fact of nature.
> **Mary Ellen:** No, I think it's more. I mean, think of all the things we have to do all our lives, just because we're women.
> **Grandma:** Well I imagine if the men were sittin' here they'd say the same thing about themselves.
> **Mary Ellen:** No that's not strictly true. I mean, the laws are

made by the men for the men: that's what Isadora Duncan
says.
Grandma: You mean that dancin' girl? Huh! From what I
read about her in that magazine she doesn't stay long enough
in one place to know anything about the laws.

As in previous quotation, Mary Ellen questions the norm of female
domesticity only to have her ideas ridiculed by the grandmother,
whose advanced age and status in the family hierarchy endow her
proclamations with an aura of 'natural' authority that the younger
woman's words may not challenge. At the end of the dialogue
reproduced immediately above, the grandmother's words and her
disapproving tone signal a moral dimension to debates regarding the
position of women. Grandma's words hint at her moral disapproval
of women who transgress traditional domestic norms. This is an
attitude that pervades the series and is clearly exemplified through
the treatment of some of the occasional female characters who visit
Walton's Mountain from time to time.

'Strange' Women

Suspicion towards cities, and people who inhabit cities, is an
enduring characteristic of *The Waltons*. This suspiciousness is
especially pronounced in the case of the occasional female characters
in the show, particularly those who arrive from outside Walton's
Mountain, and who are commonly portrayed pejoratively, as either
sexually precocious young women or, if more mature, as sexual
sophisticates who transgress the moral requirements of femininity
upheld by the regular female characters in the show. Typical of this
pattern is Sarah Jane Simmons (Sissy Spacek) who first appears in
'The Townie' (S1 E23). Sarah Jane is the daughter of a neighbour
of the Waltons, who yearns to move away in order to experience
the 'whole exciting world a whirlin' around out there, just waiting
for anybody with the gumption to hop on board and ride it to the
stars'. She is a sexually forward young woman – described by her
own mother as a 'man-crazy sneak' and by another character as a

'hip-wiggling mountain wench' – who solicits kisses from John-Boy and is forthright in her expressions of desire to escape the domestic chores that dominate the lives of the women of Walton's Mountain. When Sarah Jane returns to the series for the second and final time in 'The Odyssey' (S2 E2) she does so as a pregnant runaway from a foster home in the city, which her mother has arranged in order to secure her education. Sarah Jane claims to have eloped and married the unborn baby's father, but inconsistencies in her account cast doubt over the veracity of her story. Ultimately, however, while the pregnancy marks her as a morally questionable woman, it is also the pregnancy that provides the narrative vehicle for the redemption of her character to the moral order prescribed by the show. The birth of the baby brings Sarah Jane back into the care of her mother and to the normative order of domesticity – as a wife and mother herself – that is precisely what she had dreamed of escaping in her earlier appearance in the show.

While Sarah Jane may be redeemed to ideological normativity at the conclusion of her brief series of appearances in the show, the same is not true of several of the other occasional female characters that appear in *The Waltons* from time to time. Some of these ideologically transgressive women are presented as morally flawed, if not outright criminal characters. Free-spirited and flirtatious Sis Bradford (Darleen Carr) in 'The Beguiled' (S3 E17) is ultimately exposed as a thief and a liar; Vanessa (Linda Purl), Curt Willard's sister, is a vamp who uses men to further her career, before deserting them and breaking their hearts, as she does with Jason in 'The Heartbreaker' (S5 E21); Bridget 'Muffin' Maloney (Vicki Schreck) is simply a 'con artist' ('The Big Brother' S4 E19). Other occasional female characters are portrayed as being either so damaged by events in their earlier lives – such as Bobbie Strom (Lee Purcell) in 'The Wing Walker' (S4 E7), who was raped at 15 – or driven by the pursuit of a vocation – Madeleine Bennett (Laura Campbell) in 'The Woman' (S3 E23) – that they are incapable of engaging in the sort of committed, emotionally intimate relationships with men that would provide the foundation for the familial domesticity that lies at the heart of *The Waltons*' normative prescription for women. Even the most enduring of these occasional female characters –

Daisy Garner, who comes close to marrying John-Boy – is ultimately positioned as a morally ambiguous character.

John-Boy first encounters Daisy during a dance marathon ('The Marathon' S3 E9), a setting already tinged with overtones of moral ambiguity. Her ambition to become a dancer takes her to New York where she again meets John-Boy ('The Achievement' S5 E25), who dates her and eventually proposes marriage ('The Revelation' S6 E21). However, while she initially accepts John-Boy's proposal, it transpires that Daisy has a 'shameful' secret: an illegitimate child from a previous relationship. Ultimately her desire to return to, and bring up, her daughter causes Daisy to break off her engagement to John-Boy. In effect the existence of the illegitimate child denies her the possibility of the normative family life she has planned with John-Boy.

Instructively, many of the personal qualities of, and desires expressed by, these occasional female characters are also shared by the eldest Walton daughter. Mary Ellen frequently indicates her desire to escape from the life of mundane domesticity that Walton's Mountain offers women, to a more glamorous life as an actress, singer or dancer. Unlike the occasional female characters discussed above, however, Mary Ellen does not actively pursue these dreams. However, her discontent with the traditional woman's role finds expression in a number of episodes throughout the show's run, often taking the form of mother/daughter 'chats' which consistently conclude with a reaffirmation of the inevitability female domesticity. The following exchange, from 'The Deed' (S1 E20) is typical:

Mary Ellen: Oh, I'm just not any good in the kitchen and I never will be.
Olivia: I'm sorry Mary Ellen. You can be good at anything you want.
Mary Ellen: Maybe something's wrong with me, but I really don't think I want to be a cook or even a wife.
Olivia: Every woman feels that way sometimes.
Mary Ellen: Even you?
Olivia: 'bout three times a day, but there's always somethin'

that needs tendin' to and we do it, and there's somethin' to be said for that ... and right now the problem is supper.

Similarly, a scene in 'The Awakening' (S2 E15) shows Olivia explaining a woman's role to Mary Ellen in terms that emphasise the 'naturalness' of female domesticity, even its inevitability as a precondition of a woman's humanity:

> **Olivia:** Becoming a woman isn't a sentence, for heaven's sakes. It's a ... it's a beginning of new possibilities. Love, marriage, children: when the time is right and if that's what you want. But in any case it's a natural cycle, that ... that's filled with joys and sorrows, responsibilities.
> **Mary Ellen:** Like keepin' house and having kids and stuff right?
> **Olivia:** No. Like being one half of the adult human race.

Despite these repeated reassurances, however, Mary Ellen continues to struggle with the prescriptions of normative femininity. Her rebellion against her prescribed female role reaches its peak in 'The Quilting' (S4 E21). This episode marks Mary Ellen's coming of age, a milestone that Grandma wishes to celebrate according to the traditions of the community. These customs, however, carry with them implications of an extremely restrictive view of the status, roles and responsibilities of women and, as such, conflict with Mary Ellen's own desires and aspirations. Taken to a more abstract level, the conflict staged in 'The Quilting' represents the incommensurability of the ideology of domesticity – that had determined women's position in society before and since the Second World War – with the demands that feminists were making in the early 1970s. John-Boy's monologue at the start of the episode sets the tone:

> On Walton's Mountain, as our parents had before us, we grew up taking for granted the traditions that shaped our lives. When my sister, Mary Ellen, took a stand against a solemn mountain custom it was a rebellion that rattled

the complacency of generations. She was seventeen, but the custom was older than even my grandmother could remember.

The custom in question – a gathering of the adult women of the community to sew together the squares of a quilt that each has produced in order to make a cover for the (marital) bed of the younger woman – has origins lost in the mists of time. The significance of the ritual is not, however, lost on Mary Ellen, who refuses to participate and rejects the quilting party's implication that she is ready to take her prescribed place in the sexual order, becoming wife and mother herself: 'I don't like what the old ways stand for. It means I'm available'. Later, Mary Ellen and Olivia explore the contents of the latter's 'hope chest' in preparation for its handover to the eldest daughter. Within the chest, Mary Ellen discovers evidence of her mother's artistic talent and learns of Olivia's youthful ambition to develop her artistry by attending college, an ambition she abandoned when she met and subsequently married John.

Tensions between Mary Ellen and Grandma reach breaking point on the eve of the quilting party after G.W. calls on Mary Ellen, bearing flowers and speaking of the possible future they might have together as a couple. Furious at her grandmother for arranging an event that apparently ordains the trajectory her future will follow, without any consideration for her own dreams and aspirations, Mary Ellen emphatically rejects the domestic role that tradition has cast for her:

> The word is out that Mary Ellen Walton is available for kitchen duty, housework and raising children. Well it's not true. I have other plans. You can go ahead and have your quilting Grandma, but I am not going to be there.

Eventually Mary Ellen relents and joins the quilting party, persuaded by a passionate speech by John-Boy about the value of family bonds and the damage that the rift between generations of Walton women would cause if Mary Ellen maintained her principled stand.

John-Boy's monologue at the end of 'The Quilting', speaks of the restoration of unity within the family, and of how the emotional bonds between family members can overcome conflict and – by implication – facilitate a reconciliation between the practices of tradition and the politically progressive demands of modernity. Thus harmony is restored to the Walton household by virtue of the elevation of familial relationships to a higher order of importance than the issue of a woman's independence, which lies at the heart of the conflict. At the episode's end the conflict is not resolved, but only temporarily subsumed into a larger structure of familial relationships, in which its need for resolution is relegated to secondary importance by what *The Waltons* presents as a more important concern over the preservation of family unity. As with many other aspects of the treatment of women in *The Waltons*, the narrative in 'The Quilting' does two things. First, it raises the prospect of a more progressive sexual politics in which women are not inevitably trapped within a restricted set of possibilities defined for them by the ideology of domesticity. But ultimately the episode does this only to demonstrate that the traditional patriarchally ordered society challenged by that progressive political position is really not so bad after all. With more than a hint of an echo of Farnham and Lundberg's antifeminist tract, the episode insists that society is structured by a complementary set of gender roles, with the woman's domestic place no less important or prestigious – and certainly no more restrictive – than that of the man: they are different but equal. Finally, in its conclusion, the episode repositions the issue that has been its central concern throughout as one that is relatively less important than it first appeared. This oscillation between the presentation of a progressive position and subsequent denial that the issue is as important or problematic as it first appears typifies *The Waltons* treatment of sexual politics, both in individual episodes (where it is relatively easy to detect) and in the longer narrative arcs concerning Mary Ellen's growth to womanhood, where its effects are more subtle.

Women's Work

Mary Ellen is the first woman in the Walton family to go into regular paid employment outside the home as her main occupation. Indeed, she is arguably the only Walton woman for whom entry into the traditionally male-dominated sphere of paid employment constitutes a significant element in the development of her character's narrative. Since this difference only really applies in the case of Mary Ellen, it is significant that this concession to the possibility of a difference between Mary Ellen's relationship to work and those of her mother and grandmother does not, then, signal an acceptance of a more widespread generational change in the position of women. Supporting this interpretation, at the end of the show's ninth season, Elizabeth, although clearly now a young woman, remains locked in the position of child, shown in one scene in the final episode cutting out and pasting together invitations in a clear echo of childhood activities. In another, Elizabeth's childlike quality is reinforced when she becomes unable to sleep properly when briefly moved out of the bedroom that she has hitherto shared with her older sisters ('The Revel', S9 E22).

Although Erin does attend secretarial college and take a job ('The Career Girl', S5 E17), she is nevertheless defined primarily – throughout the entire series – in terms of her attractive appearance and her rather romantic disposition. As a result, Erin is never placed in the position of rebelling against the woman's domestic role in the same way that Mary Ellen is. Closer analysis of the development of Mary Ellen's character along the show's longer narrative arcs reveals how the show maintained an overarching regressive conservatism in its representation of women while superficially acknowledging the real changes taking place in the world outside the series.

Mary Ellen's desire to pursue a career as a nurse was first introduced as one of the series' recurring themes during Season Three. The earliest indications of her future vocation are signalled in 'The Job' (S3 E11), in the opening scene of which Mary Ellen reads and recites facts about Florence Nightingale and, in a later scene, practices her bandaging skills on her brothers and sisters, and some of the domestic animals. This choice of vocation marks

a significant change in the development of Mary Ellen's character. In her younger years, Mary Ellen had always talked of her future life as being far away from Walton's Mountain and entailing some ostensibly glamorous career, such as an actress or dancer. This dream of the younger Mary Ellen is a far cry from the reality of becoming a nurse and serving the community in which she has grown up. Mary Ellen's change of direction is highly significant, since her new aspiration is key to the series' negotiation of the contradiction between its overarching regressive vision of a woman's place in the home, and the small concessions to the demands of feminism that the series makes from time to time. In essence, by allowing Mary Ellen to have a career as a nurse, *The Waltons* responds to both contradictory demands; she gains autonomy by becoming a wage earner but does so by taking a career path that is hardly an incongruous choice for a woman. As a profession, nursing had been established as a 'feminine vocation' long before the period in which *The Waltons* is set, and certainly long before the 1970s. The reference to Florence Nightingale early in 'The Job' reinforces this fact. Furthermore, nursing is an occupation that retains strong associations with the nurturing role traditionally assigned to women by the ideology of domesticity. In *The Waltons* nursing is, in other words, a type of paid domesticity.

A strong sense of the compromise implicit in Mary Ellen's decision to enter the nursing profession is discernible in 'The Abdication' (S4 E11), an episode set just before her entry to nursing school. In one scene, Mary Ellen gazes longingly at the night sky from her bedroom window, reading, as she explains to Elizabeth, the story told by the stars. As Mary Ellen recounts it, the story tells of a 'little girl' who 'used to dream all the time':

Mary Ellen: ...She dreamed that one day she grew up and become a famous actress, and she dreamed that she'd get married to a rich man and get lots of diamonds. For a while she even dreamed that she'd join a big league baseball team.
Elizabeth: What happened to the little girl.
Mary Ellen: Oh, she grew up and decided to become a nurse.

The scene is tinged with a palpable aura of regret: Mary Ellen acknowledges, 'here I am about to enter nursing school and I don't even know if I've lived yet'. Yet, if Mary Ellen is tempted to question her decisions, the scene also creates a strong sense that, in reality, she has no choice at all. Her destiny is 'written in the stars' and, while she can dream of alternative futures, she can only live in the material reality of the restricted possibilities that are available to women in *The Waltons'* regressive gender economy.

On the face of it, the development of Mary Ellen's character narrative is a secondary element in this episode. However, while it is not the main story, the two major narrative strands of the episode together serve to foreground the question of the options available to Mary Ellen as she moves from childhood to womanhood. The two narrative strands in 'The Abdication' tell interrelated stories. The first concerns the arrival on Walton's mountain of a film crew who are filming part of a movie; the second relates to the abdication of King Edward VIII. Although these are independent strands, parallels are drawn between the two stories through the development of a brief romance between a member of the film crew, Todd Clark (Stephen Collins), a vaguely upper-class Englishman, and Mary Ellen. Although this brief relationship is never very serious, nor expected to last, and although its ending is not dramatic in itself, the implied equivalence between Edward/Wallis Simpson and Todd/Mary Ellen inflects Mary Ellen's developing story with some of the qualities of Edward's abdication. In effect, by connecting Mary Ellen's story with that of the King's abdication, Mary Ellen's decision to pursue a career is portrayed as an abdication of a sort, a decisive break with the traditional ways and values – especially the ideology of female domesticity – and a shift into a modernity in which these values have been replaced with other priorities. In presenting this shift in the way it does, the episode positions its construction of modern womanhood as an ambivalent identity. The autonomy that Mary Ellen undoubtedly gains by her decision to take a career rather than remain at home is counterpointed by a profound sense of a loss of something that is inherently good and valuable. Near the end of the episode, the family gathers around the radio to listen to Edward's announcement of his renunciation of the

throne of England. Listening to Edward's speech, Mary Ellen sheds a tear. Ostensibly this is the reaction of a romantic, impressionable young woman to the story of a love so powerful that it has diverted a man from his 'inevitable' destiny. The tear shed by Mary Ellen is ambiguous, however, registering at once sadness at the loss of the King's throne and Mary Ellen's romantic sensibility. But it also registers the parallel between the King's story and Mary Ellen's own destiny as a woman in modernity; it is a tear shed by Mary Ellen for her own loss of innocence, her own departure from 'tradition' and 'duty' as she becomes the first Walton woman to move decisively outside the domestic sphere and into new and uncertain world of paid employment beyond.

Despite the melodrama of this transitional moment in 'The Abdication', the fact that Mary Ellen's future lies in the field of nursing facilitates a successful recuperation of her femininity for the domestic ideology that determines the limited range of possibilities available to women. A sense that Mary Ellen's movement into paid employment in fact registers very little real change in the way *The Waltons* envisions the meaning of womanhood – and the order of gendered roles, rights and responsibilities – is captured in a line spoken by Olivia in 'The Nurse' (S4 E13): 'A son is a son 'til he takes a wife, a daughter's a daughter for the rest of your life'. Olivia's words simultaneously evoke a powerful sense of the maturing male child's passage to manhood – to the day when he will take his (dominant) place in the patriarchal familial order – and, at the same time, of the woman's perpetual infantilisation – she remains a 'daughter for the rest of your life' – patriarchy's rationale for women's oppression.

'The Nurse', the first episode in the series to actually show Mary Ellen's movement outside the domestic sphere, portrays this move as a highly ambiguous one from the outset. As John-Boy's introductory monologue indicates, 'it was a time of *joy and pain* for her, and for the rest of us as well' [my emphasis]. Mary Ellen's eagerness to move away from Walton's Mountain is evident early in the episode. But her expression of this desire during a conversation with John-Boy is framed in terms that suggest a wish simply to get away from home as much as a positive calling to enter the

nursing profession: 'I just want to ride down off this mountain into the rest of the world'. In this respect, then, it is possible to see Mary Ellen's career progression as registering two key aspects of contemporary feminist discourse. First is the overarching desire to escape the life of domestic drudgery. Second, Mary Ellen's pursuit of a career registers women's positive desire for the autonomy to be gained by entering paid employment. That these two elements of feminist discourse are not precisely identical is exploited by *The Waltons* in order to perfect its ideological sleight of hand: appearing to embrace a progressive political stance – by allowing Mary Ellen to have her career – but then immediately reinstating a more restricted vision of the possibilities for women by creating strong parallels between the domesticity she has left behind and the type of career she is able to pursue: nursing as a kind of paid, extra-domestic domesticity.

In 'The Nurse', Mary Ellen's long-anticipated entry into nursing school immediately hits an obstacle. At the first entrance test for admission to the school, Mary Ellen finds she is unable to answer significant parts of the paper due to gaps in her earlier education. In order to pass the test she will have to undertake further study and apply again. Mary Ellen's disappointment returns her to the family and the familiar domestic setting in which she has lived her childhood. Crucially, at the moment when she has been most strongly asserting her adulthood and independence, her inability to take the test instantly returns her to a state of infantilisation; once again she becomes a little girl who runs crying into her father's embrace.

Mary Ellen eventually overcomes her disappointment, replacing it with a determination to acquire the knowledge necessary to pass the entrance test. When lessons with John-Boy prove inadequate for the task of mastering the chemistry she must learn, Mary Ellen turns to the only available source of inside information about entrance to nursing school, the local nurse, Nora Taylor (Barbara Ede-Young), for help with the study needed to pass the entrance exam. Mary Ellen finds nurse Taylor working at the home of a family further up the mountain, caring for a sick mother. On her arrival at this family's home, Mary Ellen discovers a scene of economic deprivation and

an extreme neglect of domestic hygiene; the family is clearly poor and, with the mother ill, domestic duties have fallen to the eldest daughter, a young and uneducated girl (we are pointedly informed that she cannot read) of unkempt appearance. In the hands of this child, the home has fallen into disarray. While waiting for Nurse Taylor to come out of the sick mother's bedroom, Mary Ellen sets about tidying up the living room and, when the nurse arrives, Mary Ellen has a proposition for her; Mary Ellen will help with the domestic chores in this household in return for the nurse's help with her study for the entrance exam. The scene achieves a number of very significant things. First, and most literally, it returns Mary Ellen to the domestic realm and establishes a sense of naturalness about her place in this setting; she is hardly inside this household before she sets about tidying up – even though it is not her home – as if to do so is an instinctive impulse for her. Second, through the exchange of domestic help for tuition – effectively giving the former the same value as the latter – the scene creates an equivalence between nursing and domesticity, between the life Mary Ellen strives for and that which she strives to escape. Finally the scene establishes a hierarchical relationship between Mary Ellen and the eldest daughter in the sick mother's family, a relationship that places Mary Ellen in the superior position and explicitly frames her ability to occupy that position in terms of her superior education, but crucially an education that is deployed in the service of domestic hygiene. In three different ways, then, this scene contrives to engineer Mary Ellen's return to the domestic sphere: it is at once her 'natural' place, a place that her educational attainments have prepared her for, and it is the eventual destination that her chosen career path will return her to. Thus it is, then, that while making ostensible concessions to the demands being made by many women in the 1970s, *The Waltons* maintains an image of the domestic sphere – albeit a slightly reconfigured one – as a woman's 'rightful' place.

This returning of the figure of progressive womanhood to the domestic sphere is repeated in a later episode, 'The Burn Out' (S4 E18). In this episode, following a fire in the Walton home, the children are sent to live with various members of the community while the house is repaired. Mary Ellen is sent to stay with the

local doctor. The aspiring nurse regards this development as 'the most exciting thing that has ever happened to me' and expects to be able to spend most of her time in the consulting room, observing the doctor at work. The doctor and his wife have other plans, however, the latter 'counting on your company and help, in the house'. This effort to return Mary Ellen to the domestic realm is unsuccessful, as she insists on assisting the doctor in his work as much as possible. This becomes the source of considerable tension between Mary Ellen and the doctor's wife, who views the young woman's interest in the doctor's work as inappropriate and highly intrusive. Both doctor and wife are clearly relieved when repairs to the Walton house are completed and normalcy is once again restored – significantly, a move that yet again returns Mary Ellen to the domesticating and infantilising setting of the family home.

Mary Ellen's character is consistently used by *The Waltons* to problematise the aspiration women were vociferously expressing during the 1970s, to have independent lives outside the domestic sphere. *The Waltons* achieves this both by its normalisation of domesticity as the 'proper' occupation for women (an aspect of the show that is evident in the construction of many of the female characters) and explicitly through its depiction of the problems that Mary Ellen encounters as she moves toward her goal of a future life and career other than as a homemaker.

The most dramatic depiction of Mary Ellen's problems is found in 'The Obsession' (S7 E4), an episode that deals with Mary Ellen's preparations for her final nursing exam. Exhausted by the combined pressures of both working as a trainee nurse and of studying outside working hours for her exam, Mary Ellen asks a doctor at the hospital for some 'pep pills...just enough for three or four days'. Predictably, however, overcoming the hurdle presented by this first test merely raises the problem of yet another exam that follows it. Pleased with the new feeling of alertness that the pills have provided, Mary Ellen retains a number of unused pills, and uses them to maintain her level of alertness once the test is done. When these pills run out, Mary Ellen obtains a further supply from the doctor, together with a supply of sedatives, which she requires to counteract the effect of the amphetamines when she needs to

sleep. Very soon, Mary Ellen is using higher doses of both uppers and downers and she becomes dependent on the pills. Although the pills enable Mary Ellen to make good progress with the studies that will enable her to have the career she dreams of, they exact a high cost: Mary Ellen becomes extremely temperamental, experiences dizzy spells and starts to neglect her baby, sleeping her medicinally induced sleep while he cries for long periods, in need of his mother's attention.

The damaging effects of Mary Ellen's addiction reach a peak on the eve of her final exam when, unable to sleep and having used up her supply of sedatives, Mary Ellen breaks into the medicine cabinet in her husband's surgery in order to obtain a further supply of pills. Having reached the lowest point in her pursuit of a career outside the domestic sphere, Mary Ellen returns to the familial fold, yet again an infantilised figure; as she tells her mother, 'I wish I was a baby again and you could rock me to sleep'. Mary Ellen's pursuit of independence and a career has turned her into the very antithesis of the strong, independent vision of womanhood her character has sought to be at other times.

Thus it is, then, that *The Waltons* constructs, in Mary Ellen, a vision of womanhood that makes superficial gestures in the direction of feminism while maintaining an underlying belief in a restricted role for women in society; as mothers, as wives, as nurturers. Even though Mary Ellen recovers from the low point she reaches in 'The Obsession', her career as a nurse is never really shown as a radical alternative to domesticity. Not only is nursing constructed as domesticity in a different form but, while she is a working woman, Mary Ellen remains a mother and also attends to her domestic duties outside working hours. If the demands of feminists in the USA in the 1970s disturbed the peace of mind of many Americans who maintained a belief in the traditional order of society,[15] then *The Waltons* worked hard to reconfigure the visions of feminism through the character of Mary Ellen Walton in a way that would reassure viewers of the show that feminist demands could be met in a way that actually entailed little fundamental change to the traditional gendered structure of society or to the 'natural' places of both men and women within that order.

6

Goodnight John-Boy?

Officially, John-Boy said 'goodnight' for the last time on 4 June, 1981: the original air date of 'The Revel' (S9 E22), the concluding episode of the final season of *The Waltons*. The familiar scene at the end of the episode has an unmistakable air of finality about it, dispensing with the usual 'goodnights' exchanged between family members and featuring instead a monologue spoken by the extra-diegetic narrational voice of John-Boy. The monologue addresses the viewer directly:

> I hope that you'll remember this house as I do. The mystical Blue Ridges that stretch beyond it into infinity. The sound of warm voices drifting out upon the night air. A family waiting and a light in the window. Goodnight.

Despite this aura of finality, the show would not remain 'asleep' for long. It returned for no fewer than three television movies in the following year – *A Wedding on Walton's Mountain, Mothers' Day on Walton's Mountain* and *A Day For Thanks on Walton's Mountain* – and a further three in the mid-1990s: *A Walton Thanksgiving Reunion* (1993), *A Walton Wedding* (1995) and *A Walton Easter* (1997). Since then the original episodes have enjoyed frequent re-runs on both broadcast and cable television channels, most recently on the Inspiration Network,[1] which started to show *The Waltons* in October 2010.

Beside these occasional television revivals, however, the survival of the mythical, nostalgic aura of *The Waltons* in the minds and

hearts of the show's numerous fans has ensured the continuing cultural significance of the show. The aim of this chapter is to examine in greater detail the phenomenon of Waltons fandom: to explore some of the meanings and significance that the series continues to possess for its dedicated fan base. In order to undertake this exploration of Waltons fandom, several sources have been used. The primary research data used in this chapter is drawn from the web forums maintained by 'The Waltons Forum'.[2] Supplementary data are drawn from posts and discussions within various relevant fan groups hosted on the social networking website, Facebook: 'Waltons', 'The Waltons' and 'I grew up watching the Waltons and I still love it', which have 286, 1,550 and 530 members respectively. While all of these internet-based sources require registration in order to be able to post comments, no limitations exist regarding access to the group in order to read the posts of other users. Posts on these sites may, therefore, be read by anyone with a computer and access to the internet. The posts placed on these forums are, therefore, unambiguously in the public domain, being willingly placed by their authors on freely-accessible websites, without any indication of an intention or desire to restrict their subsequent use.[3] Some authors of posts adopt anonymising screen identities while others do not. Since the research undertaken for this chapter involves material freely placed in the public domain by its authors and freely accessible by all, it is not considered that the use of this material in this book raises any problematic ethical issues. Contributors to the forum have, therefore, not been anonymised further than their self-anonymising screen identities for the purposes of this chapter.

This chapter has a larger purpose than simply describing how Waltons fans talk about the show and use it in defining their identities as fans. Recent years have seen an explosion of scholarship on the subject of fandom and, as much as it attempts to understand Waltons fandom, this chapter also seeks to use the phenomenon of Waltons fandom to test some of the conceptual frameworks that theorists have developed in order to understand fandom more generally. The first step to understanding the larger significance of the precise character of Waltons fandom, therefore,

is to contextualise Waltons fandom by examining some of the claims that media scholars have made for fandom generally.

Conceptualising Fandom

In recent years, the study of the activities of fans has come to play an increasingly important role in media scholars' understandings of the uses made of media texts and, particularly, how those texts are deployed by readers in the act of defining identities and producing social meanings. The origins of what is today thought of as 'fan theory' can be located in the late 1980s and early 1990s, in seminal works such as Janice Radway's *Reading the Romance* (1987), Ien Ang's *Watching Dallas* (1989) and Christine Geraghty's *Women and Soap Opera* (1991). While certainly not the first works of cultural criticism to consider fans, these were notable for their radical divergence from the earlier conception of fans evident in the writings of those working under the Frankfurt School's influence, which usually dismissed fans as hapless dupes of the 'culture industries'. This way of understanding mass media consumption was typical of scholars such as Adorno and Horkheimer, who saw, in the fans of mass culture, an assimilation 'to what is dead', an 'enigmatically empty ecstasy' – the very antithesis of politically efficacious agency.[4] However, in stark contrast to the pessimistic evaluation of fandom offered by the Frankfurt School, later theorists such as Radway, Geraghty and Ang proposed that, through fantasies of identification with the characters in popular texts such as soap opera or romance fiction, fans – predominantly women in these early studies – used media texts to create for themselves an opportunity for a momentary escape from the realities of their busy lives – lives often dominated by the imperatives of domestic labour, by their roles as wives and mothers. These texts provided their fans with an opportunity to indulge in the (frequently guilty) pleasures they offered, a chance to attain a competence in the understanding of those texts. Possession of this type of esoteric competence provided a sense of identity for fans, a feeling of belonging within a community

of like-minded individuals sharing a common (and often intense) interest in these texts.

That these early studies focused on the activities of women fans, and were driven by feminist political imperatives, is crucial for contextualising the way fan studies has developed since. Feminism has certainly produced a progressive shift toward greater equality between the sexes, with gains for women politically, socially and economically. Notwithstanding these gains, however, patriarchy has proven remarkably resilient in practice, as continuing wage disparities between men and women in similar jobs, and other enduring instances of sexual inequality, demonstrate. Given that these continuing inequalities between men and women were, if anything, more pronounced in the 1980s when these pioneering studies were undertaken, it is not difficult to see that the women whose fandom was examined in these early studies formed part of a real subordinate class within the existing socio-political order maintained by the operations of power within patriarchy.[5] As these early studies demonstrate, one of the tactics adopted by members of this subordinated class was to take pleasure where they could in symbolic escape into the fantasies of other possible life-chances offered by romance and soap opera texts. This vision of a politically oppressed class taking refuge within fantasy – and, by so doing, engaging in an act of symbolic resistance against their oppression – is the key idea that has shaped the more recent development of fan studies. But there are important differences between the works of the earliest theorists to take fandom seriously and those who followed, whose work will be discussed further in the following paragraphs.

The most prominent of these 'second wave' fan theorists is Henry Jenkins.[6] Like earlier theorists of fandom, Jenkins' work focuses on the ideas of fantasy and escapism, but also draws some of its key ideas from the work of Michel de Certeau, particularly the notion of textual 'poaching'. Jenkins' work on fandom amplifies the significance of some of the fannish tendencies and practices discussed in the earlier accounts of fandom offered by Ang, Geraghty, Radway and others. The effect of this amplification is to produce a rather hyperbolic account of fandom, in which

Jenkins conceives the activities of fans as a kind of politico-cultural dissidence or resistance to the hegemony of mainstream culture. This belief represents an important point of departure between Jenkins' understanding of fandom and the understandings offered by the earlier theorists. Radway, for example, was ambivalent about the political efficacy of fan activity, recognising that there was an inherent political contradiction in the uses her romance readers made of their chosen texts – acknowledging explicitly 'the possibility that although romance reading may enable women to resist their social role and to supplement its meager benefits, romances *may still function as active agents in the maintenance of the ideological status quo*' [my emphasis].[7] Jenkins, on the other hand, conceives the relationship between fans and the objects of their fandom as a much less ambiguous form of political subversion. Borrowing from de Certeau, Jenkins argues that media fans should be seen as 'textual poachers' – as raiders plundering the precious semantic resources provided by media texts and then using these in ways never intended by their creators, in order to create new meanings. Conceived thus, the media fan becomes a kind of textual terrorist – 'guerilla fighters, making tactical raids on the structures of the powerful by poaching on their texts', as Milly Williamson puts it in her compelling and convincing critique of Jenkins.[8] In Jenkins' account the fan is a semiotic revolutionary practicing acts of rebellion and resistance using the very materials that were created by 'the establishment' for the purpose of reproducing and sustaining the reigning cultural hegemony.

Jenkins' vision of the fan-as-subversive has become a highly influential one in recent years. Taking a similar position to Jenkins, Camille Bacon-Smith presents another peculiarly hyperbolic account of the political dimension of the practices of fans, conceiving fans as creative cultural producers whose fannish activities amount to a:

> bending of popular culture artifacts – in some cases, popular culture icons – [which] is a subversive act undertaken by housewives and librarians, schoolteachers and data input clerks, secretaries and professors of medieval literature,

under the very noses of husbands and bosses who *would not approve*, and children *who should not be exposed* to such acts of blatant civil disobedience.[9]

In Bacon-Smith's account, the characterisation of the fan as a subversive – a member of an underground resistance, fighting the forces of textual authority and authorial power by appropriating textual resources to their own ends – appears to be no mere metaphor: 'Beneath the grins and the giggles and the pajama party atmosphere', claims Bacon-Smith, gatherings of fans, are an 'act of rebellion', the dangers of which to the reigning cultural hegemony are such that these meetings demand a level of secrecy and insider knowledge between fans which 'can only be compared to the poetry movement in Russia'.[10]

Bacon-Smith's account of fan activities may push the theorisation of fandom to an absurd extreme, but in essence the vision she presents, of fans as creative appropriators of the resources provided by the television series or franchise which provides the focus of their fandom, really differs only in degree from that found in Jenkins' work. Between Jenkins and Bacon-Smith we find, then, the essence of 'second-wave' fan scholarship, which has now come to represent the reigning orthodoxy in the theorisation of media fandom.

I have already alluded to the fact that the indebtedness of contemporary theories of media fandom to earlier work that employed feminist theories to understand the activities of female fans has important implications for understanding the way that later theorists have conceptualised fandom. In building on the ideas of the earlier feminist accounts, these later fan theorists appropriate ideas that were highly relevant to the understanding of the activities of social groups that existed under conditions of real political oppression and marginalisation, but without giving sufficient consideration to the question of how appropriate it is to apply these ideas to the conceptualisation of social groups that do not necessarily consist of the oppressed or marginalised. There is, however, another important element in the heritage of Jenkins' and Bacon-Smith's work, and that of much of the more recent research on fandom, which compounds this error.

As well as feminism, contemporary fan theory owes a great deal to a version of subculture theory that developed out of the British cultural studies tradition in the 1970s. In a similar vein to the arguments Jenkins makes about the practices of media fans, the pioneers of youth-subculture theory earlier suggested that the activities of subcultural groups amounted to a rejection of establishment authority and of the structures of power that attempted to hold that authority in place. Like media fans – who, according to Jenkins, plunder the riches of mainstream texts, reconfiguring their meanings through a type of semiotic terrorism – subculture members were thought of as *bricoleurs*; creative appropriators who take conventional objects and radically change their meanings through 'unauthorised' modification of those objects and by the juxtaposition of objects never intended by their creators to be seen together. Subculture members were, as Dick Hebdige put it, 'resisting through rituals...challeng[ing] the symbolic order which guarantees their subordination' as a precursor to more direct forms of political activity.[11] Two very important consequences follow from this lineage of contemporary fan theory; consequences that severely limit the credibility of fan theory's insistence on seeing media fandom as a politically subversive act. First is that there is a clear sense in Hebdige's understanding of subcultural resistance that the symbolic challenge to the establishment, enacted by 'dressing strangely, striking bizarre attitudes... issuing rhetorical challenges to the law'[12] was a supplement to other forms of political action that included more literal forms of resistance to authority – 'breaking rules, breaking bottles, windows, heads'.[13] In Hebdige's account, then, it is clear that spectacular symbolic acts of resistance were not so much an end in themselves as they were a necessary prerequisite to gaining access to the adult world of real politics by overcoming the obstacles to political participation created by the socio-linguistic act of defining subculture members as 'youth': as '"children", "youngsters", "young folk", "kids"'.[14] While Hebdige's explanation may be convincing in its original context, it is quite a stretch to give the same argument much credibility when applied to, say, the fans of television shows rather than members of spectacular subcultures engaging in real acts of political defiance. For this argument to have

credibility it would be necessary for these media fans to be engaged in other forms of political resistance; something that 'second wave' fan theorists conspicuously neglect to demonstrate. The second issue arising from 'second wave' fan theorists' decision to follow the trajectory of subculture theory flows from the exclusive focus this has on spectacular instances of fandom. These groups may indeed provide the most visible manifestations of fandom but they are exceptional cases, and any basis there might be for arguing that the activities of these groups can in some way be seen as resistant derives in large part from their very visibility, and the fact that they are *exceptional* rather than the norm. By focusing on the exceptional, however, these theorists risk losing sight of the very obvious point that there are numerous instances of fandom which involve none of the 'resistant' behaviours which second wave fan theory attributes to media fans. These theorists of media fandom follow the subculture theorists who went before them too closely, and inherit some of their blind spots, particularly the 'downplaying of the "middlebrow" or of any cultural experience which is not "spectacular" or "resistant"'.[15]

It is my argument that these two consequences of subculture theory's legacy to fan theory represent key weaknesses in the way that fandom is currently understood. Fan theory mistakenly conflates symbolic acts of non-conformity with real acts of political resistance. That is not to say that the fan who wears Vulcan ears or dresses as Obi Wan Kenobi on one occasion may not also engage in acts of political resistance on another; perhaps even while so dressed. It is important to acknowledge, however, that the wearing of Vulcan ears or Jedi clothing does not, in itself, amount to an act of political resistance by any stretch of the imagination.

Before proceeding to look at aspects of Waltons' fandom in detail, it is fair to note that while there are some significant variations between different ways of conceptualising fan behaviour across the corpus of writing on fandom, there are also some significant points of agreement. If it is possible to construct a spectrum (albeit a highly schematic one) across the literature on fandom between those at one end, such as Geraghty, Ang and Radway, who conceive fandom as an escapist practice and make

fairly modest claims about fandom's political efficacy (as opposed to its very real value as escapism), and the likes of Jenkins and Bacon-Smith, at the other end of the spectrum, who envisage fandom as a form of subversion, it is necessary (and productive) to note that there exist a few areas of broad agreement, even between writers who offer fundamentally different analyses of the activities of fans. Before turning to consider how fan theory can inform an analysis of Waltons' fans, it is worth reflecting briefly on the points of accord and discord between *fan-as-escapist* and *fan-as-subversive* camps.

There are two major points upon which both schools of fan theory agree. The first is that fans are active producers of meaning and not merely passive consumers of the object of their fandom. Implicit in this is a general agreement that the texts around which fandom develops are polysemic to some degree and, therefore, capable of sustaining multiple different interpretations from different perspectives. Following from these conclusions is the second common point of agreement between theorists of fandom: that power over the meanings of the texts around which fandom develops does not inevitably reside with the authors of those texts, but is often a site of contestation between the 'authors' of the texts, and their 'readers'. This power struggle over textual meaning is inherent in de Certeau's understanding of readers as *bricoleurs* who deploy various 'tactics' to read texts – of which they are not the producers – 'against the grain' in order to derive meanings that are 'useful' to those readers but which may be oppositional insofar as the 'official', authorised meaning of the text is concerned. This understanding of reading as an active process enables readers to 'maneuver "within the enemy's field of vision"' as de Certeau puts it,[16] a conception of reading practices that is imported into fan studies by Jenkins' adoption of de Certeau's ideas. However, this sense of the reader as having an active role in producing the meanings of texts can also be found in Radway's account of her romance readers, an account that Radway states is essentially 'a semiotic one in the sense that it focuses on the way that human beings actively make sense of their surrounding world'.[17] Nor is the sense of resistance or oppositionality within fannish reading

practices – so central in Jenkins' argument – entirely absent from Radway's account either:

> Because reading is an active process that is at least partially controlled by the readers themselves, opportunities still exist within the mass-communication process for individuals to resist, alter, and reappropriate the materials designed elsewhere for their purchase.[18]

Many of the variations between different accounts of fandom are, therefore, differences of degree rather than fundamentally different ways of understanding fan activity. At first sight it might appear impossible to reconcile the relatively innocuous activities of Radway's 'Smithton' romance readers – who seek, in romance-reading some relief from the mundanity of domestic duty – with the vision of Vulcan-eared 'guerrilla raiders' (presumably with their semiotic phasers set to 'kill'), conjured up by Jenkins' and Bacon-Smith's insistence on seeing fandom as a form of subversion. However, within both accounts it is possible to detect a common quest for a utopia that each group of fans finds through their uses of the texts in question. In this respect, then, it is worth interrogating the assumption that fans differ greatly from non-fan users of media texts who also find within those texts an avenue of symbolic escape from the problems of everyday life or – as Valerie Walkerdine describes the activity of girls reading comic books – 'solutions and escapes, ways out, in fantasy and in practice, by the proffering of what and who one might be'.[19] Given that this sort of mundane escapism lies at the heart of what is hyperbolically described as textual 'raiding' and 'poaching' by Jenkins and others, it is perhaps hardly surprising that the texts around which many fan communities develop are often texts that, at any level of reading, already contain powerful elements of fantasy (Star Trek, Star Wars, vampire fiction and television, etc.), featuring, as they do, an array of powerful, autonomous characters around whom fans can relatively easily (without subverting the 'official' meanings of these characters in any way) construct fantasies of their own empowerment and autonomy.

If the difference between the *fandom-as-escapism* vision offered by Radway, Geraghty and Ang (among others) and the *fandom-as-subversion* model proposed Jenkins and Bacon-Smith is – in this respect, at least – one of degree, in other ways the two accounts are at radical variance. Inherent in *fandom-as-subversion* accounts is an implicit disavowal of real-world politics. Within this theoretical frame, the broad range of real political issues becomes subordinated to a narrow version of identity politics. This focus on the politics of identity enables fans to become consumed by their elaborate fantasy worlds to the extent that they are able to imaginatively disengage from the politics of the material social realities in which they live, to reside instead in fantasy. In Jenkins' account, this abnegation of real politics seems to be considered an act of political subversion in itself. This aspect of the understanding of fandom offered by theorists who see fans as subversives is particularly vulnerable to criticism. Toby Miller, for example, has rightly questioned the validity of fan theorists' conflation of fans' acts of symbolic non-conformity with real political resistance, asking whether fans can really:

> be said to resist labor exploitation, patriarchy, racism, and U.S. neo-imperialism, or in some specifiable way make a difference to politics beyond their own selves, when they interpret texts unusually, dress up in public as men from outer space, or chat about their romantic frustrations?[20]

In the brief analysis of Waltons' fandom that follows I will suggest that they cannot; that, in fact, fandom is little more than a distraction from the realities of everyday life: political realities which some (maybe many) fans – far from expressing their resistance – appear to accept their inability to change by the very act of retreating into fantasy worlds. More than this, I argue that coming to the conclusion that fans might engage in politics through their fannish activity is a consequence of fan theory's exclusive focus on an extremely limited set of examples of spectacular fandom, upon which basis claims are made about fandom more generally; claims which are empirically underdetermined and which may be destabilised by

greater attention to non-spectacular instances of fandom. I argue that, as a consequence of its selective omissions and blind spots, much 'second-wave' fan theory is of limited value for understanding fandom in a more general sense than the specific cases in question. As a corrective to the tendency of many fan scholars to overplay the spectacular, the examination of Waltons fandom that I undertake below is very much an exploration of fandom of an unspectacular, middlebrow sort. Significantly, in the context of the brief discussion of fan theory that precedes this account, I argue that this small case study quite clearly demonstrates the fallacy of any theory of media fandom that simplistically equates fan uses of media texts with symbolic resistance. Indeed, the analysis that follows demonstrates that fans' deployment and reworking of textual materials can often be anything but resistant to either the 'official' meanings of the text in question or to the political hegemony more generally.

Waltons on the Web

There are numerous websites devoted to providing information about *The Waltons*, its creator and cast. While many of these are the work of fans of the show, my examination of Waltons fandom in this chapter focuses exclusively on sites built around a 'forum' format in which any registered member of the group can post topics and engage in discussion with other group members. Sites such as the 'Waltons Weblog' (http://thewaltons.wordpress.com/) and the 'Waltons Digest' (http://the-waltons-home-page.com/WaltonsDigest/waltonsdigest.htm) are not considered in this chapter since they appear to be the work of one person and offer only very limited opportunities for discussion between several fans. 'The Walton's Mountain Community Center' (http://users.galesburg.net/~atkins/waltons.html) is excluded for the same reason. At the time of writing, a 'Community Center' subgroup, 'The Waltons Webring' is apparently no longer in existence, and another fan forum site, 'The Waltons Fanpop Fan Club' (http://www.fanpop.com/spots/the-waltons) also appears to be defunct: although it has a small number of members (24), nothing has been ever posted to the

site. Other fansites have been more successful, however. The social networking site, Facebook, hosts four different groups having some relationship to the show. One of these, 'The Waltons' (http://www.facebook.com/Waltons), appears to be defunct: despite having been 'liked' by 7,785 people (accessed 29 December 2010), it has no members and only one post, placed on 11 November 2008, saying 'Stay tuned! More stuff will be added soon'. The largest of the remaining Facebook groups, 'The Waltons' (http://www.facebook.com/group.php?gid=2221047206 – accessed 29 December 2010), has 1,527 members and, notwithstanding the fact that it explicitly refers to the television show in the group description, it was apparently set up as a family interest group for people who share the surname 'Walton'. This original purpose has not, however, deterred numerous fans of the show from registering as members, and the group has organically evolved to be more like a fan group. While this appropriation of this group by fans of the television show might be interpreted as a sign of the existence of a thriving and proactive community of Waltons fans on Facebook, I would suggest that the limits of this interpretation are demonstrated by the banal nature of the comments posted to this group page and to the two other extant fan groups on Facebook: 'I Grew Up Watching the Waltons and I Still Love It' (http://www.facebook.com/group.php?gid=2375812037) and 'Waltons' (http://www.facebook.com/group.php?gid=68877496368). Most of the posts to these groups consist of simple expressions of 'like' for the show, interspersed with a large number of posts which either speculate about, or provide information concerning, the latest television reruns of the show. Across the range of these sites there is little evidence of the sort of fan creativity – let alone the resistance – that fan theorists like Jenkins and Bacon-Smith have identified as hallmarks of fandom. Indeed, so limited and bland is the content in these sites that they offer little in the way of material for analysis at all and they are not given further consideration in this chapter.

A more active community of Waltons fans is, however, to be found in 'The Waltons Forum' (http://waltonswebpage.proboards.com/index.cgi). Since it is the richest source of data on Waltons fandom, the posts on 'The Waltons Forum' provide the material

analysed in greater detail in this examination of Waltons fandom. The argument that emerges from the analysis is that, while it is certainly possible that some fan groups appropriate textual resources to their own – sometimes resistant – ends, this is not an adequate (and is often not even an accurate) account of the behaviour of fans in general. I do not propose, in this chapter, an alternative model to the dominant accounts of fandom. Waltons fans are themselves too small and specialised a community to permit such general claims to be made, and there is ample evidence in the literature of equally small, specialised groups of fans of other media texts who behave in quite different ways to Waltons fans. However, I do argue that what we see when we examine Waltons fandom as expressed through 'The Waltons Forum' demands that we develop a more sophisticated understanding of fandom than the reductive *fandom-as-subversion* model that currently holds sway.

The Rebirth of the Author: The Waltons *as a 'Readerly' and a 'Writerly' Text*

In 1968 Roland Barthes famously proclaimed the 'Death of the Author'. Despite giving the author prominence in the dramatic title of his essay, the demise of authorship was really little more than the logical corollary of a broader shift within literary theory that was the real focus of Barthes' essay: a shift of power over the meaning of a text from its creator to its readers. This was a theme that recurred throughout Barthes' later work, and which registered something of an epochal shift in the understanding of the process of making meaning; a theoretical shift often characterised (rather over-simplistically) as being from structuralism to post-structuralism. Barthes' work around this time is, then, emblematic of broader theoretical shifts which displaced the producer of a text from the position of authority over its meaning hitherto occupied by 'the author' and replaced this centralised authority with a relatively anarchic and fragmented conception of meaning production in which the 'active' role became the possession of the text's myriad readers. After this shift, there was no longer any

question of thinking about what the author had intended when s/
he wrote the text, nor even of what the text itself 'meant' in any
final, definitive sense. Instead, any individual text simply became
a resource for active readers, a container of semantic elements
that remained only potentially meaningful until 'activated' by a
reader in the particular context of a specific instance of reading.
Barthes may have conceived the 'death of the author' as the act
that enabled the 'birth of the reader'.[21] But it also delivered –
placenta-like – the polysemic text; only potentially meaningful in
itself, but having the capacity to yield a wide range of meanings,
limited less by the constraints structured within the text itself
than by the various identities of its readers and the contexts
inhabited by them.

This shift to a pluralistic, reader-activated theory of meaning
is an essential prerequisite for fan theory's conception of media
fans as 'textual poachers' or subversives: it is the potential to
make a wide variety of meanings from a given text that enables
fans to appropriate elements of the original media text and use
them in ways not authorised by the text's creators. This purloining
of the text's riches is seen as a central part of the creativity of
fans by theorists like Jenkins, facilitating an array of creative fan
endeavours ranging from simply reading the 'official' text 'against
the grain' in order to produce interpretations at variance with
the producer's intended meanings, to acts of material creativity,
in which fans literally create new texts based on characters,
themes and settings they have plundered from the source texts
and reworked into new narrative and sometimes visual forms.
'The Waltons Forum' provides evidence that Waltons fandom
exhibits both of these forms of fan creativity: through communal
discussion of the interpretation to be given to events that occur
within the diegetic world of the series, and through the creation
of new fan-authored texts utilising characters and settings from
the show. To the extent that debates between fans necessarily
involve some negotiation of ambiguous meanings in ways that
might not be those originally intended by the show's creators,
it seems Waltons fans exhibit at least one of the patterns of fan
behaviour conceptualised by Jenkins and others as a 'resistant'

endeavour. However, closer attention to efforts by members of 'The Waltons Forum' to negotiate textual meaning reveal an underlying dynamic that is anything but resistant, as the following examples demonstrate.

A post placed on the forum in December 2009 begins an initially unremarkable discussion between forum members concerning the meaning of, or the underlying reasons for, events that occurred in the show. Referring to the enforced absence of the actress Ellen Corby (Grandma Walton) from Season Six as a result of her suffering a stroke, the initiator of the thread – screen-name *stldan* – remarks that s/he found the absence of references to Grandma in Season Six rather unnatural and indicative of a certain callousness by the show's producers toward the actress and the popular character she played:

> it strikes me as very glaring that she is rarely, if ever, mentioned. What an awkward and disrespectful way of dealing with her illness and absence – to essentially pretend that she doesn't exist. She is such a vital character that it defies any logic to completely ignore her not being at home.
> I suppose they took Ms Corby out of the opening credits due to some sort of contractual issue. Still, I'm sure she was committed to coming back, and this seems like one more awkward attempt to avoid addressing the issue.[22]

In early responses to this post, other forum members agree with the sentiment expressed by the initiator of the thread: for example, one member – screen-name *ssMarilyn* – replies, 'I agree and feel the same way about the way they treated her absence. I'm watching that series right now and it really bugs me that the family acts so happy and rarely ever mentions Grandma, especially Zeb!'[23] Another respondent – screen-name *tankeryanker* – also endorses this view, wondering why the programme makers apparently found it problematic to simply incorporate the actress's illness as a plot device to explain her character's absence:

I never understood why they did not just come out and say that she had a stroke and that, that [sic] is why she is in the hospital. Would have made a heck of a lot more sense than the way that they wrote it.[24]

The next post in this thread is particularly important and represents a turning point in the discussion. This post comes from the forum member, *ericscott*, the screen-name adopted on 'The Waltons Forum' by the actor Eric Scott, who played Ben in the television show. Scott's post explains the treatment of Corby's absence thus:

At the time, Ellen was very much on all our thoughts and prayers. We were visiting her at home and she was visiting us on the set. We really did not know if she would be able to return to the rigors of a TV series. How to deal with it on the show was discussed constantly by the producers. I remember the opinion was we did not want to constantly bring it up, it would deter from the new storylines that we were trying to convey. It was not meant as a disrespect and I am sorry you feel that. Remember, the show was not a constant thread of life, like the Tv show "24", we intentionally missed alot of lifes [sic] events ... I hope that clarifies some of the wonderful mysteries of this show.[25]

Scott's intervention in the thread changes the direction of the discussion, and subsequent posts reveal both a willingness to accept Scott's explanation and palpable relief that a sense of order and certainty – crucially flowing from one who speaks from a position of authority – has been restored. The reply immediately following Scott's post is particularly instructive:

Glad to see you drop in on us every now and then. Sometimes things get misunderstood and need cleared up. If anybody would know the situation, you would because you were there.[26]

This sentiment is echoed by two further posts submitted later in the day: 'The way you explain it makes sense'[27] and 'It's great to have Eric's input. From a viewer's pov, sometimes it's hard to move on as easily as the writer's [sic] would like us to'.[28]

This thread thus moves through two distinct phases, punctuated by the intervention by Scott. In the first phase there is palpable disgruntlement at the perceived awkwardness with which Corby's illness was handled by the show's producers and at the way her character (one of the most popular among fans) was effectively just written out of the show for a period after her stroke, when it would have been possible to incorporate reference to this extra-diegetic event into the show in order to maintain a sense of continuity about Corby's presence in the cast. In this phase of the discussion there is a sense that the kind of utopia that *The Waltons* presents on-screen for its fans might be undermined by more cynical attitude prevalent among its makers. Scott's intervention does two things. First, and most explicitly, it offers reassurance to the fans that those involved in the production of the show were duly concerned about Corby's wellbeing, were not treating the actress callously after her illness and that there was, in fact, no disparity between the impression of caring, community values created on-screen in the show, and the values really possessed by those involved in the production. More significantly, however, the second effect of Scott's intervention is the re-establishment of authority over the meaning of the text on behalf of its producers. For the fans contributing to this thread on the forum this intervention decisively ends the debate and resolves all speculation about the producers' motives. Furthermore, for these fans this is apparently a desirable state of affairs. Indeed the intervention produces an almost palpable sense of relief that any ambiguities surrounding the treatment of Corby and her character have been 'cleared up'; that all contradictions have been removed, all debate terminated by authoritative voice of one who 'would know the situation ... because you were there'.[29]

A similar situation arises in another thread on the forum. In this thread one member – screen-name *tankeryanker* – raises a question about the correct running order of episodes and expresses frustration that episodes are listed 'out of order' on the DVDs.[30]

This post registers the fact that episodes were often broadcast in a different order to that in which they were filmed, a source of frustration for many fans. The post generates some discussion about this aspect of the show, with fans falling into one of two camps: those who think the running order matters and who find this aspect of the broadcast of episodes a source of frustration, and those who regard this as a matter of little importance. A link to an episode list online, posted by another forum member in response to the original request, merely serves to highlight the problem, drawing the reply from the thread originator, 'but that is not the way the episodes were filmed. That is the order they were viewed originaly [sic] and/or placed on the DVDs'.[31] As the thread progresses, additional replies confirm the originator's feeling that filming order and broadcast order were different, leading to occasional continuity incongruities between episodes. Opinions about the importance of this differ between forum members. For *rhonda* it is an inconsequential matter:

> Hmmmm. I don't understand why it is so important to know in what order they were filmed!! If when reading a book it was printed in the order that it was written then we wouldn't be able to make heads or tails out of it! On the dvd's they are in order that they origionially [sic] appeared! How on earth can that be 'out of order'?[32]

For others it is an annoyance, one that disrupts the verisimilitude of the series:

> some of us do not like to watch Erin graduate in one episode and then later watch her, Ben, and Elizabeth [sic] get sent to school (which she should have already graduated from). If I knew the proper order, then I will watch them in the proper order and not watch hair lengths lengthen and shorten and lengthen again etc ... [33]

The next reply, by *rhonda*, registers the absence of consensus among fans about the importance of the running order of episodes

and whether there is a 'correct' way in which they should be watched:

> I understand what you are saying and I meant no disrespect. I guess we all watch them in different ways and I have seen each episode so many times they are like listening to stories my Grandparents used to tell. When I watch and or listen, it's comforting to me like those old stories they were ramdom [sic] stories of my Grandparents [sic] lives and never in any particular order.[34]

At this point in the discussion *ericscott* intervenes once again:

> I think your assessment is the most accurate when we were filming. Unlike a soap opera which has running story lines, we always felt that each episode was stand alone. Yes there were times that a story line was carried over (marriages, deaths) but they weren't often.
>
> Carol, I remember finding out that the Hunt was not going to be shown first and my reaction was shock but when you look at the entire product, it shouldn't deter. There was ALOT [sic] of discrepencies [sic], how about Erin jumping over me!! Take the series as a man's memories, sometimes consistant [sic] sometimes not, but always entertaining.[35]

Yet again Scott's intervention serves to terminate the fans' debate over ambiguities about the show's meaning – the question whether the episodes possess a chronology or not – and whether this is important so far as the integrity and enjoyability of the text are concerned. As in the other example discussed above, Scott's post achieves this by asserting the creative authority of one of its makers over the text and its meanings. As was also evident in the earlier example, this assertion of authority is one to which forum members are very willing to submit. One member, *rhonda*, evidently finds the intervention of one of the show's stars a matter of considerable excitement and regards Scott's intervention as

settling the debate decisively, treating his post as a 'summing up' rather than one opinion among others:

> Oh my gosh, Eric Scott! This is so exciting that you take the time to read and comment here! Thank you for playing Ben, thank you to everyone that brought these wonderful characters and stories to life!! I truly believe that it is the Greatest Television Series Ever!! Thank you, thank you, thank you!!
> I loved how you summed it up by saying 'Take the series as a man's memories, sometimes consistant [sic] sometimes not, but always entertaining'. May these memories continue to entertain for generations to come![36]

In total, *ericscott* contributes 12 posts to 10 individual threads on 'The Waltons Forum'. Of these, 8 posts are of the same character as those discussed above; they are interventions that clarify aspects of the show from the perspective of one involved in its creation. As such, these interventions represent clear claims of authority over the interpretation of ambiguities within the text. And on each of these occasions, forum members welcome *ericscott*'s interventions and appear only too willing to acquiesce in the power relationships that Scott's posts imply insofar as the meaning of the text that is the object of their fandom is concerned.

That Scott's invocation of the authority of presence in order to determine textual meaning raises no objection from Waltons fans might seem unremarkable in itself. In isolation it is not particularly noteworthy. However, in the context of the claims of textual 'nomadism' and 'semiotic guerrilla warfare' that have been made on behalf of fandom by the likes of Jenkins and Bacon-Smith, it becomes a significant problem. Such claims are impossible to reconcile with the extraordinary passivity demonstrated by members of 'The Waltons Forum' in the examples above. These Waltons fans certainly do not appear to be 'poachers' traversing the text in search of semiotic booty to plunder and appropriate to their own ends. Indeed their evident subservience to one whose claim to authority over the text is as flimsy as Scott's[37] seems to signal a positive desire among forum

members for a text in which the ambiguities necessary to allow readers some room for manoeuvre to create meanings of their own for the text have been reduced, even eliminated completely, through the operation of a revitalised authorial sovereignty; a 'rebirth' of the author. Contrary to the claims made for fandom by theorists such as Jenkins and Bacon-Smith, if the evidence provided by 'The Waltons Forum' is any guide, Waltons fans yearn for clear, unambiguous meanings; meanings that are underpinned by the authority of a figure who (if not literally the text's creator) can, with some legitimacy, be invested with that status for the purpose of exercising interpretive authority, eliminating ambiguities and decisively ruling on the 'proper' meaning to be taken from the text.

Putting this into the context of some of the theory outlined earlier in this chapter, if Barthes' claim of the 'death of the author' registered a moment of liberation for readers, who were freed by the demise of authorial power to indulge in their own creative play with the text, Waltons fandom appears to show that this new textual freedom is not universally welcomed by readers/viewers: there are some readers who wish to have textual meaning determined by an author-figure and are willing to accept their subservience to the power of the author as a reasonable price for clarity and stability of meaning. If Barthes was right to suggest that texts may be 'readerly' or 'writerly', then perhaps it is also necessary to think about readers in the same way; on the evidence of 'The Waltons Forum' it appears that, whatever the status of the text itself, there are some – perhaps many – ('readerly') readers who are unwilling to accept the responsibility for meaning-making that 'writerly' reading entails.

That is not to say that Waltons fans engage in activities that are fundamentally different from those of other fans (they endlessly discuss the text, have conventions, some write fan fiction and poetry). They are, however, differently creative from the kinds of fans whose activities have tended to provide the main focus of fan theory thus far; the goal of the activities of Waltons fans is radically different from that of the kind of fans discussed by Jenkins, Bacon-Smith, Hills, etc. Nowhere is this more apparent than in the creative writing of Waltons fans.

The desire of Waltons fans to submit to what they perceive as the legitimate authority of the text, and its creators, is evident in one (very) short story posted by a *Waltons Forum* member – screen-name *Kelvin* – in the forum's 'Writing Corner'. The story, entitled *Advice for Jim Bob*, takes two characters from the show, Jim Bob and John-Boy, and constructs a tale of brotherly love, which has as its ideological essence an insistence upon the wisdom of elders and the 'natural' authority of the elder brother over his younger sibling. The story begins with Jim Bob angry as a result of taunts levelled at him by a classmate. Questioned by John-Boy about the reason for his anger, Jim Bob explains that his classmate had called him 'dumb' several times that day and tells his elder brother that 'I was gonna find my "friend" and then he was gonna "get it"'.[38] After physically restraining his younger brother, John-Boy lectures him about the foolishness of resorting to physical violence against the other young man. Although not fully convinced by John-Boy's argument, Jim Bob decides not to seek a fight that night. Later in the week circumstances provide Jim Bob with an opportunity to prove his worth against the other boy without resort to fisticuffs, by fixing a car that the other boy cannot. This enables Jim Bob to appreciate the wisdom of his older brother's advice. The story concludes with Jim Bob sharing his reward for fixing the car with John-Boy to thank him for 'telling me I'm Jim Bob Walton'.[39] It is instructive that the moral of the story is framed in this precise way; John-Boy has not merely advised his younger brother as to the correct course of action but, in the process, has reminded him of who he is – his identity (as a Walton) – and of the moral values that this identity entails. Jim Bob's recognition of his older brother's wisdom in this particular instance is also a recognition of the structures of authority and moral obligation which establish and hold in place a fixed sense of self and of the moral values that this self encompasses. In this fan-authored story, Jim Bob refrains from violence because to do so would be a transgression of traits of his character and moral values that were established originally within the television series. This story is highly instructive because it exemplifies a tendency to

be found more generally throughout the fan literature on 'The Waltons Forum'; a tendency to reproduce – as far as possible without modification, let alone transgression or inversion – the moral values and ethical codes established by the master text, the television series.

In another story – *The Stranger*[40] – a fan author adopts several elements from the series: the characters, setting and tone, and also a version of the narrational voiceover that begins and ends each episode. There is little connection between the two voiceovers and the substance of the story, but the character of these voiceovers is instructive for the way that they express the same belief in a 'timeless and true' set of values within a changing world that is central to ideology of the show. The story opens by re-stating the sense of changelessness that is core element of the ideological character of *The Waltons*:

Walton's Mountain had always been a reminder to the Walton family that, though times my [sic] change, places may be torn open by war and people may be taken suddenly, the mountain and the surrounding bountiful wilderness would be ever the same, an unmoving rock in the sea of time.[41]

Although this theme of timelessness has no obvious connection to the substance of the story, the tale that follows is also entirely consistent with the typical themes and values to be found in the television show, dealing with the mundane realities of family life in hard times, the kindness of strangers and revealing a rather utopian, romantic conception of rural life and community in a not-too-distant past that provides the setting for 'rose-tinted' nostalgia. At the end of the story the narrator (now evidently speaking from the perspective of the present) once again uses the mountain, the family and community that live in its shadow as a metaphor for timelessness:

Today in the early 21st Century, the house still stands. Though it is inhabited only by a few of the Waltons who

originally lived there, the mountain is unchanged. The rock
in the sea of time, where Waltons are born, grow up, live and
die. Eventually being buried in the grounds of the mountain
and living forever as the memories of a happy simiplar [sic]
time.[42]

The most distinctive feature of these particular examples of Waltons
fanfic (fan fiction) – their absolute fidelity to the ideological concerns
and values of the original text – appears to be a more general
characteristic of the fan writing that is posted on 'The Waltons
Forum'. It is nowhere better exemplified than in the poems regularly
posted by one member of the forum, *jackiladypoet*, whose many
poems attract consistent praise from other members of the forum.
This fan author's poetry typically deploys characters, settings and
the sentiment of the television show, reproducing these elements
'full and straight'[43] without any trace of modification, irony or
recontextualisation that would signal a radical reworking of the
ideology of the show.[44]

Waltons Fandom and the Fantasy of 'Normality'

In his chapter on fan writing in *Textual Poachers*, Henry Jenkins
questions the validity of Michel de Certeau's dismissal of the
possibility for television viewers to become 'textual poachers' in
the same way that readers of literature can, due to the nature of
the device through which television programmes are received and
the enormous technical barriers to fan production and distribution
of television texts.[45] Refuting de Certeau's position, Jenkins argues
that, notwithstanding such obstacles, the practices that typify
television fandom are far less passive than de Certeau allows and
'blur the distinction between reading and writing'. Jenkins asserts
that the:

ongoing process of fan rereading results in a progressive
elaboration of the series 'universe' through inferences and
speculations that push well beyond its explicit information;

the fans' meta-text, whether perpetuated through gossip or embodied within written criticism, already constitutes a form of rewriting. This process of playful engagement and active interpretation shifts the program's priorities. Fan critics pull characters and narrative issues from the margins; they focus on details that are excessive or peripheral to the primary plots but gain significance within the fans' own conceptions of the series. They apply generic reading strategies that foreground different aspects than those highlighted by network publicity.[46]

Taking the media text as little more than a common starting point, a repository of semantic resources shared between fans, Jenkins regards media fandom as a form of communal sociality in which participants reshape those resources to their own ends, developing their own pools of shared knowledge in which the interpretation wrought from the text may be significantly different from the 'official', 'authorised' reading:

> Fan writing builds upon the interpretive practices of the fan community, taking the collective meta-text as the base from which to generate a wide range of media-related stories. Fans, as one longtime Trekker explained, 'treat the program like silly putty,' stretching its boundaries to incorporate their concerns, remolding its characters to better suit their desires.[47]

But Jenkins is careful to acknowledge that such examples of fan creativity emanate from a complicated relation between the 'original' media text and the way that fans would ideally like it to be:

> fan culture reflects both the audience's fascination with programs and fans' frustration over the refusal/inability of producers to tell the kinds of stories viewers want to see. Fan writing brings the duality of that response into sharp focus: fan writers do not so much reproduce the primary text as they

rework and rewrite it, repairing or dismissing unsatisfying
aspects, developing interests not sufficiently explored.[48]

Jenkins' own interest in fandom takes shape around a concern
with the results of this latter aspect of fandom – the remoulding
of the 'meta-text' – and many fan theorists who have followed
after Jenkins pursue this course as if it were the only one, as if
the first dynamic identified by Jenkins in this quotation – the pure
'fascination' with the text – either did not exist, or is a characteristic
of those who engagement with the text is as something other
than fans; mere passive consumers. Matt Hills formalises this
dualism, conceiving these 'non-fans' as the 'imagined Other' of
fandom in an opposition that pits '"good" fans' against the '"bad"
consumer'.[49] The basis for this dualism seems suspect, however,
since the judgment of who falls into which of these categories is a
verdict reached from a particular vantage point; that of an 'aca-
fan' claiming to speak from a position of privilege, and from that
perspective proclaiming what counts as true fandom, dismissing
that which does not fall within a narrow range of fan traits as mere
consumerism.[50]

Waltons fans are problematic for the theoretical frameworks
that scholars of fandom have developed and for the discourses
those scholars use to talk about fandom; neither seems equal to the
task of explaining such mundane fandom. On the one hand, the
fact that there are fan clubs, annual conventions, internet forums
and other paraphernalia of fandom – and that those who use these
channels to discuss, garner and share information about the series
constitute a discrete group, distinct from less committed viewers
of the show (the mere consumers), with a clear sense of communal
bonds between them – suggests that these individuals should be
seen as lying on the 'fan' side of any fan/consumer dichotomy.
There is a qualitative difference between Waltons fans and less
committed Waltons viewers that gives the fans a distinct identity
different to that of an ordinary viewer. To this extent, at least,
Waltons fans appear to be little different from the fans of other
media texts around whose activities recent theories of fandom have
been constructed.

There, however, the similarities end and Waltons fandom begins to exhibit characteristics that are quite different from those that scholars of fandom have taken to be emblematic of the phenomenon generally. The problem posed by the fluid boundary between fans and consumers is considered at some length by Matt Hills in *Fan Cultures*. Hills discusses the implications for fan theory of the structuring set of dualisms that operate within its discourse: (good) fan/(bad) non-fan; 'aca-fan'/fan-scholar; rational academic/irrational cultist, and so on. Hills' answer to the question whether the contradictions within these dualisms can be resolved is that they probably cannot, and that the best solution that theory can offer is probably a compromise that recognises the inherent contradictions of fan identities.[51] While this is a welcome dose of realism after the far-fetched claims of some other fan theorists it nevertheless still seems that the focus of many fan theorists (Hills included, to some extent) on instances of what we might call 'cult fandom' represents a serious impediment to gaining an understanding of mundane fandom. While Hills places some emphasis on his recognition of the existence of non-cult fans, the centrality of the cult variant to the development of 'second wave' fan theory has given cult fandom a gravitational pull which Hills struggles (and ultimately fails) to escape. The problem at the centre of Hills' work appears to originate in an overly narrow conception of the media 'consumer'. For Hills the contradiction within the fan/consumer dichotomy arises from the fact that cult television fans are almost always also consumers of commercial artefacts relating to the object of their fandom. They are, therefore, always inherently compromised by their reliance upon, and participation in, the capitalist system of production and exchange to which instances of subversive fan activity are understood to be in opposition. That may be true, as far as it goes, but is does not account for the kind of fan-consumer who only consumes and does not attempt to subvert; the type of fan who is content with the position of consumer within capitalism and for whom no such contradiction or compromise exists. The silence of recent fan theory on the subject of this sort of uncompromised consumer-fan represents, in my estimation, a far greater void in our knowledge of fan behaviours than any created by the contradictions that exercise Hills.

While it has not been possible to undertake a more thoroughgoing examination of the parameters of Waltons fandom generally within the constraints of this chapter, it is clear even from the few examples discussed herein that Waltons fandom has a distinctive character that is articulated in ways which mark it as quite different from the kinds of fandom that have typically been the focus of scholarly attention. Like other media fans, Waltons fans do engage in (often heated) discussion among themselves about the meaning or significance of events that occur in the show. But, as the example provided by Eric Scott's intervention in several of these discussions illustrates, Waltons fans are very content to defer to the authority of an individual involved in the creation of show (the official text), whose word is taken to determine the 'true' interpretation and to terminate further discussion about whatever subject has been under debate. If fans are supposed to be textual poachers, as Jenkins and others suggest, then these fans of the Waltons appear to be all too willing to obey the gamekeeper's command to cease their activities and return their plunder to its 'rightful owners'.

An obedience to the ideological prescriptions of the original (official) text is discernible in the fanfic posted to 'The Waltons Forum'. In this respect Waltons' fans seem to act rather differently from those considered by Jenkins.

According to Jenkins' account, fanfic expresses an ambivalence toward the original text, a desire for more of the same mixed with a desire to take the text to places where the original could not (or would not) go ; to '[repair] or dismiss unsatisfying aspects' and to '[develop]interests not sufficiently explored' in the original.[52] So far as fanfic posted to 'The Waltons Forum' is concerned this is only partially the case. Waltons fanfic certainly demonstrates a hunger among fans for more of the same – reflecting their affection for and fascination with the show. However, their desire seems not to be for additional material that moves the official text in directions its creators will not allow it to go, but which instead follows as closely as possible the contours of the original. Waltons fanfic may introduce novelty through the development of new story-lines and even by introducing new characters but it does nothing to destabilise the ideological ground of the official

text. Putting this observation in terms of the 'ten ways to rewrite a television show' proposed by Jenkins,[53] it becomes evident that, while certain of these rewriting tactics are acceptable to Waltons fanfic authors, others are determinedly 'off-limits'. The 'writing corner' of 'The Waltons Forum' contains few examples of the practices of 'recontextualisation', 'timeline expansion'[54] or 'refocalisation' described by Jenkins, but there is little reason to think that these would be considered particularly remarkable or objectionable by members of the forum, since they can be safely accommodated without fundamentally disturbing the ideology of the original text. The 'writing corner' provides ample examples of the 'genre shifting' described by Jenkins, in the form of the many poems published therein. The short story, *Goodnight*,[55] provides an excellent example of Jenkins' sixth category, 'crossovers'. In this story the author imagines the outcome of a meeting between the Waltons and the Ingalls family from the television show, *Little House on the Prairie*. The premise of the story represents quite a radical departure from the original Waltons text, particularly since the meeting is framed by a narrative context in which characters exhibit self-awareness regarding both series' status as television shows; a point of departure from the observance of diegetic verisimilitude in the originals. However, this imaginative fan fantasy is realised without divergence from the ideological paths described by both of the original television shows: formally, it may be radically different from either of them in many ways, but it nevertheless remains faithful to their ideological tenor. Finally, among Jenkins' categories to be found within Waltons' fanfic, are examples of 'personalisation' – stories which 'efface the gap that separates the realm of their own experience and the fictional space of their favorite programs'[56] – in which fan authors imagine their lives in the modern world as improved by being lived through the family and community values expressed by the show.[57]

Because of the fidelity to the moral tone of *The Waltons* observed in fanfic on 'The Waltons Forum', it is unsurprising than none of the writing to be found therein exhibits the remaining characteristics of fanfic proposed by Jenkins. Certainly no examples of what Jenkins calls 'moral realignment' exist within the Waltons fanfic.

The disruption of the moral universe of the show that would be necessitated by this shift would be unthinkable for a group of fans so compliant with the ideological purposes of the original text. More than that, however, any moral realignment would serve no purpose for these fans: they are in such accord with the moral values expressed by the original text that any divergence from these – let alone subversion of them – would be counterproductive for them, destroying their pleasure in the text. Similarly there is little sign of what Jenkins terms 'character dislocation'. The phenomenon described by Jenkins involves a more radical move than simply displacing characters from their customary settings. In Jenkins' formulation characters in the original text may form the basis for new characters in fanfic but those new characters exhibit traits that are opposed to those of the original: heroes become villains and so on. Again it is inconceivable that this practice could serve any purpose for such an obedient set of fans. There are examples of what Jenkins terms 'emotional intensification' within the fanfic but this focus on intensely emotional moments seems to be premised entirely on the guaranteed pleasures to be derived from seeing crises resolved and order restored at the end of the story. So far as Jenkins's final category, 'eroticization' is concerned, unsurprisingly this appears to have no place within Waltons fandom, and no examples can be found on 'The Waltons Forum'.

This examination of Waltons fanfic suggests that Waltons fans have little to gain from a radical rewriting of the original text: their pleasures seem to derive more from the unadulterated original text than from rewriting it to better fit their fantasies. Indeed their fantasies appear to be better served by sublimating their own identities as fans to the text's moral and ideological prescriptions than by striving to adapt the text to fit their needs. This is, perhaps, the most important point to comprehend when trying to reconcile the kind of fandom exhibited by Waltons fans with the types of fandom which have been more typically the subject of research by fan scholars. One of the key pleasures of fandom, according to most accounts, is the facility that it offers for fans to retreat into elaborate fantasy worlds that they share with other fans and within which they can collectively evade and resist the constraints placed upon

them in their ordinary lives. In this 'weekend-only' utopia, fans enter an 'alternative reality whose values may be more humane and democratic than those held by mundane society'.[58] In this respect there is little difference between Waltons, and any other fans. The real difference lies in the precise character of the fantasy that exists in this alternative utopia rather than any fundamental divergence of practice. For Waltons fans the fantasy is not of a utopian place that is the radical Other of the material world they actually inhabit (as it may be for fans of other types of text), but a nostalgic version of that very same world as it is communally imagined to have really been just far enough in the past to be recognisably similar to today's material reality, but sufficiently distant temporally to be just beyond the living memory of most members of the community of Waltons fans; distant enough to have become tinged with romantic idealism in the memories of those few fans of an age to have any memory of the time. Rather than a wild fantasy of a radically different reality, Waltons fandom exhibits the character of an 'invented tradition' as described by Svetlana Boym, being 'of a ritual or symbolic nature which seeks to inculcate certain values and norms of behaviour by repetition which automatically implies continuity with the past'.[59] For Waltons fans, the imagined utopia that their fandom revolves around is essentially a fantasy of 'normality': normality of a particular kind, not so very different from America today, but slower, kinder and less materialistic than in the present. Their utopia is America as it is fantasised to have been by the collective nostalgic imagination of fans. America as those fans consider it should be now, with all existing systems of authority and power remaining in place, moderated only by the kinder values that Waltons fans imagine to have characterised American life in a past just at the cusp of memory. This close proximity between lived reality and its imagined, utopian counterpart registers something that is fundamentally different about Waltons fans and the cultist fans typically studied by scholars of fandom. As Jenkins observes, 'nobody can live permanently within this Utopia...fans must come and go from fandom, finding this "weekendonly world" where they can... before being forced to return to the workaday world'.[60] While it is not difficult to see that this would be true of fans whose

fantasy lives involve retreat into imaginary worlds quite unlike that in which they actually live, such a clear separation between the fantasy and the material realities of the social world is more difficult to maintain when the particular utopia created by fans is premised upon a strongly held political conviction that it faithfully represents the everyday world as it once was and as it should be once more. This endows Waltons fandom with a political dimension that marks this type of mundane fandom as potentially more important for theorists of culture than some of the more spectacular and superficially subversive types of fandom. Unlike these latter, spectacular types, the ideological precepts held dear by mundane fans quietly traverse the boundaries between text and society; in the process reproducing themselves and the structures of power and authority that they imply, in a manner far more insidiously pervasive than the admittedly more visible, petulant outbursts of spectacular fandom.

Conclusion

Afterlife

On 17 April 2011, two days after I start to write this chapter, and almost thirty years after the final season ended the first time around, *The Waltons* will once again appear on American television screens in a new instalment of what long ago ceased to be merely a weekly television show and had become instead a kind of modern myth or saga: a story built around elements of history but eschewing empirical veracity in favour of the heroic, inspirational and ultimately ideological trajectory that typifies folklore. So while some (especially, I imagine, Waltons fans themselves) may consider it odd that I should start to write this conclusion such a short time before a new instalment is released, my own view is that it would be irrelevant to wait, since it has long been the case that it is the *idea* of *The Waltons*, rather than any particular individual episode or incident, that has passed into the common store of cultural currency, from which it can be withdrawn at any time and invoked in its ideological totality through the most fragmentary reference: the opening bars of the theme tune or the 'goodnight John-Boy' catchphrase.

Earlier in this book I considered some of the reasons why *The Waltons* was needed by America in the early 1970s, how it addressed some of the anxieties that characterised the time and soothed them, working to restore a sense of faith in the American Dream; in the project of modernity in the USA, and in the fundamental goodness of 'Americanness'. Precisely because the idea of *The Waltons* has transcended its literal, material presence, it is not necessary to give the same degree of attention to the

reasons why the series came to an end in 1981. But things had
certainly changed. America in 1981 was a rather different place
from America in 1972. American troops were no longer in Vietnam;
civil unrest had abated; the Energy Policy and Conservation Act of
1975 had established the Strategic Petroleum Reserve, designed to
avoid the gasoline shortages America had experienced in 1973; and
politically there had been a decisive swing to the right, culminating
in the election of Ronald Reagan to the presidency in late 1980.
Culturally, there was a perceptible change in the mood of the
country, with new television shows which in many ways seem the
antithesis of *The Waltons* enjoying high viewer ratings: shows
such as *Dallas* (1978–91), *Falcon Crest* (1981–90) and *Dynasty*
(1981–89) – confident displays of American wealth and power
perhaps, but not of harmonious families and caring communities.
Many of the problems that America faced at the start of the 1970s
had not gone away, however, and some of the other television
shows and movies on-screen in 1981 showed American cities to
be every bit as beset with crime, violence and racial tensions as
in 1972: gritty, realist television crime dramas such *Hill Street
Blues* (1981–87) and cinematic fantasies of an urban America
that remained infested with crime and violence to the extent of
making parts of cities into 'no-go-zones', such as *Escape from
New York* (Carpenter 1981 USA) and *Fort Apache, The Bronx*
(Petrie 1981 USA). But it is impossible to extrapolate from these
trends simple reasons for the departure of *The Waltons* from US
television screens in 1981. Commercial reasons will have played
the major part in the ending of *The Waltons*, it being a predictable
part of the cycle of any television show that had been on screen
for nine years that newer shows, which provided novelty, would
eventually come to displace the 'old favourite' from its position in
the ratings. Ultimately it really doesn't matter why *The Waltons*
ended because, in a very important way, it never did. In a literal
sense, of course, the show was no longer regularly on screen in the
way it had been (notwithstanding repeats and 'specials'). But, years
before this happened, the show had changed from being a simple
sign in a system of first-order signification – which would require
its continued literal presence in order to be able to signify anything

– and became what Roland Barthes conceives as a signifier in 'a second-order semiological system'; metalanguage or 'myth'.[1]

Myth, according to Barthes' formulation, performs a dual semiotic operation. It is at once an 'empty, parasitical form' and a meaning that is 'already complete'.[2] The form of myth is not the symbol itself; the physical trace has far too strong a sense of presence to function as myth. The form, as Barthes puts it, 'recedes', leaving the meaning 'formless, unstable, nebulous'.[3] The signifier becomes absent but the signified remains. This is not to say that the disappearance of *The Waltons* from American television screens was a necessary prerequisite of its becoming myth. Rather, its ascendance to a higher, mythical order of signification long before it had disappeared from the screen, relegated its continued presence on-screen to secondary importance alongside its operation as myth. Once *The Waltons* had been present long enough to ingrain itself in the consciousness of the audience, it became possible to invoke the myth – the idea of *The Waltons*; its ideology, its values – by whistling a snatch of theme tune; by uttering a 'goodnight John-Boy'. This happened long before the series was pulled, and remains the case whether or not it is possible to regularly watch the show. Thus it would add nothing to my analysis of the show to wait two more days for the latest update. On my reading, the ideological work of *The Waltons* was complete long ago.

Through its ascendancy to the level of the mythological, *The Waltons* has become generally available as an intertextual element of everyday 'speech' or cultural signification. Perhaps the perfect example of the ubiquity of the myth can be found in the cover version of *The Waltons* theme tune added as a bonus track to the 2003 re-release of the album, *March 16–20, 1992*, by the alternative country band, *Uncle Tupelo*. It is not difficult to imagine various different ways it would be possible to parody the tune – a punk, or reggae version perhaps, or its use as a sample in hip hop – and thus to mock the quaintly anachronistic values that this mythic version of *The Waltons* represents. However, while certainly audibly different from the original, *Uncle Tupelo* play their cover version straight, using authentic bluegrass instrumentation to evoke, apparently without any obvious irony or humorous intent, the enduring aura

of the television show and the simple American virtues that it has come, through its continuing mythic presence within the cultural meta-language, to signify. Although *The Waltons* may have said its final 'goodnight' long ago, its passage into the realm of myth ensures that its disappearance from television screens will never fully eliminate the traces of its enduring influence throughout American popular culture.

Notes

Introduction

1 Miller, J. H. 1999: 292. *Black Holes* is an unusual work in which Miller's writing appears on the right-hand pages with Asensi's commentary on Miller's work on the left-hand pages.
2 Davis, M. 1936: location 2101.
3 Williams, R. 1977.
4 Williams, R. 1989.
5 Adorno, T. and Horkhemier, M. 1997. Adorno, T. 2001.
6 Sarris, A. 1968: 29. Perhaps no better example of this exists than the efforts of Henry Jenkins and Camille Bacon Smith to reinvent cult television fandom as both an expression of oppression and of resistance to that oppression.
7 Couldry, N. 2000: 3.
8 Wolfgang Iser argues that such exclusions are essential to the maintenance of the authority of the canon but also amount to a form of censorship of the excluded texts. Iser, W. 2000: 13.

Chapter 1

1 At the time of writing, *The Waltons* can be seen at Noon, 1pm and 8pm Eastern Time on the 'Inspiration Network' (http://www.insp.com/shows/thewaltons/).
2 Although there were character storylines that continued through the various seasons and frequent references to events that had occurred in earlier episodes, in general the stories in each episode were self-contained, even to the extent that episodes sometimes appeared out of chronological sequence. 'The Pony Cart' (S5 E10), for example, is set in the summer of 1937, and 'The Best Christmas' (S5 E11) just before Christmas that year. Several subsequent episodes are set earlier than this, however. 'The Elopement' (S5 E15) takes place in spring 1937, and 'The Inferno' (S5 E19) specifically on 6 May 1937, the day of the Hindenberg airship disaster.
3 Hamner, E. Jr and Giffin, R. 2002: 19.
4 Hamner, E. Jr and Giffin, R. 2002: 21.
5 Person, J.E. Jr 2005: 12.

6 Hamner, E. Jr and Giffin, R. 2002: 30.
7 Ibid, 30.
8 Hamner's own account of this differs from that contained in Person, J. E. Jr 2005.
9 Ibid, 30.
10 Ibid, p.31.
11 Wylie, J. C. 1962: 48.
12 Ibid.
13 A few years after the publication of *Spencer's Mountain* this approach would reach its apotheosis in Truman Capote's *In Cold Blood*, which inaugurated a new literary genre, the non-fiction novel, and established a pattern for the *New Journalism* that was to follow.
14 Prescott, O. 1965: 29.
15 In the novel the great depression is referred to in the past tense and there are occasional references to the threat represented by Hitler and Mussolini, thus positioning the time after the worst of the depression but before the Second World War.
16 The passage of time in the television series is rather haphazard. In early episodes in both Seasons One and Two John-Boy's age is said to be 17, suggesting that the character didn't age at all in the year that passed between the broadcast of the two seasons. In the earlier Television Special, 'The Homecoming', John-Boy's age is given as 15. Season Four is set in 1936, probably close to the time when *Spencer's Mountain* is set, so it seems that the television series starts much earlier in the depression than the novel.
17 Hamner, E. Jr 1961: 110.
18 Ibid, 175.
19 Ibid, 11.
20 Ibid, 16.
21 Ibid, 17.
22 Ibid, 18.
23 Ibid, 18–19.
24 Ibid, 19.
25 Ibid, 31.
26 Ibid, 31–32.
27 Ibid, 35.
28 Ibid, 212.
29 Letter dated 3 May 1962, Daves to Hamner. Delmer Daves Collection, Stanford University Library: Box 66, Folder 11.
30 Letter dated 10 May 1962, Hamner to Daves. Delmer Daves Collection, Stanford University Library: Box 66, Folder 11.
31 'Top Rental Films of 1963', *Variety*, 8 January 1964: 37.
32 *Variety*, 27 February 1963: 6.
33 Ibid.
34 *New York Times*, 17 May 1963: 26.
35 Perlstein, R. 2008: 57.
36 Hamner, E. Jr and Giffin, R. 2002: 41–44.
37 Ibid, 44–45.
38 Person, J. E. Jr 2005: 68.

Chapter 2

1 Rhodes, J. P. 2001: 1.
2 President Richard Milhous Nixon: 1972 State of the Union Address.
3 Thompson, H. S. 1973: 57.
4 Cohan, S. 1997: 1.
5 See, for example, Schulman, B. J. 2001: 1.
6 Quoted in Schulman, B. J. 2001: 2.
7 Morrow, L. 1988.
8 Quoted in Perlstein, R. 2008: 108.
9 'The Fire This Time', *Time* magazine, 4 August 1967.
10 Ibid.
11 'A Time of Violence and Tragedy', *Time* magazine, 4 August 1967.
12 Perlstein, R. 2008: 254.
13 Between *Stand!* and *There's a Riot Goin' On* the band released a greatest hits album.
14 Aletti, V. 1971.
15 'West Coast Story', *Mad*, No. 172, April 1971: 4–11, p.6.
16 Ibid, 7.
17 Ibid, 11.
18 Slocum-Schaffer, S. A. 2003: 168.
19 Statement by White House press secretary Ronald Zeigler. 'Kent State University', in the Weekly Compilation of Presidential Documents, Vol. 6, No. 19, May 11, 1970 (Washington, DC; US Government Printing Office, 1970), p. 613. Cited in *Mission Betrayed: Richard Nixon and the Scranton Commission Inquiry into Kent State*. An e-book by Charles A. Thomas. Available http:// speccoll.library.kent.edu/4May70/MissionBetrayed.htm#_ftnref3. (5 October 2008).
20 Nixon had first used the term 'silent majority' in an address to the nation on the subject of America's involvement in Vietnam on 3 November 1969. Available http://www.watergate.info/nixon/silent-majority-speech-1969.shtml. (5 October 2008).
21 Slocum-Schaffer, S. A. 2003: 173.
22 'Teen-Age Sex: Letting the Pendulum Swing', *Time* magazine, 21 August 1972. http://www.time.com/time/magazine/article/0,9171,878002-1,00.html (7 October 2008).
23 Ibid.
24 Glass, L. 2002. Available http://findarticles.com/p/articles/mi_qa4053/ is_200210/ai_n9085969 (17 October 2008).
25 Blumenthal, R. 1973.
26 Ibid.
27 Further evidence of this trend can be found in the establishment of the sexually explicit and resolutely 'tasteless' *Screw* magazine in 1968. *Screw* gained a foothold within popular culture, and particularly the counterculture through its employment of well-known countercultural writers, such as artists such as Robert Crumb. In 1974, *Screw* was joined in the hardcore porn market by *Hustler*.
28 Presumably the composition of Falwell's 'moral majority' was very similar to that of Nixon's 'silent majority', reflecting the convergence between

fundamentalist Christian views and political life that would in due course
produce the political climate of the 1980s.

29 Falwell, J. and Towns, E. 1973: 81.
30 Falwell, J. 1978.
31 'Empty Pockets on a Trillion Dollars a Year', *Time* magazine, 13 March 1972.
 Available http://www.time.com/time/magazine/article/0,9171,903368-1,00.html
 (3 December 2008).
32 Ibid.
33 Husock, H. 1997.
34 Phillips, K. R. 2005: 87.
35 Cited by Kammen, M. 1997: 177.
36 Gilbert, M. J. and Head, W. 1996: 1.
37 Quoted in Tucker, S. C. 1999: 140.
38 Schulzinger, R. D. 1997: 331.
39 Tucker, S. C. 1999: 158.
40 Ibid, 167.
41 'Man and Woman of the Year: The Middle Americans', *Time* magazine,
 5 January 1970. Available http://www.time.com/time/magazine/article/
 0,9171,943113,00.html. (9 December 2008).
42 Ibid.
43 Lyrics copyright of Marvin Gaye, 1971: *Mercy, Mercy Me (The Ecology)*.
 Tamla Records.
44 'Nostalgia', *Life*, 19 February 1971: 39.
45 28 January 1972.
46 'The Nifty Fifties', *Life*, 16 June 1972: 39.
47 *Newsweek*, 16 October 1972, front cover.
48 *Mercy, Mercy Me (The Ecology)*. Tamla Records 1971.
49 Curtis, J. 1987: 251.
50 Ibid.
51 For example, Cooper B. L. 1991: 86.
52 Op cit.
53 Generally taken to be a reference to the recently deceased singer Janis
 Joplin, although more significant here for the fact that no 'happy news' is
 forthcoming.
54 This line could be taken as either a reference to the riots of the 1960s or
 perhaps to Vietnam. In either case the picture of America it implies is not a
 happy one.
55 Wicker, T. 1991: 3.
56 Genovese, M. A. 1990: 6.
57 Ibid.
58 Wills, G. 1971 cited in Genovese, M. A. 1990: 6.
59 State of the Union address 22 January 1970.
60 Ibid.
61 State of the Union address 22 January 1971.
62 'It's all Still There', *Life*, 7 July 1972.

Chapter 3

1 President George H. W. Bush, 1992.
2 Parents' Television Council Press Release. Available http://www.parentstv.org/ptc/news/release/2010/0106.asp (9 May 2011).
3 Newcomb, H. 1974.
4 Robinson, J. and Skill, T. 2001.
5 Chambers, D. 2001: 4–5.
6 Ibid.
7 Robinson, J. and Skill, T. 2001: 139.
8 Coontz, S. 1992: 9.
9 Ibid, 24.
10 Ibid, 29.
11 Devlin, R. 2005: 9.
12 *Look* magazine, 1958.
13 *Life*, 4 January 1954: 42–45.
14 Robinson and Skill note that 'During the period September 1950 through August 1995, a total of 630 fictional television series featuring a family aired on four commercial television networks (ABC, CBS, Fox and NBC). Just over 72 percent of these series were situation comedies, and approximately 28 percent were dramatic programs'. 2001: 146.
15 See Bakhtin, M. 1968.
16 Eagleton, T. 1981: 148.
17 That *The Simpsons'* hometown shares the same name is no mere coincidence. See Turner, C. 2004:31.
18 The show in fact ran with this title and line up for the first three seasons only after which it was re-titled *The Danny Thomas Show*, and the family composition and the cast changed.
19 Morowitz, L. 2007: 37.
20 Ibid.
21 Herman Munster is the only one of these fathers in employment. Gomez Addams is a self-employed lawyer who works from home and seems to have independent means, Jed Clampett is independently wealthy following his oil strike. Notwithstanding the fact that he has a job, even Herman manages to spend a great deal of time within the family home.
22 Moss, S. 1965: 4245.
23 Hamamoto, D. 1991.
24 Cited in ibid, 63.
25 Ibid.
26 See the more detailed account in Chapter 6.
27 Ozersky, J. 2003: 72.
28 Berger, A. A. 1976: 11.
29 Both men are displaced in time, argues Berkowitz 2006: 206.
30 Ibid.
31 Quoted in Ozersky, J. 2003: 64.
32 Ozersky, J. 2003: 79.
33 A study of audience responses to *All in the Family* found that viewers tended to see Bunker's character as providing justification for whatever views they already held. Vidmar and Rokeach 1974, cited by Ozersky, J. 2003: 70.

34 Miller, M. C. 1988: 205.
35 Barr received a writing credit for over 200 episodes and executive producer credit for almost as many.
36 Turner, C. 2004: 87.
37 'Lisa's Sax' (S9 E3).
38 Turner, C. 2004: 97.

Chapter 4

1 Faludi, S. 1999: 5.
2 Chopra-Gant, M. 2006: 139–45.
3 Zaretsky, N. 2007: 110.
4 It is worth noting again that diegetic time in *The Waltons* often displays an erratic sense of chronology. In later series several episodes are set out of chronological sequence. 'The Pony Cart' (S5 E10) is set in the summer of 1937 while the following episode, 'The Best Christmas' (S5 E11) is set seven days before Christmas 1937. While this could be understood as an excusable, if extreme, example of ellipsis, necessary to ensure the appropriate timing of the broadcast of the Christmas episode, several later episodes in this season remain set in 1937, 'The Elopement' (S5 E15) being set explicitly in the Spring of that year.
5 In fact the voice was that of Earl Hamner Jr, further connecting John-Boy's character with the idea of authorial power.
6 'The Literary Man' (S1 E11).
7 John-Boy's precise status in the military is itself ambiguous. Initially referred to as a civilian correspondent he is later referred to as a Staff Sergeant on attachment to *Stars and Stripes*, in 'The Home Front' Pt 2.
8 See Benedict Anderson's discussion of the dialectic of remembering and forgetting and its role in the production of identity in Anderson, B. 1991: 187–206.

Chapter 5

1 Mr Justice Blackmun delivering the opinion of the US Supreme Court in Roe v. Wade, 22 January 1973.
2 Words spoken by Mary Ellen Walton in 'The Cradle' (S2 E19), first broadcast 31 January 1974.
3 Hill, R. 1998: 81.
4 Cited by Hill, R. 1998: 84.
5 Ibid, 76.
6 Ibid, 82.
7 Lundberg, F. and Farnham, M. 1947: 143.
8 Ibid, 159.
9 Ibid, 167.
10 Ibid, 356.
11 Ibid, 369.
12 See Bradley, P. 2003: 133–37.

13 Mary Ellen's character – especially in early episodes – often contradicts this tendency. However, the young Mary Ellen is explicitly constructed as a 'tomboy', and this is presented as a non-normative feminine type in the early seasons of the show.
14 The scene which is discussed more fully in the previous chapter.
15 Either America's 'silent majority' or 'moral majority' depending on whether you listened to Richard Nixon or Jerry Falwell.

Chapter 6

1 A non-denominational religious cable television network dedicated to bringing to the viewing public 'redemptive programming' (Inspiration Network Mission Statement. Available http://www.insp.com/about-insp/ (4 November 2010)).
2 Available http://waltonswebpage.proboards.com/index.cgi (numerous dates during 2009 and 2010).
3 'The Waltons Forum' alone has explicit rules regarding conduct within the forum, but these rules do not include a prohibition on subsequent use of posts on the forum. Available http://home.comcast.net/~waltonswebpage/ FORUMRULES.HTML (4 November 2010).
4 Adorno, T. 2001.
5 This is not to imply that patriarchy has ceased to exist or that women's social, political and economic advances in the intervening years have completely eliminated their disadvantage within a political system which remains stubbornly patriarchal.
6 In a curious example of historical amnesia, Jenkins and his contemporaries are described as 'first wave' fan theorists in a recent anthology of scholarship on fandom, apparently ignoring the truly pioneering work undertaken earlier by the likes of Ang, Radway and Geraghty. See Gray, J., Sandvoss, C. and Harrington, C. L. (eds) 2007.
7 1987: 17.
8 2005: 98.
9 1992: 3.
10 Ibid, 4–5.
11 2002: 18.
12 Ibid.
13 Ibid.
14 Ibid.
15 Couldry, N. 2000: 3.
16 De Certeau, M. 1988: 37.
17 Radway, J. 1984: 8.
18 Ibid, 17.
19 Walkerdine, V. *Schoolgirl Fictions*. London, New York: Verso (1990).
20 Miller, T. 2005: 99.
21 Barthes, R. 1989: 55.
22 *Grandma's Absence in season 6*.- Available http://waltonswebpage.proboards. com/index.cgi?action=display&board=general&thread=956&page=1#11119 (10 January 2011).
23 Ibid, reply #1.

24 Ibid, reply #2.
25 Ibid, reply #3.
26 Ibid, reply #4.
27 Ibid, reply #7.
28 Ibid, reply #8.
29 Ibid, reply #4.
30 *Proper Order of Episodes*. Available http://waltonswebpage.proboards.com/index.cgi?action=display&board=general&thread=788&page=1#9764 (11 January 2011).
31 Ibid, reply #4.
32 Ibid, reply #7.
33 Ibid, reply #9.
34 Ibid, reply #10.
35 Ibid, reply #11.
36 Ibid, reply #13.
37 His character was, after all, one of the more peripheral of the central cast; he was not one of the 'official' authors within the production team, and was a child at the time and so probably had limited involvement in crucial production decisions.
38 *Advice for Jim Bob*. Waltons Forum Writing Corner. Available http://waltonswebpage.proboards.com/index.cgi?board=writing&action=display&thread=1242 (17 January 2011).
39 Ibid.
40 Available http://waltonswebpage.proboards.com/index.cgi?board=writing&action=display&thread=1196 (19 January 2011).
41 Ibid.
42 Ibid.
43 Hall, S. 1992: 136.
44 This author declined permission for any of her work to be reproduced in this book. However, typical examples of her verses are available at http://waltonswebpage.proboards.com/index.cgi?board=writing&action=display&thread=1498 (Xmas with the Waltons); http://waltonswebpage.proboards.com/index.cgi?board=writing&action=display&thread=1352 (Autumn on Walton's Mountain); http://waltonswebpage.proboards.com/index.cgi?board=writing&action=display&thread=515 (Way of the Waltons); http://waltonswebpage.proboards.com/index.cgi?board=writing&action=display&thread=803 (Walton's Mountain Essence); http://waltonswebpage.proboards.com/index.cgi?board=writing&action=display&thread=272 (Kaleidoscope of Waltons [sic] Mountain. (All, 23 January 2011).
45 Jenkins, H. 1992: 155.
46 Ibid.
47 Ibid, 156.
48 Ibid, 162.
49 Hills, M. 2002: 27.
50 Ibid.
51 Ibid, 29.
52 Jenkins, H. 1992: 162.
53 Ibid.
54 *Good Night*, discussed further below involves some timeline expansion.

55 Http://waltonswebpage.proboards.com/index.cgi?board=writing&action=dis play&thread=505 (27 January 2011).
56 Jenkins, H. 1992: 171.
57 The poems of jackiladypoet and the short story, 'What's Happened to Thanksgiving Today?'. Available http://waltonswebpage.proboards.com/ index.cgi?board=writing&action=display&thread=940 (27 January 2011) are exemplary.
58 Jenkins, H. 1992: 280.
59 Boym, S. 2001: 42.
60 Jenkins, H. 1992: 282.

Conclusion

1 Barthes, R. 1992: 114–15.
2 Ibid, 117.
3 Ibid, 118–19.

Bibliography

'The "Waltons Factor" Comes Under Fire', *Property Week* 1997: 11–12.

Adler, Tim. *Hollywood and the Mob: Moves, Mafia, Sex and Death.* London: Bloomsbury, 2007.

Adorno, Theodor. *The Culture Industry: Selected Essays on Mass Culture.* London: Routledge, 2001.

Adorno, Theodor, and Max Horkheimer. *Dialectic of Enlightenment.* London: Verso, 1997.

Albada, Kelly Fudge. 'The public and private dialogue about the American family on television', *Journal of Communication* 50.4, 2000: 79–110.

Aletti, Vince. 'Review of "There's a riot going on"', *Rolling Stone* 23 December 1971.

Anderson, Benedict. *Imagined Communities: Reflections on the Origin and Spread of Nationalism.* Revised ed. London: Verso, 1991.

Ang, Ien. *Watching Dallas: Soap Opera and the Melodramatic Imagination.* Trans. Della Couling. London: Routledge, 1989.

Anon. 'The New American Domesticated Male', *Life*, 4 Jan. 1954.

——. 'Trigger of Hate', *Time*, 20 August 1965.

——. 'Cities: The Fire This Time', *Time*, 4 August 1967.

——. 'Man and Woman of the Year: The Middle Americans', *Time*, 5 Jan. 1970: n. pag. http://www.time.com/time/magazine/article/0,9171,943113,00.html. Web. (9 Dec. 2008).

——. 'Nostalgia', *Life*, 19 February 1971.

——. 'Empty Pockets on a Trillion Dollars a Year', *Time*, 13 Mar. 1972. http://www.time.com/time/magazine/article/0,9171,903368,00.html. Web. (3 Dec. 2008).

——. 'The Nifty Fifties', *Life*, 16 June 1972.

——. 'Teen-Age Sex: Letting the Pendulum Swing', *Time*, 21 August 1972.

Arnold, Matthew. *Culture and Anarchy.* Cambridge: Cambridge University Press, 1960.

Arnott, Teresa, and Julie Matthaei. *Race, Gender, and Work: A Multicultural Economic History of Women in United States.* Boston: South End Press, 1991. *Questia.* Web. (13 Jan. 2009).

Bacon-Smith, Camille. *Enterprising Women: Television Fandom and the Creation of Popular Myth.* Philadelphia: University of Pennsylvania Press, 1992.

Bailey, Beth, and David Farber. *America in the Seventies*. Kansas: University Press of Kansas, 2004.

Bakhtin, Mikhail. *Rabelais and His World*. Cambridge Mass., and London: MIT Press, 1968.

Barker, Martin, and Julian Petley. *Ill Effects: The Media/Violence Debate*. 2nd ed. London: Routledge, 2001.

Barthes, Roland. 'The Death of the Author', in *The Rustle of Language*. Berkeley and Los Angeles: University of California Press, 1989.

——. *Mythologies*. London: Vintage, 1993.

Bell, Daniel. *The Coming of Post-Industrial Society*. New York: Basic Books, 1973.

——. *The Cultural Contradictions of Capitalism*. New York: Basic Books, 1976.

Berger, Arthur Asa. *The TV-Guided American*. New York: Walker, 1976.

Berkowitz, Edward. *Something Happened: A Political and Cultural Overview of the Seventies*. New York: Columbia University Press, 2006.

Blumenthal, Ralph. 'Porno Chic', *New York Times*, 21 January 1973.

Bourdieu, Pierre. *Distinction: A Social Critique of the Judgement of Taste*. London: Routledge, 1989.

Boym, Svetlana. *The Future of Nostalgia*. New York: Basic Books, 2001.

Bradley, Patricia. *Mass Media and the Shaping of American Feminism, 1963–1975*. Jackson Mississippi: Mississippi University Press, 2003.

Bryant, J., and J.A. Bryant. *Television and the American Family*. Mahwah, NJ: Lawrence Erlbaum Associates, 2001.

Castleman, Harry, and Walter J. Podrazik. 'A Sample of '70S Television' in Mark Ray Schmidt (ed), *The 1970s*. San Diego: Greenhaven Press, 2000.

Cavicchi, Daniel. *Tramps Like Us: Music & Meaning Among Springsteen Fans*. New York: Oxford University Press, 1998.

Cawelti, John G. 'That's What I Like About the South: Changing Images of the South in the 1970s', in Elsebeth Hurup (ed.), *The Lost Decade: America in the Seventies*. Aarhus and Oxford: Aarhus University Press, 1996.

Chambers, Deborah. *Representing the Family*. London: Sage, 2001.

Chantler, A. 'The Waltons: Frankenstein's Literary Family?', *Byron Journal*, 1999: 102–04.

Chopra-Gant, Mike. *Hollywood Genres and Postwar America: Masculinity, Family and Nation in Popular Movies and Film Noir*. London: I.B.Tauris, 2006.

Cohan, Steven. *Masked Men: Masculinity and the Movies in the Fifties*. Bloomington and Indianapolis: Indiana University Press, 1997.

Collins, Robert M. *More: The Politics of Economic Growth in Postwar America*. Oxford: Oxford University Press, 2000.

Comfort, Alex. *The Joy of Sex: A Cordon Bleu Guide to Lovemaking*. New York: Crown Publishers, 1972.

Coontz, Stephanie. *The Way We Never Were: American Families and the Nostalgia Trap*. New York: Basic Books, 1992.

Cooper, B. Lee. *Popular Music Perspectives: Ideas, Themes, and Patterns in Contemporary Lyrics*. Bowling Green OH: Bowling Green State University Popular Press, 1991. *Questia*. Web. (12 Dec. 2008).

Couldry, Nick. *Inside Culture: Re-Imagining the Method of Cultural Studies*. London: Sage, 2000.

Curtis, Jim. *Rock Eras: Interpretations of Music and Society, 1954–1984.* Bowling Green OH: Bowling Green State University Popular Press, 1987. *Questia.* Web. (12 Dec. 2008).

Davis, Maxine. *The Lost Generation: A Portrait of American Youth Today.* New York: Macmillan, 1936.

De Certeau, Michel. *The Practice of Everyday Life.* Berkeley, Los Angeles, London: University of California Press, 1988.

Devlin, Rachel. *Relative Intimacy: Fathers, Adolescent Daughters, and Postwar American Culture.* Chapel Hill and London: University of North Carolina Press, 2005.

Dialectic of Sex: The Case for Feminist Revolution. New York: Morrow, 1970.

Douglas, William. *Television Families: Is Something Wrong in Suburbia?* Mawah NJ: Lawrence Erlbaum Associates, 2003.

Dow, Bonnie J. *Prime-Time Feminism: Television, Media Culture, and the Women's Movement Since 1970.* Philadelphia: University of Pennsylvania Press, 1996.

Dyer, Richard. *Only Entertainment.* 2nd ed. London and New York: Routledge, 2002.

Eagleton, Terry. *Walter Benjamin: Towards a Revolutionary Criticism.* London: Verso, 1981.

Edwards, Tim. *Cultures of Masculinity.* London and New York: Routledge, 2006.

Ehrenreich, Barbara. *The Hearts of Men: American Dreams and the Flight From Commitment.* New York, London, Toronto, Sydney, Auckland: Anchor Books, 1983.

Faludi, Susan. *Stiffed: The Betrayal of the Modern Man.* London: Chatto and Windus, 1999.

Falwell, Jerry. *How You Can Help Clean Up America: An Action Program for Decency in Your Community.* 1978. Lynchburg, VA: Liberty Publishing Co., 1978

———. *The Fundamentalist Phenomenom: The Resurgence of Conservative Christianity.* Garden City NY: Doubleday, 1981.

Falwell, Jerry, and Elmer Towns. *Capturing a Town for Christ.* Old Tappan NJ: Fleming H. Revell Company, 1973.

Foley, J P. *Why Not More Programs Like 'The Waltons',* in M. Suman (ed.), Religion and Prime Time Television. Westport CT: Praeger, 1995.

Friedan, Betty. *The Feminine Mystique.* New York: W. W. Norton, 1963.

Frum, David. *How We Got Here: The 70'S: The Decade That Brought You Modern Life – for Better or Worse.* New York: Basic Books, 2000.

Garrett, E A. 'President's Column the View From Walton's Mountain', *Family Medicine* 34.7, 2002: 495–97.

Genovese, Michael A. *The Nixon Presidency: Power and Politics in Turbulent Times.* Westport CT: Greenwood Press, 1990. *Questia.* Web. (12 Dec. 2008).

Geraghty, Christine. *Women and Soap Opera: A Study of Prime Time Soaps.* Cambridge: Polity, 1991.

Gilbert, Mark Jason, and William Head. *The Tet Offensive.* Westport CT : Praeger, 1996. *Questia.* Web. (18 Dec. 2008).

Gitlin, Todd. *The Sixties: Years of Hope, Days of Rage.* New York: Bantam Books, 1987.

——. *Inside Prime Time*. Berkeley, Los Angeles, London: University of California Press, 2000.

——. *Media Unlimited: How the Torrent of Images and Sounds Overwhelms Our Lives*. New York: Metropolitan Books, 2001.

Glass, Loren. 'Bad sex: second-wave feminism and pornography's golden age', *Radical Society* 29.3, October 2002: 55–66.

Goldberg, Steven. *The Inevitability of Patriarchy*. London: Temple Smith, 1977.

Grant, William E. 'The inalienable land: American wilderness as sacred symbol', *Journal of American Culture* 17.1, 1994: 79+.

Gray, Jonathan. *Watching with the Simpsons: Television, Parody, and Intertextuality*. London and New York: Routledge, 2006

——. *Television Entertainment*. London and New York: Routledge, 2008.

Gray, Jonathan, Sandvoss, Cornell and Harrington, C. Lee (eds). *Fandom: Identities and Communities in a Mediated World*. New York and London: New York University Press, 2007.

Greer, Germaine. *The Female Eunuch*. London: Paladin, 1971.

Hall, Stuart. 'Encoding/Decoding', *Culture, Media, Language: Working Papers in Cultural Studies, 1972–79*. Stuart Hall (ed.). London: Routledge, 1992.

Hamamoto, Daniel Y. *Nervous Laughter: Television Situation Comedy and Liberal Democratic Ideology*. New York: Praeger, 1991.

Hamner, and Earl H. Jr. *Fifty Roads to Town*. New York: Random House, 1953.

——. *Spencer's Mountain*. Cutchogue, NY: Buccaneer Books, 1961.

——. *The Homecoming: A Novel About Spencer's Mountain*. Cutchogue, NY: Buccaneer Books, 1970.

Hamner, Earl H. Jr, and Ralph Giffin. *Goodnight John-Boy*. Nashville: Cumberland House, 2002.

Hebdige, Dick. *Subculture: The Meaning of Style*. London: Methuen, 1979

——. *Hiding in the Light: On Images and Things*. London: Routledge, 2002.

Hill, Rebecca. 'Fosterites and Feminists, or 1950S Ultra-Leftists and the Invention of Amerikkka', *New Left Review*, 1998: 67–90. Online. Available http://www.questia.com/read/98684790?title=Fosterites%20and%20Feminists%2c%20Or%201950s%20Ultra-Leftists%20and%20the%20Invention%20of%20AmeriKKKa (18 Dec. 2009).

Hills, Matt. *Fan Cultures*. London: Routledge, 2002.

Himmelstein, Hal. *Television Myth and the American Mind*. Westport CT: Praeger, 1994.

Hoggart, Richard. *The Uses of Literacy: Aspects of Working-Class Life with Special Reference to Publications and Entertainments*. London: Penguin, 1992.

Hollander, Xaviera. *The Happy Hooker*. New York: Dell, 1972.

Horowitz, Daniel. *Betty Friedan and the Making of the Feminine Mystique: The American Left, the Cold War, and Modern Feminism*. Amherst MA: University of Massachusetts Press, 1998.

Hurup, Elsebeth. *The Lost Decade: America in the Seventies*. Aarhus and Oxford: Aarhus University Press, 1996.

Husock, Howard. 'Public Housing As a "Poorhouse."', *Public Interest* Issue 129, Fall 1997: 73–85.

Iser, Wolfgang. *The Range of Interpretation*. New York: Columbia University Press, 2000.

Isserman, Maurice, and Michael Kazin. *America Divided: The Civil War of the Sixties*. New York and Oxford: Oxford University Press, 2000.

Jameson, Fredric. *Postmodernism or the Cultural Logic of Late Capitalism*. Durham: Duke University Press, 1991.

Jenkins, Henry. *Textual Poachers: Television Fans and Participatory Culture*. London and New York: Routledge, 1992.

Johnston, Carolyn. *Sexual Power: Feminism and the Family in America*. Tuscaloosa AL: University of Alabama Press, 1992.

Kammen, Michael. *In the Past Lane: Historical Perspectives on American Culture*. Oxford: Oxford University Press, 1997. *Questia*. Web. (18 Dec. 2008).

Kaufman, Will. *American Culture in the 1970s*. Edinburgh: Edinburgh University Press, 2009.

Kimball, Roger. *The Long March: How the Cultural Revolution of the 1960s Changed America*. San Francisco: Encounter Books, 2000.

Kimmel, Michael. *The Gendered Society*. Oxford: Oxford University Press, 2000.

——. *Manhood in America: A Cultural History*. Oxford: Oxford University Press, 2006.

Lewis, Justin. *The Ideological Octopus: An Exploration of Television and Its Audience*. New York and London: Routledge, 1991.

Look Magazine. *The Decline of the American Male*. New York: Random House, 1958.

Lundberg, Ferdinand, and Marynia F. Farnham. *Modern Woman: The Lost Sex*. New York and London: Harper and Brothers, 1947.

Mailer, Norman. *Why Are We in Vietnam*. New York: Holt, Rinehart and Winston, 1982.

Marcuse, Herbert. *One-Dimensional Man*. Boston: Beacon Press, 1966.

Mead, Walter Russell. *Mortal Splendor: The American Empire in Transition*. Boston: The Houghton Mifflin Company, 1987.

Milett, Kate. *Sexual Politics*. New York: Doubleday, 1970.

Miller, J. Hillis. *Black Holes*. Stanford: Stanford University Press, 1999.

Miller, Mark Crispin. 'Deride and conquer', in Todd Gitlin (ed.), *Watching Television*. New York: Pantheon Books, 1988.

Miller, Toby. 'Turn off TV studies!', *Cinema Journal* 45.1, 2005: 98–101.

Moore-Gilbert, Bart. *The Arts in the 1970s: Cultural Closure?* London and New York: Routledge, 1994.

Morgan, Robin (ed.). *Sisterhood Is Powerful*. New York: Vintage Books, 1970.

Morowitz, Laura. 'The monster within: The munsters, the addams family and the American family in the 1960s', *Critical Studies in Television* 2.1 Spring, 2007: 35–90.

Morrow, Lance. '1968 Like a Knife Blade, the Year Severed Past From Future', *Time*, 11 January 1988.

Morrow, Lance, Tom Curry, Martha Smilgis, and Lisa Towle. 'Family Values', *Time*, 31 August 1992.

Moss, Sylvia. 'The New Comedy', *Television Quarterly* 4. Winter, 1965: 4245.

Newcomb, Horace. *TV: The Most Popular Art*. Garden City NY: Anchor Press, 1974.

Obst, David. *Too Good to Be Forgotten*. New York, Chichester, Weinheim, Brisbane, Singapore, Toronto: John Wiley and Sons, 1998.

Ott, Brian L. *The Small Screen: How Television Equips Us to Live in the Digital Age*. Malden, MA, Oxford, UK and Victoria, Aus.: Blackwell, 2007.

Ozersky, Josh. *Archie Bunker's America: TV in An Era of Change, 1968–1978.* Carbondale, IL: Southern Illinois University Press, 2003.

Perlstein, Rick. *Nixonland.* New York: Scribner, 2008.

Person, James E. *Earl Hamner: From Walton's Mountain to Tomorrow.* Nashville: Cumberland House, 2005.

Phillips, Kendall R. *Projected Fears: Horror Films and American Culture.* Westport CT: Praeger, 2005. *Questia.* Web. (18 Dec. 2008).

Prescott, Orville. 'Review of You Can't Get There From Here', *New York Times,* 11 June 1965: 29.

Radway, Janice. *Reading the Romance: Women, Patriarchy and Popular Literature.* London and New York: Verso, 1987.

Reich, Charles A. *The Greening of America.* Harmondsworth: Penguin, 1971.

Rhodes, Joel P. *The Voice of Violence: Performative Violence As Protest in the Vietnam Era.* Westport CT and London: Praeger, 2001. *Questia.* Web. (12 Dec. 2008).

Robinson, James D., and Thomas Skill. 'Five Decades of Families on Television: From the 1950s Through the 1990s', in Jennings Bryant and J. Allison Bryant (eds), *Television and the American Family.* Mahwah, NJ: Lawrence Erlbaum Associates, 2001.

Rubin, Eva R. *Abortion, Politics, and the Courts: Roe v. Wade and Its Aftermath.* New York, Westport CT: Greenwood Press, 1987.

——. *The Abortion Controversy: A Documentary History.* New York, Westport CT: Greenwood Press, 1994.

Rudnick, Lois P., Judith E. Smith, and Rachel Lee Rubin (eds). *American Identities: An Introductory Textbook.* Malden, MA, Oxford, UK and Victoria, Aus.: Blackwell, 2008.

Ruoff, Jeffrey. *An American Family: A Televised Life.* Minneapolis, London: University of Minnesota Press, 2002.

Sarris, Andrew. *The American Cinema: Directors and Directions, 1929–1968.* New York: E. P. Dutton, 1968.

Sartor, Margaret. *Miss American Pie: A Diary of Love, Secrets and Growing Up in the 1970s.* New York: Bloomsbury, 2006.

Schmidt, Mark Ray. *The 1970s.* San Diego: Greenhaven Press, 2000.

Schulman, Bruce J. *The Seventies: The Great Shift in American Culture, Society, and Politics.* New York, London, Toronto, Sydney, Singapore: The Free Press, 2001.

Schulzinger, Robert D. *A Time for War: The United States and Vietnam, 1941–1975.* Oxford: Oxford University Press, 1997. *Questia.* Web. (19 Dec. 2008).

Scodari, Christine. '"No politics here": Age and gender in soap opera "cyberfandom"', *Women's Studies in Communication* 21.2, 1998: 168+. Available: http://www.questia.com/PM.qst?a=o&d=5035384699 (n.d.)

Skolnick, Arlene. *Embattled Paradise: The American Family in An Age of Uncertainty.* New York: Basic Books, 1991.

Slocum-Schaffer, Stephanie A. *America in the Seventies.* Syracuse: Syracuse University Press, 2003.

Spigel, Lynn. *Make Room for TV: Television and the Family Ideal in Postwar America.* Chicago and London: University of Chicago Press, 1992.

Staiger, Janety. *Media Reception Studies.* New York and London: New York University Press, 2005.

Stevenson, Nick. *David Bowie: Fame, Sound and Vision*. Cambridge: Polity, 2006.

Taylor, Ella. *Prime-Time Families: Television Culture in Postwar America*. Berkeley, Los Angeles, London: University of California Press, 1989.

Taylor, Greg. *Artists in the Audience: Cults, Camp and American Film Criticism*. Princeton NJ: Princeton University Press, 1999.

Thomas, Charles A. 'MISSION BETRAYED: Richard Nixon and the Scranton Commission Inquiry Into Kent State'. *Online. Available http://speccoll.library. kent.edu/4may70/MissionBetrayed.htm* (19 Dec. 2009).

Thompson, Hunter S. *Fear and Loathing : On the Campaign Trail '72*. New York and Boston: Warner Books, 1973.

——. *Songs of the Doomed*. London: Pan Books, 1991.

——. *Fear and Loathing in Las Vegas*. London: Flamingo, 1993.

Tincknell, Estella. *Mediating the Family: Gender, Culture and Representation*. London and New York: Edward Arnold, 2005.

Tucker, Spencer C. *Vietnam*. London: UCL Press, 1999. *Questia*. Web. (19 Dec. 2008).

Turner, Chris. *Planet Simpson: How a Cartoon Masterpiece Documented An Era and Defined a Generation*. London: Ebury Press, 2004.

Vidmar, Neil, and Milton Rokeach. 'Archie bunker's bigotry: a study in selective perception and exposure', *Journal of Communication* Vol. 24 No. 1 March 1974: 36–47.

Walkerdine, Valerie. *Daddy's Girl: Young Girls and Popular Culture*. London: Palgrave Macmillan, 1997.

Wattenberg, Ben J. *The Real America: A Surprising Examination of the State of the Union*. New York: Capricorn Books, 1976.

Whyte, William H. *The Organization Man*. New York: Simon and Schuster, 1956.

Wicker, Tom. *One of Us: Richard Nixon and the American Dream*. New York: Random House, 1991.

Williams, Linda. *Hard Core: Power, Pleasure and the 'Frenzy of the Visible'*. Expanded Paperback ed. Berkeley, Los Angeles, London: University of California Press, 1999.

Williams, Raymond. *Culture and Society, 1780–1950*. Harmondsworth: Penguin, 1963.

——. *Marxism and Literature*. Oxford: Oxford University Press, 1977.

——. 'Culture Is Ordinary'. *Resources of Hope: Culture, Democracy, Socialism*. London: Verso, 1989.

Williamson, Milly. *The Lure of the Vampire: Gender, Fiction and Fandom From Bram Stoker to Buffy*. London: Wallflower Press, 2005.

Wills, Garry. *Nixon Agonistes: The Crisis of the Self-Made Man*. Boston: Houghton Mifflin, 1971.

Wright, Will. *Sixguns and Society: A Structural Study of the Western*. Berkeley, Los Angeles, London: University of California Press, 1975.

Wylie, John Cook. 'A Boy Grows Up in Nelson County, Virginia', *New York Times Book Review*, 1962: 48.

Zaretsky, Natasha. *No Direction Home: The American Family and the Fear of National Decline, 1968–1980*. Chapel Hill: University of North Carolina Press, 2007.

Index

210 *The Waltons*